exploratorium

THE ART OF TINKERING

THIS SPECIAL INK
CONDUCTS ELECTRICITY!
Open up this book
and discover how to hack it.

2012/01
GDROM 2309

MEET 150+ MAKERS WORKING AT THE
INTERSECTION OF ART, SCIENCE & TECHNOLOGY

Karen Wilkinson & Mike Petrich

Try positioning an LED and a battery on the ink and fiddling with them to make the LED light up. Now place more than one LED on the ink—what happens? What about when you try different-colored LEDs? Or when you put an LED far away from the battery? Now you're tinkering—check out the back of this book for more ideas on how you can play with this ink!

THE ART OF
TINKERING

expl**O**ratorium®

THE ART OF
TINKERING

MEET 150+ MAKERS WORKING AT THE INTERSECTION
OF ART, SCIENCE & TECHNOLOGY

Karen Wilkinson
& Mike Petrich

weldon**owen**

CONTENTS

Welcome to *The Art of Tinkering*, a celebration of working—and learning—with your hands. For each of the artists here, we've offered an in-depth look at how they tinker—along with a survey of additional makers working with similar tools, materials, or techniques, and a related activity for you to try on your own.

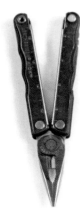

FOREWORD

TODAY, A RADICAL RESURGENCE IN MAKING IS UNDERWAY, CHANGING ART, EDUCATION, INDUSTRY, AND WHAT IT MEANS TO CREATE.

For many, tinkering is something that a previous generation used to do. Yet it is possible that tinkering is something that many of us do without knowing it has a name—even those who do it may not realize that they do it well. What is the current value of tinkering and what is its place in our lives and culture?

Tinkering is the essential art of composing and decomposing physical things to suit a variety of purposes—from practical to whimsical. Tinkering is both a manual and mental labor, perhaps even a labor of love. By the process of tinkering, we learn how to change and shape the world in small but significant ways and adapt it to our personal needs. In spirit, it is close to hacking, a more recent term applied to modifying software and computers. While tinkering can use traditional techniques and materials, today it integrates digital technologies as well.

The Art of Tinkering is both an invitation for everyone to tinker and an appreciation of creative artists who introduce us to many different forms of tinkering. This book captures and shares with a new audience the work of Karen Wilkinson and Mike Petrich at the Exploratorium's Tinkering Studio. They are recognized leaders in developing the practices of tinkering as a form of public engagement, organizing meaningful hands-on activities for young and old as well as curating the work of artists and makers that encourage us to see tinkering in a new light.

I have enjoyed collaborating with Karen and Mike over the years since I started *Make Magazine* and Maker Faire. We share a common mission: We want people to see themselves as makers and producers, defined more by acts of creation than consumption. We also share an expanding roster of talented individuals whose projects delight us and who inspire us all to become makers—many of the artists in this book have been at both the Exploratorium and Maker Faire. Making is something that anyone can do, but we should understand it as something we *need* to do. As the poet Frank Bidart wrote: "we are creatures who need to make." It is how we learn who we are.

The growth of the Maker movement is a sign that people are discovering and rediscovering their own capacity to tinker and make. They find it enjoyable and meaningful, both personally and socially. And as our lives are increasingly dominated by screens and virtual interactions, *The Art of Tinkering* reminds us to keep exploring the creative potential of our physical interactions with real things and real people. It is how we reveal who we are.

Dale Dougherty
Editor & Publisher
of *Make Magazine*

Al Belleveau's *Tool Box*, a clever assemblage of tools made for carrying other tools. ▶

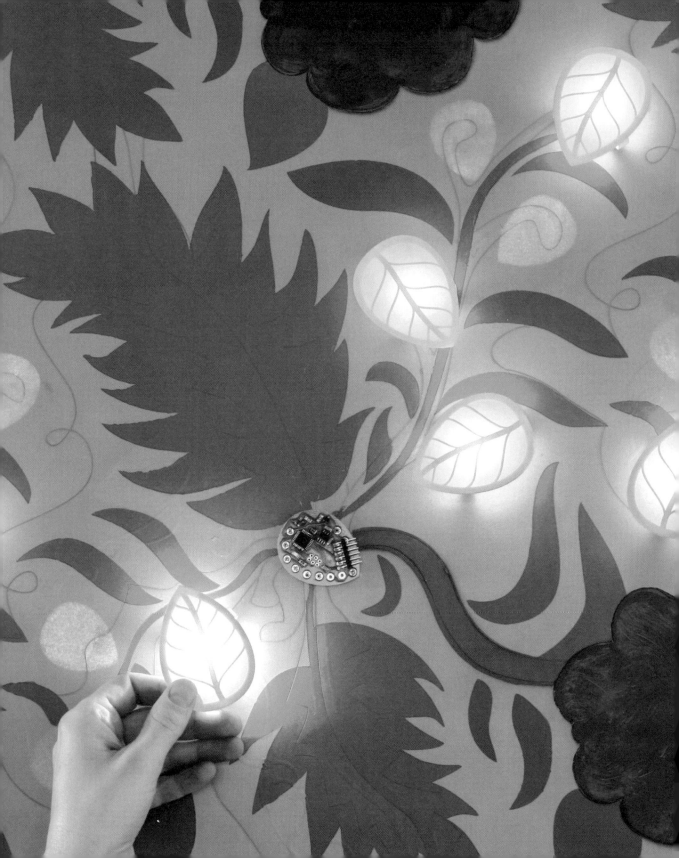

INTRODUCTION

THE PURE, FOCUSED BLISS OF TINKERING ISN'T JUST FOR ARTISTS OR ENGINEERS. IT'S A WAY THAT WE CAN ALL BE MORE HUMAN.

One of my fondest childhood memories is of my dad bringing home an old typewriter from the dump as a gift. My brother and I quickly set upon it with screwdrivers and wrenches—what a beautiful thing it was! Full of brass gears and delicate, ornery springs, with lovely round black keys for letters. We spent countless hours transforming its pieces into jewelry, small vehicles, doll furniture, and sculptures.

For me, the memory of that magical and absorbing typewriter exemplifies the compulsive, human heart of tinkering. People revel in taking things apart, putting them back together, and making new things. We work joyfully and obsessively to build utterly personal creations—like giant marble slides, ingenious and witty automata, colorful rag quilts, and cardboard puppets. Because when you make these things, you articulate aspects of being human that cannot be communicated any other way.

I am incredibly fortunate to have a career in tinkering. As a professor and the director of the High-Low Tech group at the MIT Media Lab, and now as an independent designer, I get to build lots of things myself. But by designing toolkits and holding workshops, I'm also able to share this joy with others: the pleasure of working with both your body and your mind, the satisfaction of feeling frustrated and then triumphant when confronted with a challenge, and the sense of freedom and opportunity that comes from making something entirely your own.

The Exploratorium's Tinkering Studio has been an inspiration since I discovered it almost 10 years ago. I had the privilege of spending a month there as a visiting artist, which shaped me as a young teacher and builder in countless ways. Most memorably, it taught me the importance of two crucial practices that are easy to overlook: retaining a sense of play in what you do and leaving room for quiet and (sometimes slow) reflection in the making process.

It is a wonderful treat to have much of the magic of the Tinkering Studio—and the magic of tinkering itself—captured in this book. It's a beautiful volume full of enchanting constructions, each one stranger and more marvelous than the last. Yet what makes it truly extraordinary is that it pays as much attention to the process of making as it does to the final products themselves. All great tinkerers are great copiers, and there's a treasure trove of secrets—about materials, techniques, and perspectives—to absorb in *The Art of Tinkering*. After reading it, I'm overflowing with ideas for new projects and I'm sure you will be, too.

Leah Buechley

Leah Buechley
Designer, Artist
& Engineer

Leah's *Living Wall,* an interactive wallpaper designed to light up and play birdsong in response to your touch.

PREFACE

THE EXPLORATORIUM HAS ALWAYS BEEN FULL OF CURIOUS INVENTIONS. AND IN THE TINKERING STUDIO, YOU NOW GET TO MAKE YOUR OWN.

I first got to know Mike and Karen in 1995 when they came back from a visit to the storied wind-art farm of whirligig creator Vollis Simpson in North Carolina. They excitedly showed me pictures and videos of his amazing wind-powered devices, and just looking at these wonderful contraptions made me want to get out there and build my own. They also stimulated a powerful set of wondering questions in me—like "I wonder how this works?" or "I wonder what would happen if I did this." I realized that these were exactly the kinds of questions that I ask as a scientist and that form the basis of the scientific process.

Since the Exploratorium opened its doors in 1969, it's had a deep commitment to providing opportunities that enhance the inquiry skills of our visitors. Every day, the public gets to experiment directly with the phenomena on display in our exhibits. Until recently, however, the exhibit developers had all the fun of making these things. Our recent move to Pier 15 in San Francisco has enabled us to offer this making opportunity to our visiting public through the opening of the Tinkering Studio.

The Tinkering Studio is a place where people get to tinker—to make something that *they* want to make. It is a place where science, art, engineering, and design merge into a delightful whole. It extends the exhibit experience in new ways by enabling people to explore their curiosity with the tools to make that happen.

Sometimes tinkering is thought of as a directionless activity, just playing around with no serious purpose or outcome. But I would contend that it is a very serious enterprise indeed. It is one that leads to important learning experiences for scientists and artists and everyone else. Participating in tinkering enhances one's sense of design and strengthens one's problem-solving skills. It lets one create a feeling for materials, their affordances, and how to work with them. And, most importantly, it stimulates individual curiosity and personal inquiry. It leads to an endless supply of questions that can carry one through a lifetime of science, art, and awareness.

Happy tinkering!

Rob Semper
Executive Associate Director
of the Exploratorium

Tim Hunkin's *Tinkerers' Clock*, a one-of-a-kind timepiece built specially for the Exploratorium. ▶

A FEW WORDS FROM
KAREN & MIKE

For us, tinkering started when we were kids—when we were encouraged to explore our environments, ask questions, and construct our own understandings of the world. We were given permission to get messy, find out for ourselves, and try out crazy ideas just for the sake of experience—and allowed to get lost in the woods and in our own imaginations.

These moments sparked a lifetime of learning through making, putting us on a trajectory that included experimenting with various media at art school and incorporating electronics into creative expression at the MIT Media Lab. Ultimately, these moments led us to the Exploratorium, where we foster similarly crucial, formative, and fun moments for our visitors. As codirectors of the museum's Tinkering Studio, we work with a group of talented, inquisitive individuals to design workshops that combine science, art, and technology in playful and inventive ways—inviting visitors to pick up a hand tool, futz around with loose parts, and make a mess while creating their own whimsical, original projects.

But what is *tinkering*? The word was first used in the 1300s to describe tinsmiths who would travel around mending various household gadgets. But in our minds, it's more of a perspective than a vocation. It's fooling around directly with phenomena, tools, and materials. It's thinking with your hands and learning through doing. It's slowing down and getting curious about the mechanics and mysteries of the everyday stuff around you. It's whimsical, enjoyable, fraught with dead ends, frustrating, and ultimately about inquiry. It's also about making something, but for us, that thing reveals itself to you as you go. Because when you tinker, you're not following a step-by-step set of directions that leads to a tidy end result. Instead, you're questioning your assumptions about the way something works, and you're investigating it on your own terms. You're giving yourself permission to fiddle with this and dabble with that. And chances are, you're also blowing your own mind.

The Art of Tinkering is our invitation to you to join in on this invaluable and enriching way of going through the world. In this book's pages, we've profiled beloved artists who have spent time at the Tinkering Studio and who embody what we call the tinkering disposition. For each artist, there are details of their processes—their favorite tools, materials, inspirations, and prototypes—and the stories of how they stumbled upon a method that works for them. Then we talk about other makers working in a similar vein to show you all the possibilities that a certain technique can yield.

Finally, there are ways that you can tinker, too: ideas to get you started on your very own explorations. Because we want you to get your hands dirty. We want you to engage, get stuck, and play with a problem until you come around to a deeper understanding. We find that the combination of confidence and competence that results from tinkering is irresistible—and if we make it part of our everyday lives, we'll all be richer for it.

Karen Wilkinson & Mike Petrich
Codirectors of the Tinkering Studio

TINKERING TENETS

Every day at the Exploratorium, we witness firsthand how empowering tinkering can be—we're there for the head scratching, the trial and error, and the *aha!* moments that result from engaging your world, both physically and mentally. Here we've put together a few of our daily practices and some of the ideas that guide us in our work, and we hope that they will help you in your own tinkering adventures.

MERGE SCIENCE, ART & TECHNOLOGY

On their own, science, art, and technology all make for interesting, fun, and rewarding explorations. But when you mix them together, you get a veritable tinkering trifecta in which technological tools and scientific principles let you express your own artistic vision. Plus, we find that when you make something that's personally meaningful to you, you get especially motivated to make it work, leading to tons of great insights into your chosen tools.

USE FAMILIAR MATERIALS IN UNFAMILIAR WAYS

The world is full of stuff that was invented to do a specific job. But taking a common object and putting it to new use will likely result in unexpected, surprising explorations—like making music with walnuts or crafting tiny cities of tape. A bonus: These materials are often cheap and easy to find, and their universality means you can use them in near-infinite ways.

CREATE RATHER THAN CONSUME

REVISIT & ITERATE ON YOUR IDEAS

EXPRESS IDEAS VIA CONSTRUCTION

PROTOTYPE RAPIDLY

When you have a new idea, it's incredibly helpful to get it out of your brain as soon as possible—to sketch a design or build a working model with stuff you have lying around. That way, you can make it real, work it out, and develop a concrete understanding of your next steps, then move on to Phase 2.

EMBRACE YOUR TOOLS

We love tools. Beyond being just plain useful, they're also an extension of your own critical thinking, letting you physically investigate the way things work—to get in there and pry, screw, hammer, and wire your way to a deeper understanding. And when you learn how to use a felting needle, multimeter, or hand drill, you open up a world of possibilities that allow you to fix things, remix things, and bring something new into the world.

BE COMFORTABLE NOT KNOWING

GO AHEAD, GET STUCK

When you tinker, you're going to mess up. You're going to get frustrated, fail, and maybe even break a thing or two. We call this getting stuck, and believe it or not, it is a very good thing. Failure tells you what you don't know, frustration is making sense of that failure in the moment, and taking action leads to a new way of knowing. Treat each of the problems that arise as a problem to play with—rather than a problem to solve—and practice working through times of frustration without judging yourself. You'll find that you develop an astonishing capacity for new understandings.

REINVENT OLD TECHNOLOGIES (AND DISCOVER NEW ONES, TOO)

In this book, you'll encounter dozens of technologies (some old, some new) from all types of art practices and industries. We encourage you to consider all the possible tactics out there that can help you realize your vision—whether your project requires old-school woodworking, photo-making techniques from the 1800s, or relatively newfangled circuitry and programming.

SEEK REAL-WORLD EXAMPLES EVERYWHERE

TRY A LITTLE "SNARKASM"

We like to joke around while we tinker, and we call our particular brand of well-meaning wit and unprecious playfulness "snarkasm." A little humor helps—it's enjoyable and it alleviates the pressure of trying to make something work.

BALANCE AUTONOMY WITH COLLABORATION

Tinkering with other people can be a blast and is a valuable way to get things done. It makes you explain your ideas, allows partners to cross-pollinate and share skills, and lets everyone be part of something larger than themselves. On the flip side, we advise going solo from time to time—it will equip you with a richer knowledge of your tools and materials, and you'll feel your confidence, your dexterity, and even your brain expand.

PUT YOURSELF IN MESSY, NOISY & SOMETIMES DANGEROUS SITUATIONS

Tinkering can get tricky. Prep to use your tools safely, and practice techniques for cutting, drilling, soldering, and welding. But the dangerous aspect of tinkering is a powerful motivator—it forces you to slow down and pay close attention to what you're doing. A little caution goes a long way.

TAKE YOUR WORK SERIOUSLY WITHOUT TAKING YOURSELF SERIOUSLY

Because tinkering should be fun. And when you let go of your ego, you give yourself permission to focus and play. That's when the good stuff happens.

TOOLS FOR TINKERING

One of the most important parts of tinkering is engaging with your tools and materials, and to do that you have to have some on hand! Here are just a few of our favorite tinkering instruments—most of which you can pick up at any hardware or hobbyists' shop, and many of which are tools recommended on the How You Can Tinker pages in this book. Don't let our suggestions limit you, though: Look for other items that can help you complete your projects, and reconsider the possibilities of the everyday stuff all around you.

A FEW TYPES
OF PLIERS

MULTITOOL

ROPE

PUNNETS
(A.K.A. STRAWBERRY BASKETS)

THREAD

HAND TOOLS FOR MEASURING,
SKETCHING, CUTTING &
FOLDING

NEEDLES, PINS,
THIMBLES & FABRIC

SCRAP
CARDBOARD

GOOD
SCISSORS

TAPE HELPS! STOCK UP
ON A BUNCH OF TYPES.

HOT-
GLUE GUN

DERDERS
(A.K.A. TOILET-
PAPER TUBES)

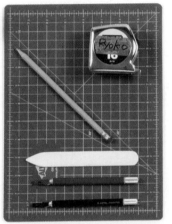

CRAFT FOAM
& FELT

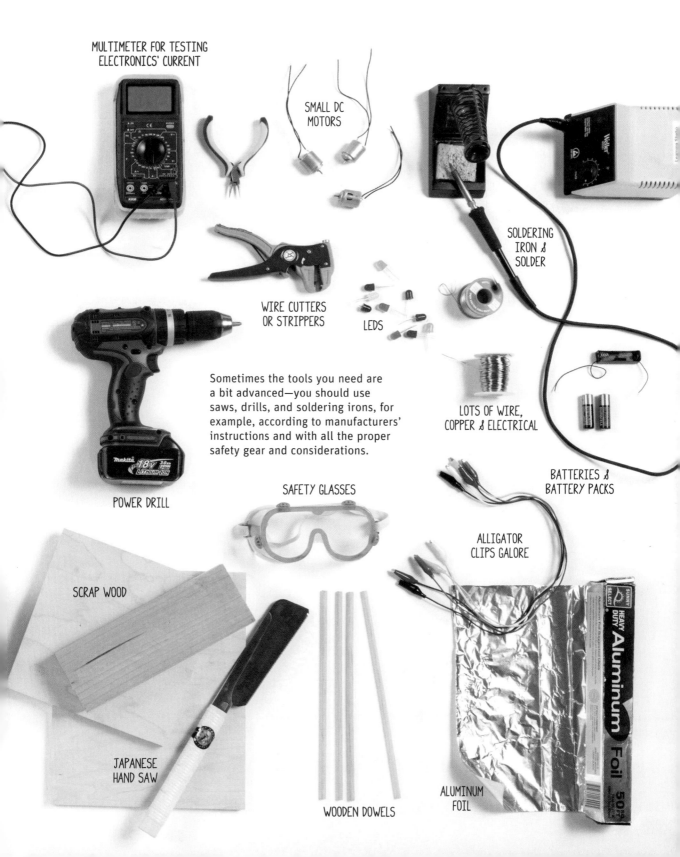

MULTIMETER FOR TESTING
ELECTRONICS' CURRENT

SMALL DC
MOTORS

SOLDERING
IRON &
SOLDER

WIRE CUTTERS
OR STRIPPERS

LEDS

Sometimes the tools you need are
a bit advanced—you should use
saws, drills, and soldering irons, for
example, according to manufacturers'
instructions and with all the proper
safety gear and considerations.

LOTS OF WIRE,
COPPER & ELECTRICAL

BATTERIES &
BATTERY PACKS

POWER DRILL

SAFETY GLASSES

ALLIGATOR
CLIPS GALORE

SCRAP WOOD

JAPANESE
HAND SAW

WOODEN DOWELS

ALUMINUM
FOIL

THE TINKERING STUDIO TEAM

The Tinkering Studio is a collection of artists, scientists, developers, educators, and facilitators who dabble in and experiment with a ton of tools, materials, and technologies. Their findings frequently turn into exhibits at the Exploratorium, or into hands-on activities that allow visitors to get in on the tinkering fun.

WALTER

I'm a designer and an artist in the Tinkering Studio. My personal art practice often informs my work at the Studio and vice versa. Here I'm sketching out a new turntable-based stringed instrument for an upcoming performance.

RYAN

I train staff and volunteers, working with them to develop a practice of facilitation—our goal is to learn more than we teach. Here I'm testing out a first go at paper circuit boards, tweaking and combining existing activities into a new one.

NICOLE

I'm an exhibit developer at the Tinkering Studio, and I was inspired by master circuit-builder Forrest Mims to make this rain-sensing umbrella, which shows that raindrops conduct electricity and that there are playful ways to make a circuit!

I love building RYOKO things as well as facilitating activities. Lately, I've been messing with wood and hand tools, and I've found that there's a fascinating variety of approaches that let you achieve similar results. The process is tinkering!

LIANNA I hunt down all the crazy materials that we need and (try to!) keep them all organized. Right now, I'm sewing a circuit because I love combining textiles with electronics in an expressive way. Plus, it really helps me understand switches.

I'm an exhibit SEBASTIAN developer and a teacher, and here I'm working on a zoetrope. I usually don't read directions, because I discover more about the way things work when I don't get it exactly right the first time.

I'm the science-content LUIGI developer in the Tinkering Studio. For me, tinkering means abandoning the idea that there's a perfect solution for any problem. It's more like a series of fruitful iterations that keep the whole project tilted toward success. As a new father, I really hope I'm right about this!

19

TINKERING IN THE WORLD

The Tinkering Studio sometimes travels to other parts of the world, teaming up with other tinkerers near and far to share the ways we explore art, science, and engineering. Wherever we go, we find that working with your hands is a fundamentally human endeavor and that tinkering is a powerful, meaningful way to engage with each other—regardless of background, gender, or age. And wherever we go, we learn a tremendous amount from the tinkerers we meet.

> ❝ We had time to think, time to talk, time to screw up, time to try something else. And there was plenty of time for things to percolate.
>
> —*Janie Ruiz*

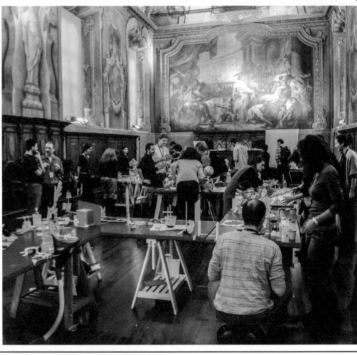

> ❝ I have never done anything like this before. I have been discovering places in my mind that I never knew existed.
>
> —*Rory Naji*

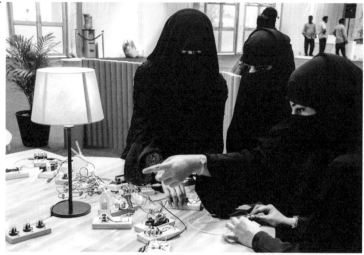

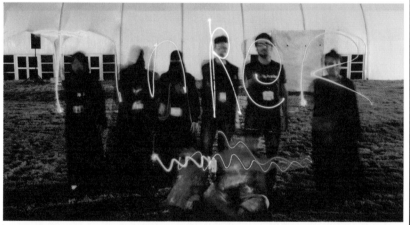

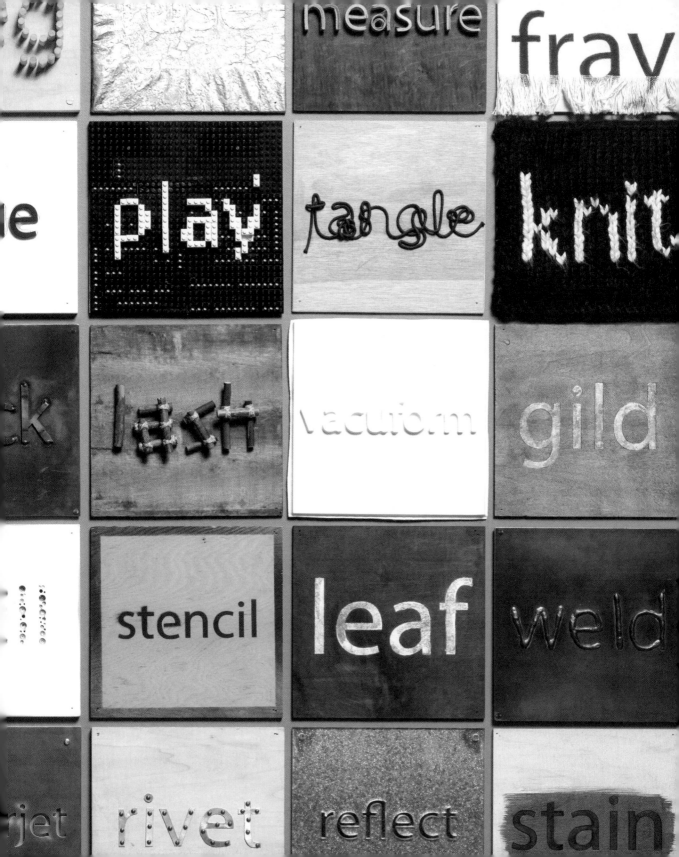

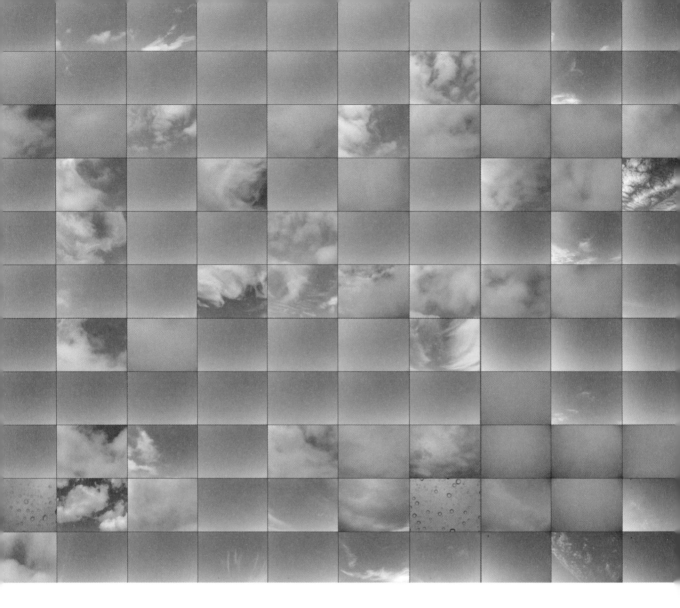

A HISTORY OF THE SKY

SOMETIMES YOU TINKER WITH CARDBOARD, OR WITH TINY MOTORS.
OTHER TIMES YOU TINKER WITH SOMETHING AS HUGE AS THE SKY.

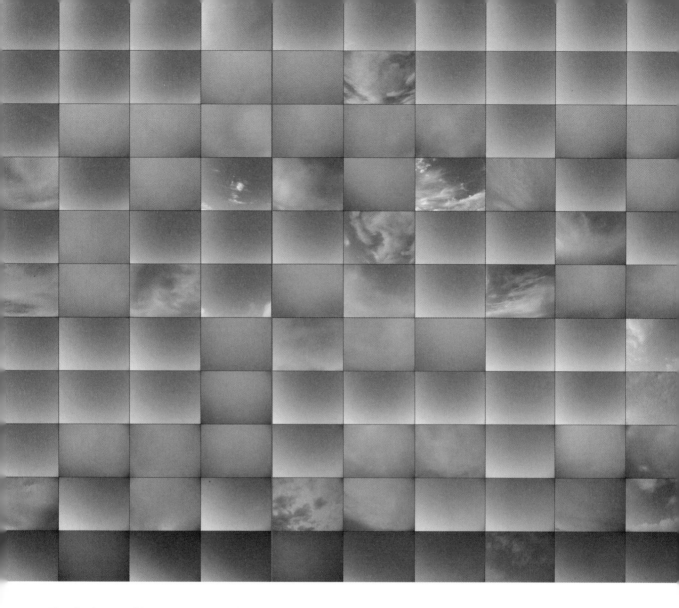

The sky is something we see every day, but whether we actually look at it is an entirely different story. So San Francisco–based computer programmer Ken Murphy documented our atmosphere's endlessly changing hues with *A History of the Sky,* a year-round collection of time-lapse videos shot continuously from the roof of the Exploratorium. To make it, Ken hacked and rigged his camera to capture an image every 10 seconds, so each of the thumbnails that you see here is a still frame from a single day's footage, all captured at the same time of day throughout the year. Ken then wrote code to create a video for each 24-hour period and arranged the videos into a large grid. To watch them all at once is to encounter the sky as we never get to see it—as a calendar in colorful motion, a side-by-side arrangement of days brightening and going black at various times across the seasons.

"It's this pattern we're all aware of, but we don't experience the rhythm of it directly," Ken says. "I wanted to shrink it down to a time scale that you could see."

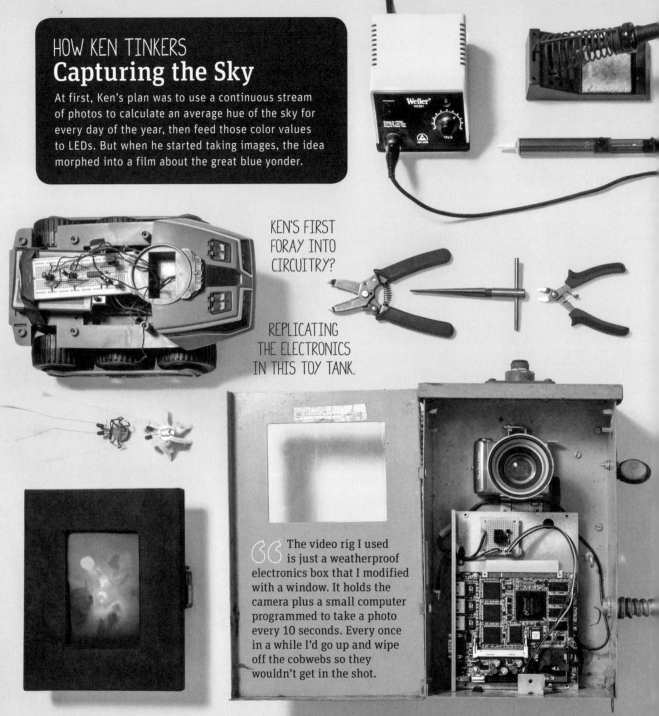

HOW KEN TINKERS
Capturing the Sky

At first, Ken's plan was to use a continuous stream of photos to calculate an average hue of the sky for every day of the year, then feed those color values to LEDs. But when he started taking images, the idea morphed into a film about the great blue yonder.

KEN'S FIRST FORAY INTO CIRCUITRY?

REPLICATING THE ELECTRONICS IN THIS TOY TANK.

" The video rig I used is just a weatherproof electronics box that I modified with a window. It holds the camera plus a small computer programmed to take a photo every 10 seconds. Every once in a while I'd go up and wipe off the cobwebs so they wouldn't get in the shot.

" I started out playing with LEDs—first with little light-up Blinkybugs, then with LED displays that went through random patterns of color. But I wanted to do something not random, so I started thinking about nature as a source of color. Eventually I came up with a big grid of LED-lit squares, each of which would represent the sky's average color for a different day of the year.

KEN'S IDEA OF
A GOOD TIME: SITTING
DOWN AND DOING A
BUNCH OF SOLDERING

TINKERER DETAILS

First tinkering moment I was obsessed with my 1,000-in-1 electronic kit, a board mounted with components that you could connect with springs.

"Real" job I worked with UNIX and web programming for 15 years. I drew on these skills for this project, which required running a Linux-controlled camera remotely, transferring data over a network, managing millions of images, and writing software for the final video.

Where tinkering happens I work in a very small workshop in the pantry off my kitchen.

" Fascination with ancient calendar monuments didn't start the project, but they occurred to me as I went. I'd still like to show the videos in a single ring someday, like Stonehenge, so you see the screens getting bright one at a time, starting with the summer solstice.

" Before I built a video rig, I prototyped the idea using a table of sunrise and sunset data, and ended up with a simple animation. The idea was that the camera would capture the sky's color during the course of the day, a script would compute the average color, and then that value would be sent to an RGB LED. I'd display all the LEDs in a big circle. But once the rig started generating time-lapse images of the sky, I was like, 'Forget LEDs: This needs to be a video piece.'

KEN'S
CODE

```
#!/usr/bin/perl
$| = 1;
# TODO: NEXT STEP: Test with pre-scaled images to see if faster
# TODO: if so, line command to explicitly set panel size
use Image::Magick;
use Getopt::Std;
use File::Basename;
use strict;
use constant NULLIMAGE =>
use constant NW
```

27

HOW YOU CAN TINKER
Try a Little Time-Lapse

When you watch time-lapse videos, they seem magical: You get to see a whole lot of action compressed into a small number of moments. But these videos are just photos of the same scene, smushed together with software. And it's fun to tinker together your own.

PICK A SUITABLE SUBJECT The first thing to consider is what your time-lapse film will be about. You'll want a subject that changes over time, so think about shooting, say, a flower as it blooms and dies during the course of a few weeks, a Popsicle melting on a hot summer's day, or an apple as it rots. The key is to pick something that you can document for a while without moving your camera, as you'll want your images to be shot from the same spot.

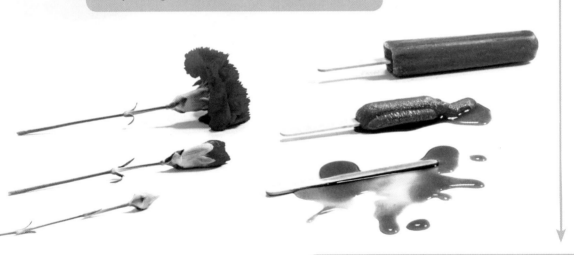

DO THE MATH Before you start, you need to know two things: how long your event will last and how long you want your movie to be. With these numbers, you can determine how much time should pass between each of your photographs so you can show a smooth, gradual change. Here's a handy formula for making your flick show at 24 frames per second (the same as most movies), but of course you can experiment to get any speed you want.

$$\frac{\text{LENGTH OF ACTUAL EVENT IN SECONDS}}{24 \times \text{IDEAL LENGTH OF MOVIE IN SECONDS}} = \begin{array}{c}\text{\# OF SECONDS} \\ \text{BETWEEN} \\ \text{SHOTS}\end{array}$$

PUTTING IT ALL TOGETHER Once you've chosen a subject, figured out the interval between your shots, and selected your gear, set up your tripod and get shooting! (It helps to set your exposure and white balance to automatic so that your camera adjusts for inconstant lighting.) You can then import your images into a photo-editing software program—QuickTime and iMovie work fine—and stitch them together into your very own time-lapse footage.

GEAR OPTIONS A tripod is key, and if you're shooting with a DSLR, an intervalometer lets you program your camera to shoot as many frames per second as you like. No fancy camera? Several websites have come up with time-lapse scripts that you can download to the SD card of a basic digital point-and-shoot—most are temporary and, most important, free. You can also simply shoot each frame on your own, without any automation.

TINKERING WITH TIME

As these artists have discovered, time-lapse and stop-action tools let you stitch together static images to tell a vividly moving story—whether the subject is the natural world or a re-imagined reality.

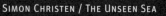

SIMON CHRISTEN / THE UNSEEN SEA
Though it clocks in at just under 3 minutes, this poetic, fog-filtered time-lapse video of the San Francisco Bay would take 10 hours to watch at regular speed, says its creator, Swiss animator Simon Christen. In it, fog rolls over the land like waves and planes dart like fireflies.

MICHAEL SHAINBLUM / MIRROR CITY
Photographer and filmmaker Michael Shainblum took his camera on a tour of several American cities, capturing time-lapse images that he then mirrored with software. The result is a hypnotic, kaleidoscopic exploration of urban bustle and geometries.

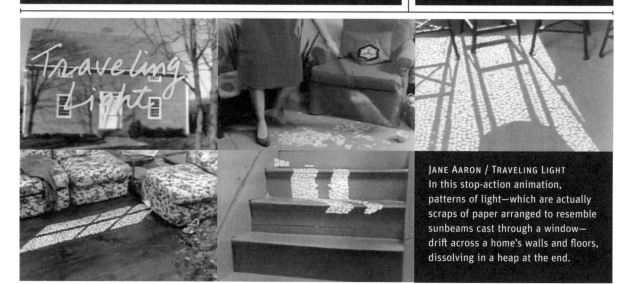

JANE AARON / TRAVELING LIGHT
In this stop-action animation, patterns of light—which are actually scraps of paper arranged to resemble sunbeams cast through a window—drift across a home's walls and floors, dissolving in a heap at the end.

KEITH LOUTIT / SMALL WORLDS PROJECT
Australian filmmaker Keith Loutit transforms the world around us into shrunken, wondrous landscapes. By scaling down and speeding up reality using tilt-shift and time-lapse tactics, Keith provides tidy, simplified scenes of chaotic modern life. He's documented parades, regattas, military marches, and rodeos, among other large-scale events.

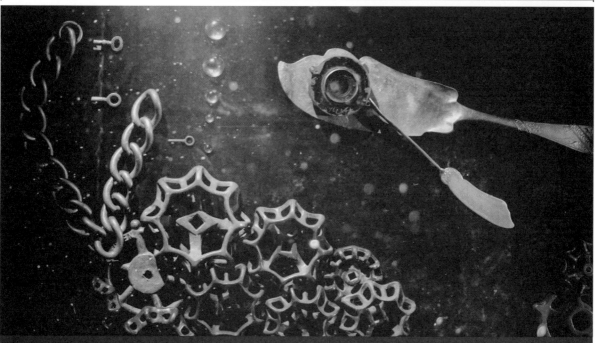

PES / THE DEEP
Beloved stop-action animation artist PES scrounged up tools and scrap metal for five years in order to create this dreamy deep-sea world—where calipers, keys, nutcrackers, and wrenches flit through chain-link seaweed and faucet-knob coral. PES shot the hand-assembled sea creatures on blue velvet, then filmed dusty particles on black and composited the footage.

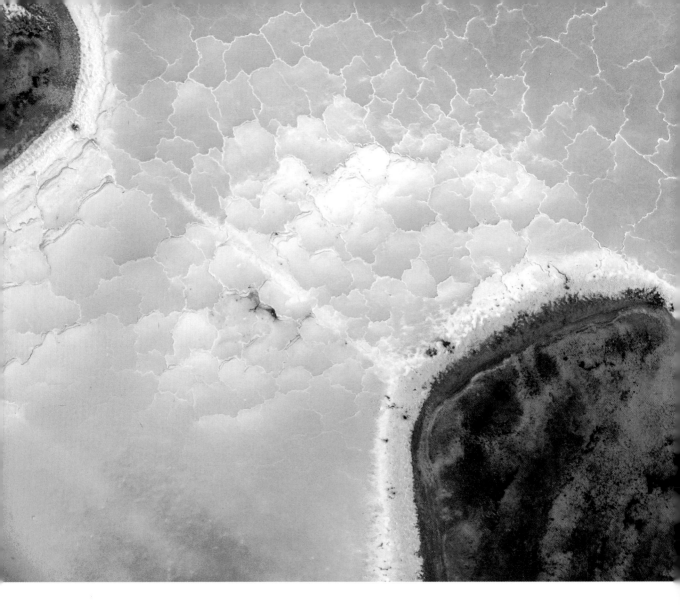

THE VIEW FROM ON HIGH

IT'S A BIRD, IT'S A PLANE . . . NOPE, IT'S A KITE-MOUNTED CAMERA
THAT CAPTURES STUNNING PHOTOGRAPHS OF THE SALT PONDS BELOW.

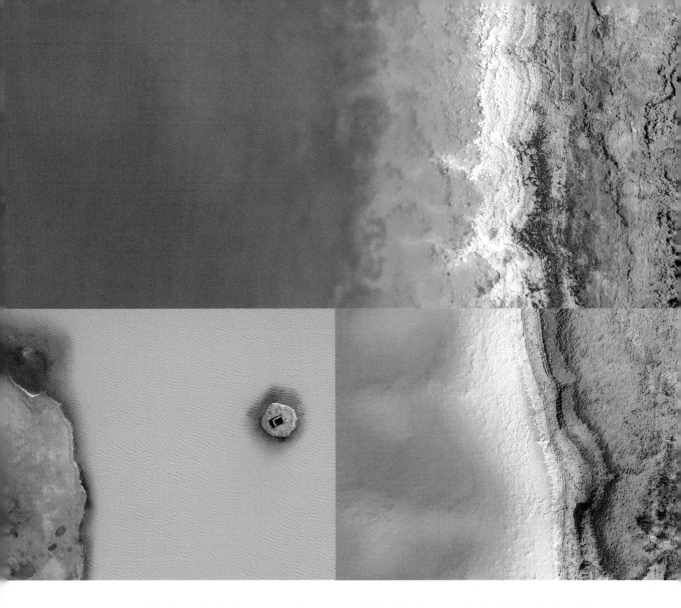

Lurk among the wetlands south of the San Francisco Bay, and you'll likely see a vivid red kite hovering above the landscape, drifting over its brightly colored salt-evaporation ponds and intriguing foliage formations. The man behind the kite strings is one Cris Benton, a retired professor of architecture at UC Berkeley and a long-time fan of kite aerial photography (KAP).

No doubt, Cris has a photographer's eye—his images flatten topographies into graphic studies of color and shape that turn our concept of landscape photography on end. But he's also got quite the tinkerer's disposition, because his tools are mainly self-made: He sews kites (all red, many *rokkakus*—a classic design) and builds remote-controlled camera-suspension systems using hacked electronics and lightweight rods and cables.

But the tinkering doesn't stop there. To keep his kites aloft and control composition, Cris has what we call a conversation with phenomena, adjusting his rig based on feedback from the wind. "The kites talk to you," he says. "Fly one for 10 minutes, and it tells you how it's doing."

HOW CRIS TINKERS
Setting His Sights High

Cris's interest in aerial photography started in the late '90s, when he sent his first rig up above Berkeley, California. But after glimpsing the salt ponds' unique topography and coloration, he teamed up with the South Bay Salt Pond Restoration Project to create a series of images called *Hidden Ecologies*. "I revisit spots twice a year," Cris says, "to get a sense of how they change over time." And when he arrives, he puts an amazing toolkit to work in the field.

THE COLORS IN CRIS'S SHOTS COMES FROM MICROORGANISMS IN THE WATER. HE ALSO MADE A MICROSCOPE RIG TO CAPTURE THEM UP CLOSE.

MATH HELPS: CRIS USES A HYPSOMETER AND SLIDE RULE TO GET THE ANGLES JUST RIGHT.

66 My decompression as a young professor was to fly radio-controlled sailplanes. One Sunday, a woman approached and asked me what channel I was on, and I noticed that she didn't have a plane. Instead, she had an aerial photography rig. We chatted for a while, and during the next six months I thought about it and got a kite and built a cradle for the camera. With the first roll of film, I was totally seduced.

66 Back in the golden age of kite photography, before aircraft showed up in the early 1900s, a Frenchman named Pierre Picavet came up with a suspension idea that involved mounting the camera below two sticks arranged in a cross with pulleys at their ends. This concept was rediscovered in the '90s, and my first rig was definitely informed by it. I added servos and a three-channel radio from one of my radio-controlled gliders, which allowed for panning, tilting, and triggering my film camera's shutter from the ground.

> My current rig is my tenth, and it has sacrificial legs that extend below the camera cradle, which give it something to land (or crash) on. I control it with a five-channel radio controller that I took from a sailplane remote control, repackaged in red wood. The remote triggers a digital camera's shutter, but it also tilts, rotates, and changes from portrait to landscape. I fly it between 10 and 300 feet [15–90 m] high, which isn't so high that it captures the same shot you could get in a Cessna.

CRIS'S FIRST EXPERIMENTS WITH FLYABLES: CLASSIC BALSA-WOOD MODEL PLANES FROM THE '50s

> I always thought that there was some secret knowledge about making kites, but as an adult I've discovered really wonderful, stable geometries and fun kite-making materials, like ripstop nylon fabric and carbon-fiber sticks and arrow shafts. I rebuilt a little antique Singer sewing machine in order to sew kites, and now for me they're pretty much like golf clubs: I keep three *rokkakus* in my car for different types of wind.

TINKERER DETAILS

Tinkering tale One day the winds were bad and I was hauling the kite across the water, when a curious family stepped out in front of me. It would have been dangerous to pull the rig between their heads, so I let it drop, then had to go and pull it out. It was kind of like crabbing.

"Real" job My work in architecture was in building science. We used sky simulators and boundary-layer wind tunnels to do air-flow visualizations around buildings.

Getting unstuck I make incredible, epiphanic leaps forward in the shower. I should take five a day.

Favorite tools I make constant use of my MacBook, adjusting the images' contrast and arranging them into grids with graphic elements connecting the photographs. I've also had a great time working on my Westfalia camper, my mobile office. It's tinkering squared.

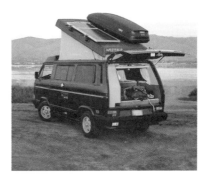

Snap Photos from the Sky

Cris's kite aerial photography rig is an electronic and aerodynamic marvel. You can try tinkering together a less-ambitious version for starters—we like this one because it uses easy-to-find, cheap stuff, and because you'll learn a bit about aerodynamics yourself by building it. And after you've played around with what a basic digital camera and a weather balloon can do, the sky will be the limit.

THE NECESSITIES Find yourself a basic, not-too-pricey digital camera with a fairly large SD card (4 gigabytes is good) and a continuous mode. (Continuous mode, also called burst, will allow you to depress your shutter button and fire off a lot of images without having to trigger your camera from the ground.) Order a weather balloon from an online source—or just pick up a whole bunch of small balloons—so you can keep your rig aloft. Finally, you'll need at least 3,000 feet (915 m) of sturdy nylon string.

CHOOSE A CHASSIS You're sending your camera up into the sky, so you'll want to fashion a mount that keeps it safe, controllable, and well balanced, and that provides a good view of the ground below. Look around for lightweight materials that you could use as a housing—here we used the top of a plastic bottle, but a cardboard box, hunk of Styrofoam, or balsa wood can be cut and fashioned into a usable chassis. Look at your camera and use its shape and size as a guide, and start prototyping.

SEND IT UP Inflate your weather balloon with helium (or blow up a bunch of balloons with helium and tether them together). Tie your chassis to the balloon's closure, along with a 3,000-foot- (915-m-) long string that will help you control the rig from below. Find yourself a clear area on a nice day, and play with getting the camera aloft by slowly letting the string out. Tinker with its height, taking shots from superhigh and some that are just about head height. As you get more confident, try sending it out over water or between buildings. Just hold on to that string!

PUTTING IT ALL TOGETHER Play with mounting your camera inside the chassis, bearing in mind that you'll want it to stay stable and level in the air. We tied about 3 feet (90 cm) of nylon string into a loop, then folded it in half to create two more loops, which we then slid over each end of the camera and taped in place. To keep the rig from spinning in the air (and making your shots turn out blurry), try adding items that will stabilize it in the wind, like plastic strips. Finally, to make your camera keep snapping pics, put it in continuous mode, then use a rubber band and a piece of cardboard to hold down the shutter button.

CAMERAS ON THE GO

Cris's sky-high shutter-snapping rig is just one example of all the cool places cameras can go, from the depths of the sea to our atmosphere's outer edge.

HARROD BLANK / CAMERA VAN
It was a dream that inspired Harrod Blank to cover his van in cameras and hit the road, snapping candid shots of people in the streets. The van features a range of photo-making devices and displays, from Polaroid point-and-shoots to TV monitors.

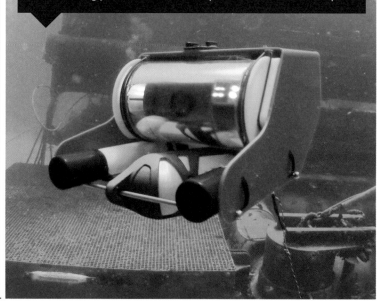

ERIC STACKPOLE & DAVID LANG / OPENROV
This aquatic robot was made to search an underwater cave for gold. No treasure turned up, but the robot has since been delivered to the masses, who are cordially invited to tweak it via open-source software. Besides taking photos, the 'bot also maps terrain and collects samples.

JUSTIN QUINNELL / MOUTH PINHOLES
Adventurous photographer Justin Quinnell has created the Smileycam: a small pinhole camera that he puts in his mouth and uses to make images, mouth agape—sometimes with a toothbrush on its way in.

Jonas Pfeil / Throwable Panoramic Ball Camera

Thirty-six mobile phone camera modules are embedded in this 3-D-printed sphere, and an internal accelerometer triggers them to shoot when the ball is thrown and reaches the highest point of its trajectory. It's also padded with foam, so spikes, punts, and volleys are fair game.

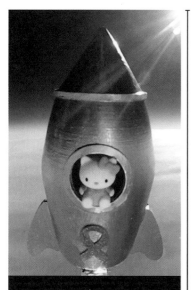

Lauren Rojas / Hello Kitty

This 12-year-old outfitted a rocket-shaped rig with a computer and GoPro cameras, then launched it into space with a weather balloon. The sole occupant? A Hello Kitty figurine.

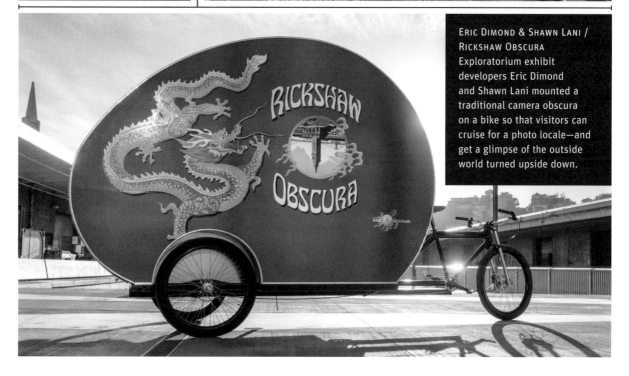

Eric Dimond & Shawn Lani / Rickshaw Obscura

Exploratorium exhibit developers Eric Dimond and Shawn Lani mounted a traditional camera obscura on a bike so that visitors can cruise for a photo locale—and get a glimpse of the outside world turned upside down.

PHYSIOLOGICAL PHOTOGRAMS

THE SECRET BEHIND THESE INTRIGUING X-RAYS? THEY AREN'T X-RAYS AT ALL.

Artist Leigh Anne Langwell is a licensed X-ray technician and a photographer who's shot step-by-step procedurals of all sorts of surgeries. But her most fascinating work happens not in the hospital but in the darkroom, where she exposes plastic and melted glue over light-sensitive paper. The results are stark, lush images that speak to our most intimate interiors—like the sperm-esque creatures you see here, which are actually clusters of ornaments modified with hot-glue tails.

"I'm thinking about the inside of the body as a community and a world in itself, and how it relates to the macro universe—machines and buildings, cosmology and planet formation—and then how those relate back to an even more miniature world, such as particle physics," Leigh Anne says. She hints at these all-encompassing relationships through her careful, meticulous shadow play and an intuitive sense of the way systems work.

Leigh Anne's photograms make good on many of the tinkering tenets: She's recycled a vintage technology to explore the intersection of science and art, and she uses familiar objects in unfamiliar ways. In addition to ornaments and hot glue, her otherworldly landscapes are made up of lace, plastic bags, and even condoms. "I end up raiding a lot of trash cans," she half-jokingly says. "And I spend a lot of time wandering around Hobby Lobby, searching for plastic bits and bobs."

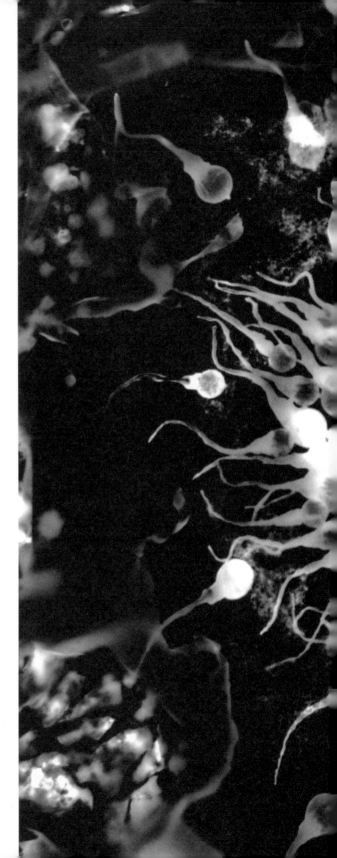

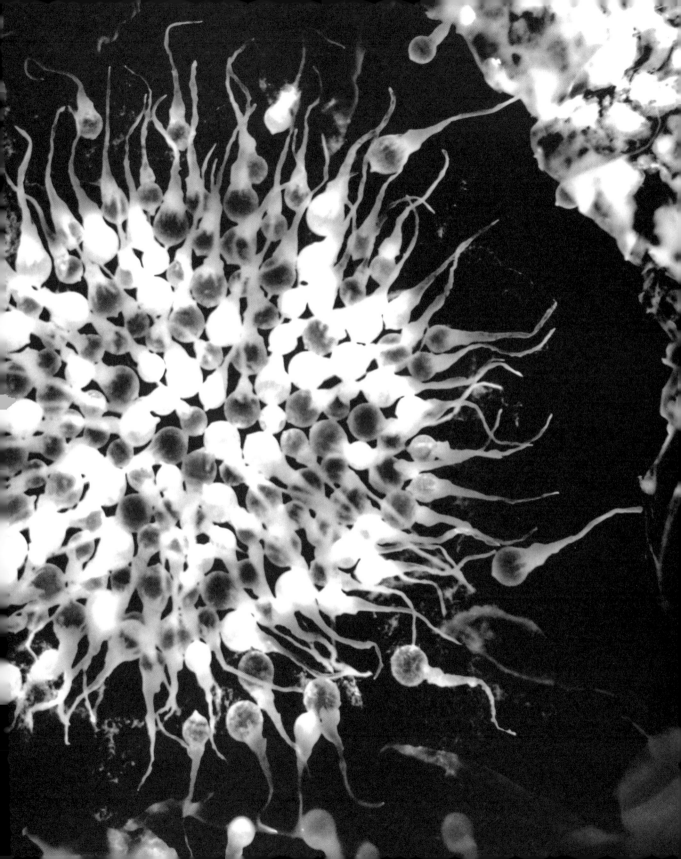

HOW LEIGH ANNE TINKERS
Searching for Shadows

Leigh Anne's shadow images definitely have to happen in the moment: "You can really only see the shadows while you're exposing them, and by then it's really too late to adjust any of the composition," she says. To make the most of the instant, she arms herself with a collection of shadow-rich materials and clever light sources that she uses to tease out her materials' light and dark sides.

TINY INSPIRATION: SPERM AND DEHYDRATED BLOOD CELLS. BIG INSPIRATION: NASA IMAGERY.

The spark for my photograms came from an early memory, when I was about three. We had a guest, and she was wearing these gorgeous sparkly rings, and when she put me to bed, she placed them on the night table under the lamp so I could watch them sparkle. And, well . . . I ate them. I remember having to go to the doctor and looking at the X-rays and thinking, 'Wow, what a place!' It looked lit from the inside—it looked beautiful.

Plastic is fabulous. I love these cheap plastic ornaments that you can take apart, and clear trash bags that you can stretch and tear and burn with a hot-glue gun. I would be lost without hot glue—a superfine thread of it will carry light, and when you really pile it on, you get internal shadows, places where it cooled on the inside before it cooled on the outside. And shellac is also the best material for controlling color. As it ages, it turns amber, so it increases the contrast between the shadows.

To develop prints, my husband and I cut huge PVC pipes in half to make troughs, and we've also built big plywood frames and draped them with plastic. For smaller prints, I use regular darkroom trays and roll and unroll the print through the chemistry to keep it moving over the paper's surface.

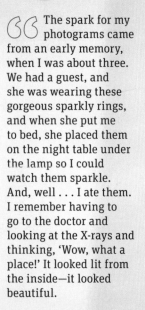

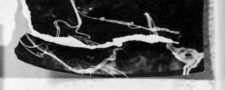

> 66 When a photogram doesn't work out, I tear up the images and arrange the pieces in a mosaic to try to figure out a study that will work. You have to be patient enough to pull it all apart and find what's compelling.

TINKERER DETAILS

Getting unstuck I'll do a shadow tour of the neighborhood and look for ones that I haven't noticed before.

Inspiration My collection of found X-rays. I'm interested in the beauty of an image that was made purely for information. I like how form and structure can have one meaning in science but a completely different one in art, and how those meanings intersect.

Favorite tool I've almost always got a pen light on me.

Next big thing I'm trying to talk about cosmology and planet formation, so I've started using fireworks to expose photographic paper. Because we all start with a big bang; almost everything comes into being with an explosion.

> 66 For me, it's about translating an object's translucency and opacity into how it's going to behave when light passes through it. I'll arrange all this stuff on photographic paper and turn on an overhead light source with very, very dim light so that I can get a longer exposure time. I'll go in with a pen light and see what kind of shadows I can get out of it. I also use electroluminescent wire and glow-in-the-dark clay. I'll try anything that emits light to expose the paper.

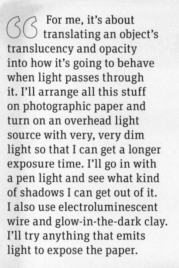

Expose Your Own Photograms

Photograms get their magic from photo-sensitive paper, which turns black when you expose it to light. But any objects placed on the paper block the brightness during the exposure, and their shadows live on as white areas on the page.

You can harness this old-school darkroom tactic to capture mysteriously beautiful images of your own—and all without the use of a camera.

SOURCING THE SUPPLIES You can find light-sensitive paper at any number of photo-supply sources. A flash is also a great tool to have on hand for exposing the paper, but in a pinch go with a bare lightbulb. And those without night-vision goggles might want to pick up a red lightbulb—it will cast enough glow in the darkness that you'll be able to see what you're doing without exposing the paper. You can buy a red lightbulb, or paint a regular one with nail polish.

SET UP YOUR STUDIO In a room that you can make completely dark, flick on your red light and set up your flash or bare-bulbed lamp 10 feet (3 m) away from your workstation. Experiment with positioning your photo paper—you can hang it on the wall and dangle your objects in front of it, or lay it down and place your shadow-makers on top.

. . . OR JUST USE THE SUN Cyanotype paper is like photo-sensitive paper, but it needs only the sun and water to create prints. To use it, find a sunny spot outside at a bright time of day. Lay out your paper on a flat area and arrange your chosen subjects on top. After two to five minutes, when the paper is pale blue, bring it inside and immerse it in water for about a minute. Lay it on a towel to dry and watch magic happen.

NOW, WHAT'S IT ALL ABOUT? The fun part is deciding which objects will star in your shadow art. Look around for anything that is translucent or has an interesting shape—from openwork fabrics and baskets to feathers, foliage, and figurines, you're probably surrounded by really neat photogram possibilities. Tinker with arranging the objects so that they'll create a compelling composition in shadow form, and then pop the flash or turn the lightbulb on and off for about two seconds. Immediately put your paper into its light-tight envelope to protect it from further exposure, and get it to a photo lab for processing.

DARKNESS AND LIGHT

When it comes to shadow play, Leigh Anne's in good company: A host of skilled tinkerers coax blackness and brightness out of quotidian objects.

JIM WEHTJE / JUGGLER WITH WAGON
This radiologist casts light on the surprising interiors of common objects, such as flowers, electronics, toys, seashells, and even roadkill.

ISAAC CORDAL / CEMENT BLEAK
Brussels-based artist Isaac Cordal models faces in the net of common kitchen sifters, then scouts for a good street lamp and wedges them in the sidewalk's cracks below. Shadows of the 3-D faces then emerge on the pavement.

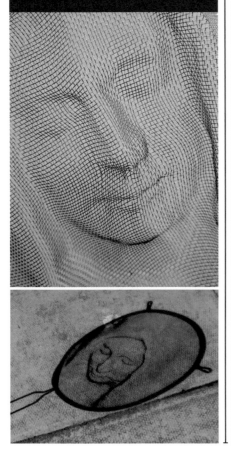

RASHAD ALAKBAROV / FLY TO BAKU
Azerbaijani artist Rashad Alakbarov suspends items from the ceiling and shines a light through them to project beautiful shadow paintings onto the wall. Here, he uses acrylic planes to create a colorful beachscape.

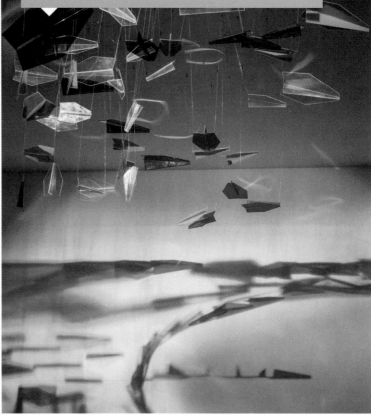

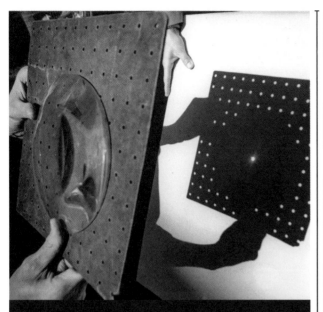

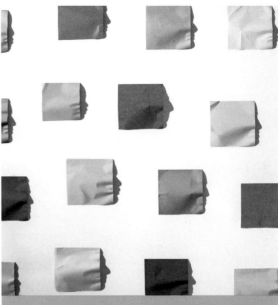

BOB MILLER / LIGHT WALK
A legendary exhibit developer at the Exploratorium, Bob Miller would hit the streets with a lens and a perforated sheet, investigating pinhole images of the sun created by light passing through the sheet's holes.

KUMI YAMASHITA / ORIGAMI
Japan-born artist Kumi Yamashita makes slight creases in origami paper, creating clever faces in profile when the sheets are lit with a single light. Each work is one part shadow, one part object casting the shadow.

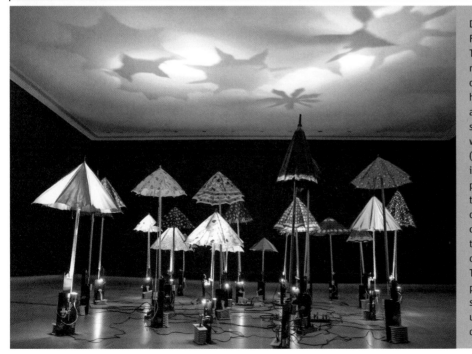

DIANE LANDRY / FLYING SCHOOL
This Canadian artist rigged 24 brightly colored umbrellas to halogen lamps, motors, and accordions that she built herself, then wired it all up to a MIDI (musical instrument digital interface) device. She runs preprogrammed sequences through a computer to control the accordions' contractions, which in turn trigger the opening and closing of the umbrellas. The installation makes a plaintive, eerie noise, and starburst shadows of the umbrellas open and close on the ceiling.

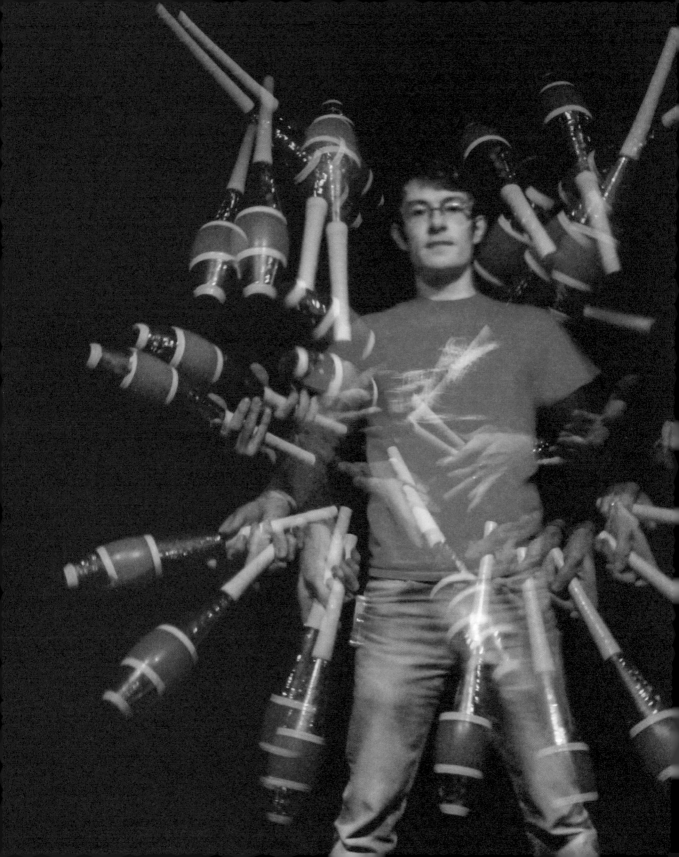

STROBOSCOPIC ADVENTURES

START WARMING UP. THIS IS ONE PHOTOBOOTH YOU WON'T WANT TO SIT STILL IN.

No, your eyes do not deceive you: The image you see to the left isn't broken—it isn't the result of faulty camera settings, or of sudden-onset vision impairment! Instead, it's a map of motion created by Nicole Catrett's stroboscope, a slotted, spinning disc that—when placed in front of a digital camera—captures moving subjects in a kaleidoscopic burst of action.

An exhibit developer at the Tinkering Studio, Nicole is known for her delightful, highly playful creations, and her stroboscope—positioned on the Exploratorium floor, where visitors routinely and gleefully experiment with its effects—is no exception. "I knew nothing about photography," Nicole happily says of the project's genesis. "But I had seen Doc Edgerton's beautiful strobe photographs, which he took to study movement patterns, and I wanted to play with that idea."

So Nicole started doing what Tinkering Studio developers do when they're intrigued by a new concept: She rigged up a prototype, futzed around to get it working just so, and then put it out for the world to enjoy. "Building the stroboscope was just the beginning. Being able to play with it, share it, and witness other people playing with it was what made the project so cool and open-ended and, well, kind of utterly magical."

HOW NICOLE TINKERS
Making New Ways to See

Nicole has made so many wonderful contraptions, it's hard to focus on just one. But a serious informality and a fascination with optics recur in her work. "I'm less interested in making the perfect image than in creating a new way to look at things," she says. "I really like making tools that people can play with!" And from the instant you set foot in front of the stroboscope and stomp on its start button, play is all you'll want to do.

WHIMSICAL INSPIRATIONS: LOOKING THROUGH MYLAR TUBES, WHICH REFLECT AND AMPLIFY COLOR WHEN LIT, AND FACES FOUND IN UNEXPECTED PLACES.

"I tried a few optics projects before I built the stroboscope. I saw a tilt/shift photograph and was just fascinated with it—I thought, 'How can that be?! I need to understand!' I wanted to make a tilt/shift telescope, so I experimented with lenses and rear projection to make the tilt-shift-o-scope, a camera obscura inside a wooden box. Users look through a hole and point the lens at a scene, and the image is projected onto a tilted piece of glass.

MORE OPTIC GIZMOS: MICROSCOPE GOGGLES AND STEREOSCOPIC LIGHTPAINTINGS

"I got really into Étienne-Jules Marey, this scientist who was obsessed with the way that animals move. In the 1800s, he took all these funny Victorian toys, like stereoscopic viewers and zoetropes, and used them for scientific research. He also played with stroboscopic photography, using an old-fashioned camera and a motorized spinning disc. I based my stroboscope on his idea, but luckily I was able to use a digital camera.

> The stroboscope never ceases to amaze me. We've tried photographing lots of stuff with it: a world champion yo-yoer and people doing cartwheels and throwing paper planes. I discovered that when you toss an object it moves in a pattern—a stick creates a beautiful, symmetrical path going up and coming down. You get these geometric drawings that I never would have known about!

EVEN NICOLE'S TOOLS ARE FUN: A BEDAZZLED MULTITOOL (FOR BETTER GRIP!) AND A GOLD-LEAFED HOT-GLUE GUN, JUST BECAUSE.

> My prototype used a paper disc, a toy motor, and a potentiometer that let me play with the disc's speed. I had to experiment to take a crisp image: getting the lighting right and taping out a space on the floor to mark where the camera was focused helped. Then there was figuring out how people could press the trigger while they were juggling in front of the camera—stepping on a switch on the floor works pretty well.

TINKERER DETAILS

First tinkering moment I remember making costumes when I was really little. We could come up with a ridiculous idea, but we had to make it happen. One year my sister was a mermaid and I was a lobster—she had me on a leash like a pet!

Tinkering strength Not being an expert. I think a lot of times expertise makes you stop seeing the possibilities—your ego gets in the way.

Advice to new tinkerers Just start! Don't let the fear of making something imperfect cripple you.

Inspiration Calder's *Circus*—he didn't take himself too seriously.

Favorite tools Pencil and paper. Doodles are a quick way to get out a rough idea.

Next big thing I'm making paper replicas of tools, like this sewing machine.

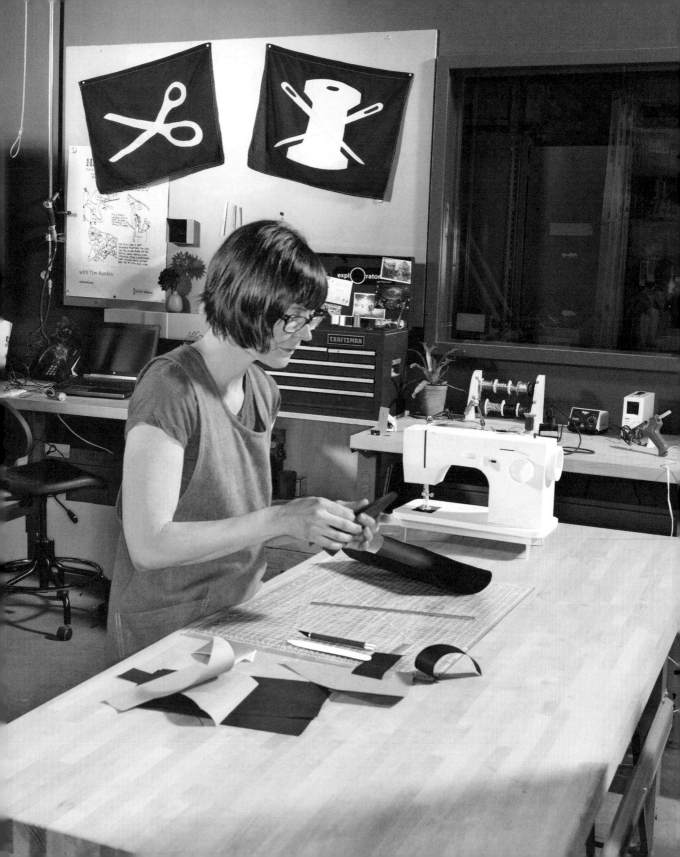

Set Up a Stroboscope

Nicole's stroboscope prototype was dead simple: A motor, a slotted paper disc, and a camera were all she needed to experiment with this fun and fascinating old-timey technology. You can build your own stroboscopic contraption with only a few more components—and then start making motion maps of whatever piques your curiosity.

BUILDING A FRAME Before you fiddle with any electronics or camera components, you need a basic mount for your stroboscope. Nicole screwed together a simple stand of 2x4s and plywood so that, when the slotted disc spins, it has enough clearance on the bottom to rotate freely. Other tools and parts you'll want to gather up front? Black cardstock, a cork, a large sewing needle, a craft knife, a hot-glue gun, a sheet of crafting foam, a 4.5-volt DC motor, a AA battery along with a battery holder, and alligator clips to connect everything. Oh, and don't forget a digital camera that can take long exposures, and a cardboard box big enough to cover the stroboscope and block light.

THE CRUCIAL SPINNING DISC The slot in this basic circle is what will give your images that cool kaleidoscope look, because the camera captures slices of the action through the slot as the disc rotates, creating a composite image. To make it, draw a circle with an 8½-inch (22-cm) diameter on black cardstock. Then grab your cork and trace it in the circle's center. Draw two parallel lines, ⅛ inch (3.2 mm) apart, from the center mark to the outer edge. Now make two perpendicular marks across the parallel lines, ½ inch (2.5 cm) from the outer edge and center, respectively. Use a craft knife to cut out the slits. Finally, cut out your disc.

START STROBOSCOPING Hang some black fabric as a backdrop, and set up clamp lights on either side. We like to set the camera's lens to the widest possible angle and the lowest possible aperture, its exposure to two seconds, and its focus to manual, but you can play around to get the effect you're after. When you're ready, hook up the battery to the motor with the unattached alligator-clip lead. Cover the entire apparatus with your cardboard box, then press the shutter button while you have a friend dance, twirl rope, fly paper planes, or juggle in front of the camera. Once your stroboscope is built, the tinkering options are endless.

ADD YOUR IMAGE MAKER Place your camera on the base behind the strobe disc. (We used Velcro to make the camera easy to position and keep still during all the action.) Glue the battery holder to the plywood base and connect it to the motor with alligator leads, leaving one unclipped. (You'll hook this one up when you're ready to shoot.) Use your craft knife to cut out the back side of your cardboard box (through which you'll access your camera) and make a hole in the box's opposite side that will give your camera a line of sight.

SETTING UP THE MOTOR Now it's time to connect your disc to the motor, which will make it spin. Start by cutting a 1/2-inch (2.5-cm) piece of cork and hot-gluing it into the disc's center. Use a sewing needle to pierce the center of the cork, then push the strobe disc and cork onto the motor shaft. You'll need to attach the motor to the base—here, we've clamped it in place with a broom-holder clip that we screwed into the wood. Wrap your motor with a piece of craft foam for a tighter fit.

MAKING MOTION PICTURES

Getting a great photograph of a subject in action has always been challenging. But for Nicole and these additional artists, that difficulty often leads to surprising and fascinating studies in motion—and some ingenious DIY image-making techniques.

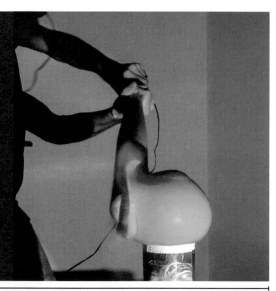

WALTER KITUNDU & LUIGI ANZIVINO / SMASH BAT
Tinkering Studio developers Walter and Luigi embedded a spring inside a baseball bat, then wired it up to a flash hacked from a disposable camera. When you hit an object, the flash goes off—capturing balloons, watermelons, and soda cans getting "smash-batted."

PETER HUDSON / CHARON
The Ferris wheel–size zoetropes that artist Peter Hudson and his crew build for Burning Man are really something to see—and make go. Twelve people tug on ropes to turn the wheel, propelling 20 skeletons in a stroboscopic dance.

MICHAEL BROWN / GHOST HORSE
In this homage to the grandfather of moving pictures, Eadweard Muybridge, LEDs illuminate mirror-backed cutouts of his iconic galloping horse, and the animation is reflected in a bell jar's frosted glass.

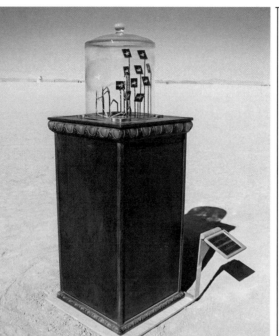

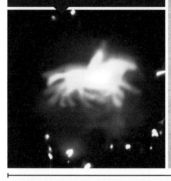

ANGEL O'LEARY / ROLODEX FLIPBOOK OF AN ADVENTURER'S ADVENTURE IN SPACE
Forget phone-number storage: Thumb through this wall-mounted Rolodex flipbook and watch as 250 drawings of a space explorer come to life.

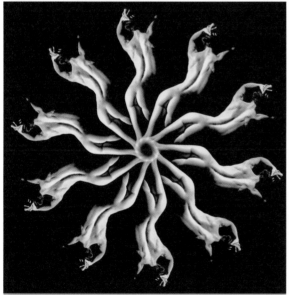

PJ REPTILEHOUSE / EPHEMERAL NUDES
To create these graphic, kaleidoscopic arrays of posed models, this Exploratorium tinkerer used stepper motors to build a camera rig that moves along two axes, and an Arduino microcontroller to synchronize the camera's motion with strobes during long exposures.

SHAWN LANI / STROBE FLOWER
In this interactive creation made by Exploratorium developer Shawn Lani, scraps of everyday plastic whirl around on a simple motor while an LED strobe hits them. Viewers are invited to participate with the exhibit, touching the plastic to change its configuration and behavior.

LUMINOUS
INSTALLATIONS

SPECTRAL HOOPS OF COLOR
STAR IN THIS DRAMATIC
STUDY OF LAND AND LIGHT.

Barry Underwood was ready to make a night of it. Armed with a film camera, glow sticks, and bits of rebar and wire, he hiked to Rodeo Beach, where California meets sea amid jagged rocks and the glimmer of passing ships. His idea? To embed illumination into the landscape, and to document the light show with a whopping six-hour exposure.

This wasn't Barry's first all-nighter in the wild. He's pitched camp in dozens of remote locations, creating ethereal, spell-binding images that transform the great outdoors into sites of curious luminescence. "The first thing you see is an object I put there," Barry says. "These little circles or dots or dashes of light. But I want people to start wondering why it's there in that particular landscape, and how it relates to the other lights and hues in the sky, water, and ground, too."

For all his interest in natural vistas, Barry got his start designing indoor spaces—notably, building sets and lighting theaters. And stagecraft persists in his current process: He tinkers with DIY lighting to set a scene, building rigs out of light sources that you're more likely to see at a club. Then there's the performative aspect of the event itself: "The photo is the end product," he says. "It's like a flash mob sets it up in the forest, and whoever happens to be there gets to see it."

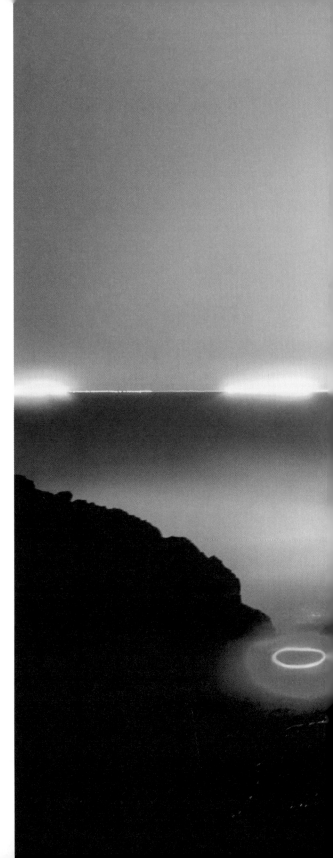

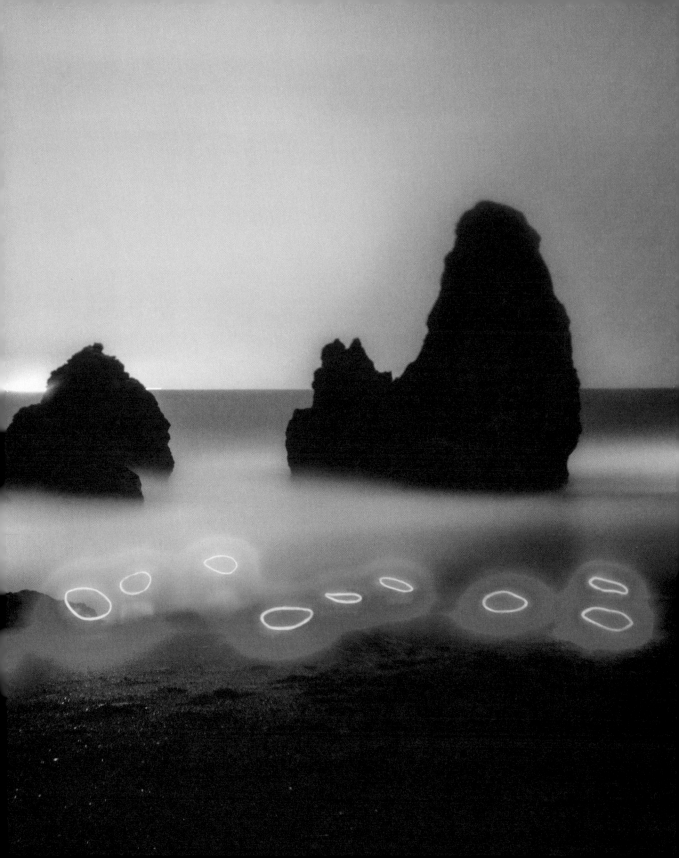

Setting a Stage in the Wild

Before showing up at sunset on the big night, Barry prepped his materials and did some test shots. "Trial and error is better *before* the actual application," he says. But like all tinkering adventures, there were frustrations: He hoped the tide would cover some of the lights, and that bigger ships would pass, providing more illumination. "You can only plan for so much," Barry acknowledges. In the end, you just sit back and enjoy the show.

BARRY USES HIS IPHONE TO TAKE TEST SHOTS, NAVIGATE THE WILDERNESS, AND KEEP HIMSELF ENTERTAINED.

" My photographs start out as drawings. Sketching is very meditative, and it lets me daydream or think through composition, logistics, and color choices. It's like coloring in a coloring book—I just make dark lines and fill in the grass, trees, sky, or water. I then transfer the drawing to acetate, which I'll put on top of the camera lens and use to compose in the landscape.

" When I was 10, my parents gave me a Polaroid Zip camera, and I'd set up my toys in the yard and photograph them. I'd put the camera low to the ground, which I still do, and my imagination would try to make the scene look real. These were my first sets, my first outdoor theaters. Spending so much time outside then has a lot to do with why I make art outdoors now.

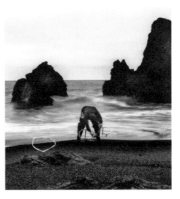

> Glow sticks and LEDs taped to 3-volt batteries are my primary light sources. I wrap them in freezer paper or put them in balloons, and by folding different widths of the paper or using various balloon sizes, I can control the glow, spreading and softening the light. The obstacle is that the glow sticks are brightest when you first crack them, so I often double them up to make them bright at the exposure's start. To keep the lights in place, I attach them to rebar with wire and pound it into the ground.

> Film allows me a larger latitude than digital cameras do. With digital cameras, whites get blown out, and they can't really handle all that darkness. And when you do a long exposure with a digital camera, there's a lot of noise, a lot of pixelation. I also like the way that film spreads and softens the light, and how it makes for much larger and cleaner prints. As for cameras, I prefer vintage Hasselblads for their square format. Something otherworldly happens with that camera, especially with an 80mm lens on it.

Kodak Professional

TINKERER DETAILS

First tinkering moment My mom told me that I took apart the washing machine at a pretty young age—just grabbed a wrench and started taking bolts off.

Getting unstuck When it doesn't work out, I'm bummed for an afternoon. But then I just go back out and do it again. You're going to fail, and you're going to understand it more deeply because you worked through that problem.

"Real" job I teach photography, and the students have a currency that they don't know about—there's nothing more fresh than hearing their unfamiliar take.

Inspiration Land artists from the '70s, like Richard Long and Robert Smithson.

Tinkering strengths I work like a machine, but I also try to stay childlike in my approach. Sketching my designs helps keep the process imaginative.

LED LOVE

In the works of these light enthusiasts, the little LED gets big play—from not-so-basic lightpainting to mind-blowing computerized projections and way-cool persistence-of-vision displays.

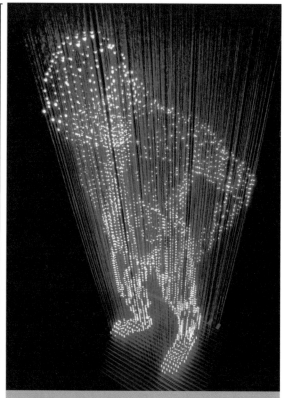

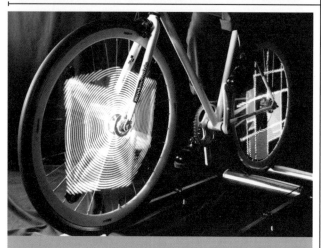

MONKEYLECTRIC / MONKEY LIGHT PRO
These waterproof, motion-activated bike-light kits allow you to display animations on your wheels as you whiz through the streets. Riding safe never looked so rad.

MAKOTO TOJIKI / THE MAN WITH NO SHADOW
This Japanese artist suspended hundreds of tiny LEDs on strings in three-dimensional patterns that, when lit, resemble life-size human and animal forms.

LEO VILLAREAL / THE BAY LIGHTS
Catch a glimpse of San Francisco's glittering Bay Bridge, and you'll notice a little something extra in its sparkle. That's the coding chops of Leo Villareal, who makes 25,000 LEDs flicker in a never-repeating pattern inspired by the environment.

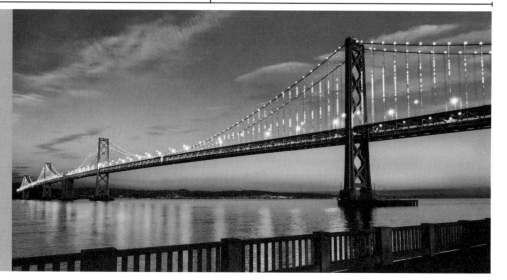

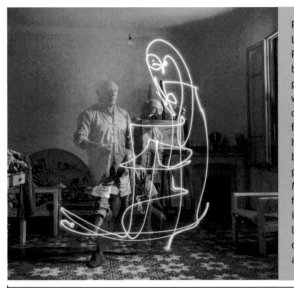

PABLO PICASSO / LIGHT DRAWINGS

Picasso may be best known for painting portraits with both eyes on one side of a face. But when he was visited by *LIFE* magazine photographer Gjon Mili in 1949, he famously traded in his brush for a light and "drew" centaurs, bulls, and his own name.

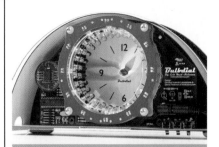

EVIL MAD SCIENTIST LABORATORIES / BULBDIAL CLOCK

With this clock, the sundial gets an upgrade: Three rings of RGB LEDs turn, shining onto a central rod and casting colored shadows that act as hour, minute, and second hands.

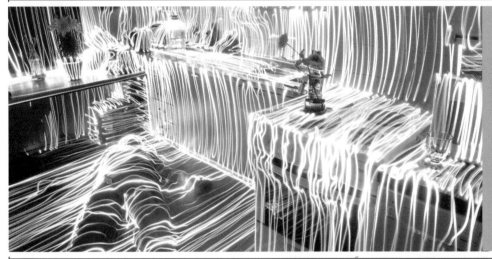

JANNE PARVIAINEN / DAYS OF OUR LIVES

Finnish artist Janne Parviainen scribbles over surfaces with a flashlight, tracing the contours of everyday settings— and often those of a slightly eerie collapsed human body, which he includes in the scene for a hint of narrative intrigue.

IBR ALGORITHM GROUP / ROOMBA ART

Seven automated dust-busting 'bots were each loaded with a colored LED and sent off on a collision course— with fantastically colorful, brilliantly chaotic results.

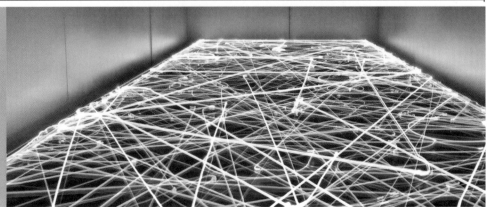

Paint with Light

Lightpainting is one of our favorite activities at the Tinkering Studio—and you just need a light source, a dark place to hang out, and a digital camera capable of making long-exposure images to try it for yourself. Sure, your sketches will disappear as you doodle them in thin air, but your camera will capture the light and make those split-second explorations last.

GATHER LIGHT SOURCES This project is all about experimentation. You'll want to have several light sources on hand so that you can play with different effects. Grab flashlights of several sizes and hues, colorful LEDs, toys with moving lights, cell phones, and electroluminescent wire. If you're outside in an open space, consider things that burn brightly like sparklers and flares (just be careful with them).

MANIPULATE YOUR MEDIUM To alter the color or effect of a light source, tape translucent materials like wax paper or colorful gel sheets (available at photo-supply sources) over the light.

THINK BIGGER Variations are endless, so keep discovering ways to make your lightpaintings unique. You can do graffiti-style sketches, trace objects, or add to items that are already in the frame—say, for instance, "drawing" wings onto a friend's shoulders. Or make it a group outing by enlisting lots of people to help create shapes or patterns that you wouldn't be able to make with just one set of hands.

GET PAINTING Place your camera on a tripod to hold it steady, and set its long exposure setting—labeled "shutter priority" or "bulb" on your camera's controls. An exposure of anywhere from a few seconds to more than 10 seconds can work. It's best if you start your lightpainting explorations with your on-camera flash turned off, as it will keep your scene dark enough that the light doodle appears vibrantly. (Later, if you have an advanced camera, try setting its flash to pop briefly during a long exposure, which will illuminate the entire scene while keeping your drawing bright. You can also quickly turn on a clamp light for the same effect.) Now get in front of the camera with your light sources in hand, and have a friend turn off the lights and trip the camera's shutter. Try turning in circles, waving your arms, or drawing a picture with the light. Check out the images and refine your motions in your next go to get your desired results.

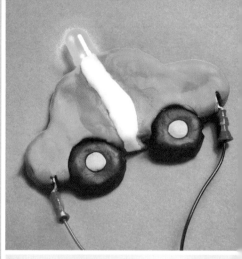
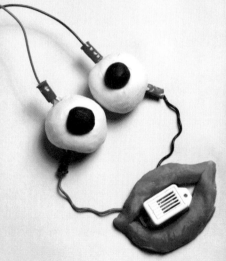
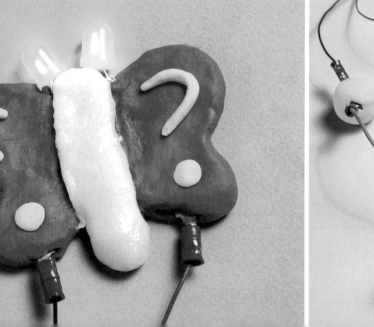
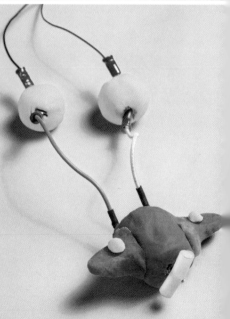

SQUISHY CIRCUITS

EVERYBODY'S FAVORITE SCULPTING SUPPLY CAN LIGHT UP, MAKE SOUNDS, AND SPIN. RAINY DAYS JUST GOT A WHOLE LOT COOLER.

AnnMarie Thomas was on the hunt. An educator and an engineer, she and her colleagues at the University of St. Thomas had long been keen to find a simple, cheap, and fun way to teach kids basic electronics without breaking out breadboard or a soldering iron, which—as AnnMarie knew from personal experience with her own children—tends to frustrate young users. "I'd been talking to faculty members," AnnMarie says. "And we all kept saying, 'Wouldn't it be cool if we could sculpt circuits out of conductive clay?'"

Enter playdough, and lots of it. Turns out the brightly colored, endlessly malleable stuff that's been a craft-table staple for generations is high in saline. (Hence that forbidden salty flavor that you may remember tasting as a kid.) This saltiness makes it conductive, so you can use it to sculpt more than bugs and towers and dinosaurs—you can use it to build bugs and towers and dinosaurs that are real working circuits.

High-school physics teachers had long been using playdough to demonstrate conductivity, and Mitchel Resnick had developed the PicoCricket, an electronic kit for kids that also makes use of the squishy stuff. So AnnMarie's team, made up of Samuel Johnson and Matthew Schmidtbauer, set out to take it further and standardize recipes for both conductive and insulating doughs, and to offer ideas for making sculptures with LEDs, microcontrollers, DC motors, and buzzers. The results revolutionized kindergarten forever and created a robust community of budding circuitry artists around the world.

Messy and seriously informal, squishy circuits use a familiar material in a wildly unfamiliar way—and make us question our ideas about circuits and who builds them. "We don't usually think of our kitchens as electrical engineering labs, or of little kids as circuit designers," AnnMarie says. "But maybe we should."

HOW ANNMARIE TINKERS
Cooking Up the Good Stuff

It took loads of tinkering for AnnMarie and her team to come up with recipes that were just right for squishy circuits. Once they had the mix down, though, the online community took the basic techniques and made them their own, much to the delight of the original cooks.

All of the playdough that we cooked for the first two years was made on a hot plate in my lab at the university. We said, 'Let's just make a bunch of batches and see which works best.' Obviously, we wanted to make the conductive dough as salty as possible, so Samuel experimented like crazy, seeing how salty it could be before it started to crystallize. We thought it would be so much cooler if we could build complicated circuits, so we needed to figure out how to make a nonconductive dough as well. We discovered that if you use deionized water and sugar instead of salt in your mix, you get an insulating version that's thousands of times more resistant than the conductive stuff.

To test the playdough's conductivity and resistance, our team member Matthew tried sticking a multimeter's prongs into batches of both conductive and insulating dough. But he found that playdough has chemical properties that make the reading unreliable. So he hit upon a method whereby we put a dough sample into a PVC tube and inserted four copper wire electrodes into it. Then we ran electricity through two electrodes, simultaneously measuring the current through those electrodes and the voltage over the other two. Taking the measurements independently allowed us to calculate the dough's resistance.

> I do most of my tinkering with a four-year-old next to me. There are fewer mistakes in the eyes of a child than there are in the eyes of an adult. One project I really enjoyed with her was the Nerdy Derby at NYU's Interactive Telecommunications Program—which was like a pinewood derby but with fewer rules. We've also enjoyed making conductive paintings and visual journals together.

ANNMARIE'S FAVORITE THING ABOUT SQUISHY CIRCUITS: YOU REALLY CAN'T MESS UP. IF IT DOESN'T WORK OUT THE FIRST TIME, JUST SQUISH IT UP AND START OVER.

> We started with simple circuits—just two lumps of dough with a light on top of them. But once we posted online tutorials and did a TED Talk, we started hearing how students around the world were using it. A preschool wanted to teach that some things conduct electricity and some don't, so they dyed the conductive dough green and the insulating dough red. A math teacher accidentally placed a motor so it was off balance and wasn't drawing steady current. As the motor spun, the lights in the playdough flickered. That's part of the fun—you create something, stick it out in the world, and see what comes back.

TINKERER DETAILS

Where tinkering happens On a big, old kitchen table in our unfinished basement. It's perfect for making a mess.

First tinkering moment I was definitely the kid who tried to build her own dollhouse. For a while I was banned from the hot-glue gun.

Advice to new tinkerers Look at it as a chance to play, and accept that not everything goes exactly the way you want it to at first.

Tinkering strength I'm not a very skilled tinkerer in any particular area, but I'm pretty fearless about dabbling in all of them—like the pop-up books I've recently been making with my daughter.

HOW YOU CAN TINKER
Sculpt Your Own Circuits

We like squishy circuits because they're a perfect mix of tech and art. Plus, the accessible materials you use to craft them are delightfully tactile and creativity-inducing. Just whip up two types of moldable dough in your kitchen and start making magic. Battery packs, LEDs, buzzers, motors, and more will come into play later, depending on what you build.

START WITH CONDUCTIVE DOUGH
Mix 1 cup (240 mL) water, 1 cup (120 g) flour, ¼ cup (75 g) salt, 3 tablespoons cream of tartar, 1 tablespoon vegetable oil, and some drops of food coloring in a pot over medium heat. Stir continuously as the mixture boils and thickens, and keep on stirring until it forms a ball in the pot's center. Let it cool slightly and knead it on a floured surface until it's nice and smooth. Store it in an airtight container; it will stay malleable for weeks.

NOW FOR THE INSULATING DOUGH
To make complicated circuits, you need a nonconductive dough, too. Mix 1 cup (120 g) flour, ½ cup (100 g) sugar, and 3 tablespoons vegetable oil in a bowl. Then incorporate up to ½ cup (120 mL) distilled water in tiny increments (about 1 tablespoon at a time) until the dough forms a cohesive lump. Knead in a little more flour until it's easy to mold with your hands. You can store this dough just like its conductive doppelganger.

MOVE ON TO COMPLEX BUILDS Now that you've got a simple LED under your belt, try replacing it with a DC motor or buzzer—just remember, you may need to use more powerful batteries to put some components into action. You can also play with parallel circuits, in which electricity is allowed to flow through multiple components independently of one another (like the dark green circuit below). Or experiment with series circuits, in which components are linked together across sections of resistant dough and rely on each other to transmit current from one to the next (like the orange circuit). Regardless of which circuits you build, let the creative medium of playdough inspire you to craft ones that are both functional and expressive.

PUT YOUR DOUGHS TO USE Grab two lumps of conductive dough, and poke one leg of each LED into each one. Take the two leads of a battery pack and stick the positive one into the lump with the LED's positive leg, and the negative one into the lump with the LED's negative leg. See the light go on? Bingo—that's your first squishy circuit. You always need a gap between your negative and positive dough lumps, so next try placing some insulating dough between them to divert electricity from the battery pack into your LED. This allows for more solid construction without any shorts.

SURPRISING CIRCUITS

AnnMarie's playdough projects illustrate a very good point: Circuits don't have to be made of green plastic—they can be crafted of many different materials. Here are additional clever circuits, along with some pleasingly geeky nonfunctioning pieces that teach beginners the basics or express an artistic idea.

EVIL MAD SCIENTIST LABORATORIES / CIRCUITRY SNACKS
The folks at Evil Mad Scientist Laboratories have devised a fun and delicious way to learn the vocabulary of circuits. For each component type, there's a foodstuff: graham crackers for breadboard, licorice for wire, gumdrops for LEDs, chocolate bars for integrated circuits, Life Savers for resistors, and more.

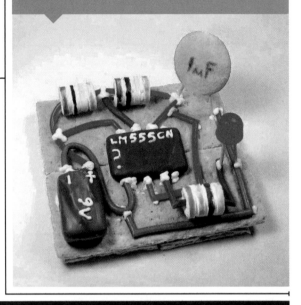

LEONARDO ULIAN / TECHNOLOGICAL MANDALAS
Inspired by electronics' hidden beauty and mandalas' spirituality, Italian-born artist Leonardo Ulian soldered together patterns of resistors, capacitors, and microchips.

BARE CONDUCTIVE / ELECTRIC PAINT

Forget printing circuits—the pens and paints developed by London-based company Bare Conductive allow you to draw repairs onto existing circuits or doodle your own working ones on pretty much any material—though the tattoo art shown here is conceptual only and not intended as a suggested use!

AYAH BDEIR / LITTLEBITS

Move over, LEGOs: littleBits are the next wave of interlocking building blocks, only these boast a whole host of electronic possibilities. Each 'Bit is outfitted with a function (such as lights, sensors, or motors) and a magnet so that you can connect them without soldering or wires.

NATHAN PRYOR / PUMPKTRIS

Lovers of Tetris and Halloween, rejoice: The two have been merged into one playable pumpkin. That's right, Pumpktris is a fully functioning game—even the stem gets used as a joystick—and includes an LED matrix that Nathan Pryor built and programmed himself.

RICHARD WOOL / CHICKEN ELECTRONICS

Some circuitry innovators are working to improve the environment. Richard Wool collaborated with Tyson Foods to recycle the poultry industry's feather waste into circuit boards. The result is a lightweight yet strong natural replacement for wasteful plastic.

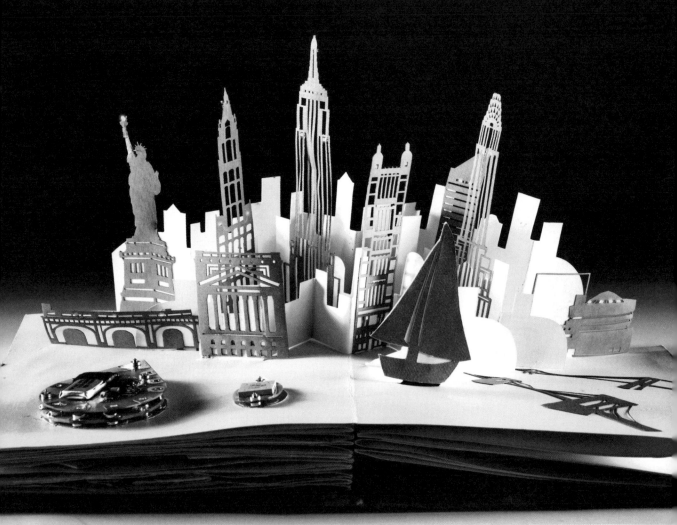

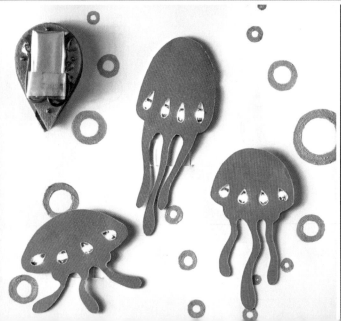

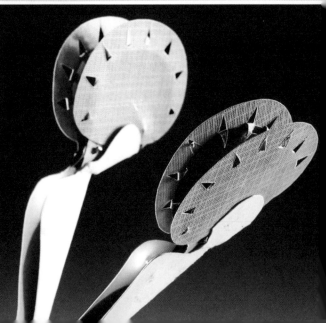

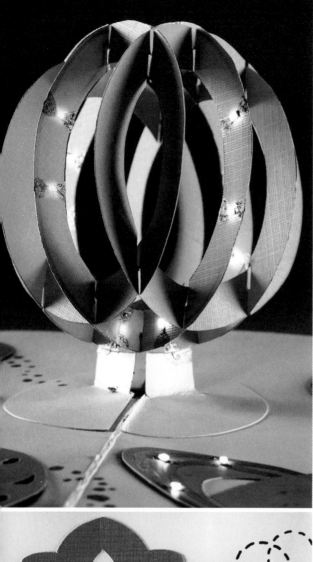

ELECTRONIC POPABLES

THIS NEW PAPERCRAFT GETS TRICKED OUT WITH SOUND, LEDS, AND TOUCH SENSITIVITY.

Pop-up books have always been magical—pull a tab, lift a lever, spin a disc, and you make a story leap up from the page. But in *Electronic Popables,* Jie Qi takes their whimsy to the next level, embedding electronics that make the pages do more than just pop: They light up, play music, twinkle in a mesmerizing pattern, rhythmically pulse, and subtly move in response to the heat of your touch. It's double the magic—and double the ingenuity.

"With mechanical systems, you can see how one thing leads to another," Jie says of her traditional paper-engineering predecessors. "Pull this lever, and its other end goes up. But adding circuits provides more surprise because electricity is silent, instantaneous, and even wireless. And with programming, you can incorporate intelligence and automation, which open up a new world."

Jie has always liked working with paper. And after a bout as a premed major, she decided to put her science chops to artistic use: "Medicine is creative in a problem-solving sense, but in personal expression, not so much. You want that out of the operating room!" So Jie joined MIT's Media Lab and got back to crafting. Turns out that with cheap conductive materials, Arduinos, and a sense of electronics' expressive capabilities, paper may just get an unexpected reboot.

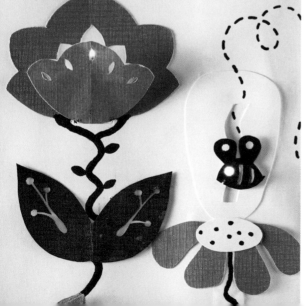

HOW JIE TINKERS
Making Paper Pop

Jie's *Electronic Popables* project does the unexpected: It transforms hardcore electronics into a storytelling medium. "I started thinking, 'How can we think about circuits as not just an engineering tool but also a craft supply?'" Jie says. The answer was to find friendly materials that are fun to use—and to make art that's equally fun to interact with.

EARLIER EXPLORATIONS: JIE BUILT PAPER FLOWERS THAT LIT UP AND BLOOMED.

When I was little, my mom brought home an origami dog. I was really intrigued, so she got me an origami book, and I looked at the diagrams. They helped me learn the physical properties of paper and fall in love with the infinite possibilities of a material that's so simple—and plentiful and cheap!

I make some circuits out of conductive paint and fabric, but I most often use copper tape from The Home Depot that's used to keep away snails. Because it's copper tape instead of wire, you can choose a place and stick it down in a line, and if it doesn't work, you can pull it up to redo it. It's like playing connect the dots, but your lines conduct electricity and the electronics glow and move when you connect them with the lines. For me, the point isn't just that I can make an LED turn on, but that the LED can help tell a story. For instance, I made a circuit to represent a neuron, and when you blow on a tiny microphone, the lights come on and 'blow your mind.'

THE PROGRAMMING BEHIND JIE'S ELECTRONIC BOOK? ARDUINOS DEVELOPED FOR PAPER BY LEAH BUECHLEY AND TUNG SHEN CHEW.

> Each page of the book shows a different circuit element. The jellyfish page uses a DIY potentiometer made of pencil graphite, so when you move the dial, the fish float and dim. The Venus flytrap page was most challenging—when you stick your finger in a leaf, it closes around your finger. So it needed muscle wire for moving the leaves, which requires high power. Then it needed a sensor to detect light touches. And all of this had to fit on a thin pop-up stem and leaf. Then there was the code. To me that was the hardest—I was learning to program, and I had to make my sensor read capacitance.

> At first I assumed that a mechanical switch would be easy to translate into an electrical one. I started by looking at the buttons and slide switches all around us and replicating those real-world examples with paper. Then I had an epiphany: When building paper switches, there's nothing keeping you from making the switch completely different—you can make it look any way you want. So I sketched some flower designs and figured out how to turn the leaves and stem into switches, then used those drawings to make the book's first page. When the book was done, I bound it so I could access its electronics from the back to fix bugs.

TINKERER DETAILS

Favorite tool I got my first X-ACTO knife in sixth grade, and I still have it. It lets me create 3-D structures with the freedom and fluidity of drawing with a pencil. But I have to be careful—since it's metal, it sometimes shorts my circuits!

Tinkering strength I'm happiest when I can go on and on uninterrupted and tweak something until I love it, focusing long enough for an idea to appear and then grow into a full-fledged thing.

Advice to new tinkerers It helps to draw or build a working model to make the idea real. Also, don't be afraid of breaking things, which is especially important when learning electronics. It also helps to find a friend to get excited with you!

Inspiration I'm interested in embedding electronics into traditional crafts, like these origami cranes that flap their wings when you squeeze their tails.

HOW YOU CAN TINKER
Play with Paper Circuits

Borrow a page from Jie's book and experiment with your own paper circuits—you can get started with the friendly light-up greeting cards you see right here. We like these cards because they allow you to express your ideas through construction, and because they demystify electronics so that everyone can play. The truly hard part is deciding who'll be the lucky recipient.

COLLECT COMPONENTS Before you build, gather a few electronic components: a coin-cell battery, copper tape (available in the gardening section at home-supply stores), and surface-mount LEDs, which you can find online. Then scour your house for small binder clips, clear tape, cardstock in a color you like, scissors or a craft knife, and tweezers. (Surface-mount LEDs are teeny-tiny, so handle them with tweezers and secure them with tape.)

POWERING UP Start by folding your paper to create a basic greeting-card shape. Then make a place for your coin-cell battery by creasing a dog-ear fold at the bottom right-hand corner of the page. Before you come up with a design, bear in mind that it should be arranged in a loop, so that electricity can flow from the battery to the LED and back to the battery again. It should also include two lines of copper tape: one that touches the LED's negative leg and one that touches the LED's positive leg. These lines of tape extend toward the dog-eared corner, with one crossing the fold. That way, when you place the battery in the corner and fold it up, the battery will press against both copper strips and complete your circuit. A binder clip will help hold the battery in place!

MAKE IT EVEN BRIGHTER Putting together a card with multiple LEDs isn't much more complicated—just position all your lights so that their positive legs are on the same strip of that awesome copper tape, and their negative legs are on another. Bear in mind that LEDs get dimmer the more you add, as they use the same power supply.

SEE IT IN LIGHTS Now that you understand how to power your circuit, design a card with its own special light-up action—maybe it's a yellow-eyed hoot owl, or candles on a birthday cake. . . . It's up to you! Sketch on the front of your card, then open it up and tape an LED on the inside where you want it to shine through the paper. Now for the crucial bit: On the inside of the card, lay down a copper-tape track on both sides of the LED so that the LED bridges a gap between the two tracks, and run the copper tape all the way to the dog-eared corner. For any places where copper tape needs to turn at an angle, fold the ends diagonally into corners and secure them with clear tape on the paper. Slide the battery into position so that, when the corner is folded up, the battery's positive side will press against the copper tape that touches the LED's positive leg and its negative side will press against the copper tape that touches the LED's negative leg.

PAPER POSSIBILITIES

Origami may be an ancient craft, but today's paper artists use cutting-edge methods to explore biology, architecture, mapping, and, of course, whimsy.

MATTHEW SHLIAN & MICHAEL CINA / ALEATORIC SERIES
Matthew Shlian uses paper to explore cellular development, collaborating with scientists to mimic organic functions. Here, he's teamed up with graphic artist Michael Cina to combine their two mediums: tessellated paper-craft and painterly abstraction.

AKIRA YOSHIZAWA / PAPER PEACOCK
The grandfather of modern-day origami, Japanese master Akira Yoshizawa pioneered the technique of "wet folding": slightly dampening the paper before creasing it for a realistic, sculpted effect.

SU BLACKWELL / SNOW WHITE IN THE WOODS
British book artist Su Blackwell has a background in textiles, and her detailed, handmade papercraft evidences a familiarity with stitching and embroidery. To make her pieces, she reads the selected book once or twice, then begins to carve elements from its pages and add three-dimensional details, like the trees, houses, and Snow White figure here. She often creates natural settings or reenvisions scenes from children's stories.

DAVID CANAVESE / MILLENNIUM FALCON
Believe it or not, this ½-inch- (1.25-cm-) long replica of the fabled *Star Wars* ship is made entirely of folded and cut paper. David's other sci-fi replicas include TARDIS from *Doctor Who* and *Stars Wars'* Rebel blockade runner and the *Imperial*-class Star Destroyer.

LISA NILSSON / TISSUE SERIES
Renaissance nuns first started quilling, the practice of rolling paper strips and arranging them into a design. Lisa Nilsson injects science into the tradition with her anatomical cross-sections of veins, muscles, nerves, bones, and organs.

KAREN O'LEARY / MODERN MAPS
An architect working in North Carolina, Karen O'Leary creates maps of major cities, trimming away land and leaving a web-like network of streets and rivers—all without the use of a lasercutter. Her work inverts our notions of positive and negative space, making familiar places seem new.

WONDROUS WEARABLES

SCI-FI FILMS HAVE ALWAYS PREDICTED THAT SOMEDAY WE'D WEAR ILLUMINATED CLOTHES. BUT WHO DREAMED THEY'D LOOK SO LOVELY?

When you think of electronic wearables, sleek and futuristic feats of textile engineering likely spring to mind—garments that light up with bold, blinding lights or magically move on their own. Garments that sense temperature changes or create sounds, and that are often made of synthetic fabrics and sewn-in battery packs, motors, and even an accelerometer or two. These costume-like pieces are flashy and smart but lack the comfort and familiarity of, say, your favorite sweater.

That may be why Grace Kim's illuminated handmade creations feel so special and surprising. Elegant, subtle, and made of oh-so-touchable natural fibers, Grace's wearables combine hard-won electronics ingenuity with old-school crafting techniques and inspiration. Case in point: Her *Sessile Handbag*—a pale, felted tote bedecked with barnacle-like circles of gathered muslin (called yo-yos by generations of crafters). LEDs are nestled inside these barnacles and sewn with conductive thread to a LilyPad Arduino, a textile-specific microprocessor coded to make the LEDs twinkle in a random, organic pattern.

It took Grace a while to hit upon a crafty approach. At NYU's Interactive Telecommunications Program, she grew frustrated with designing pieces that were bogged down with wires and heavy components. "I marched into my advisor's office and blurted, 'I don't like technology!'" Grace says. "The thing I cared about most was aesthetics. I wanted the electronics to help the aesthetics instead of taking them over."

From there, Grace got inspired by Scandinavian patterns from the '60s and turned to knitting, felting, and embroidery as more fashion-friendly tactics. "The more traditional crafts you know, the more tools you have at your disposal when you're trying to make something new," she says. Because even the future could stand a good lesson from the past.

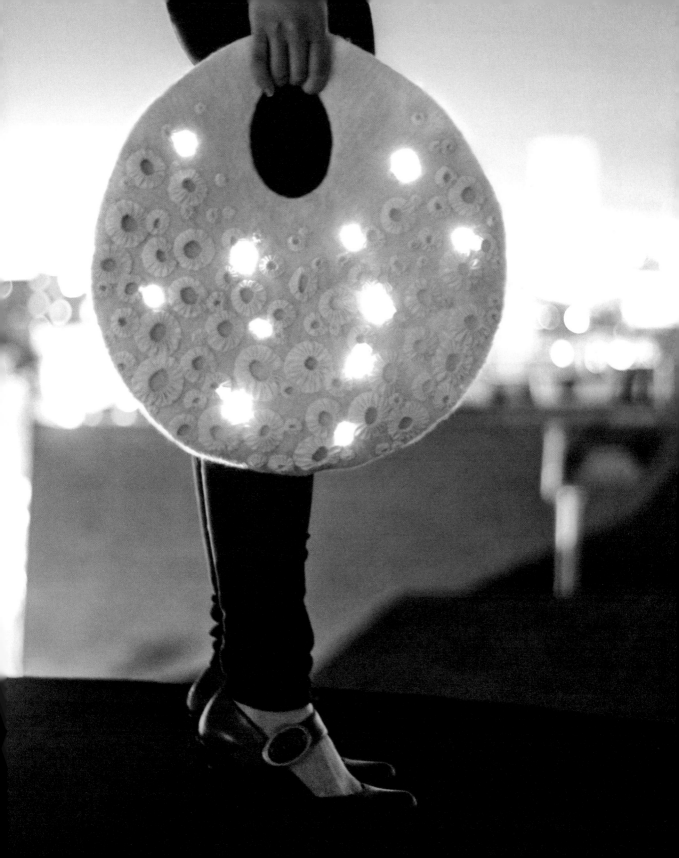

HOW GRACE TINKERS
Crafting with Lights

To create her wondrous handbag, Grace holed up in her apartment and tirelessly knitted, felted, and prototyped her way to an eye-pleasing accessory. But as with so many other tinkerers before her, the story really starts in her childhood, when she learned the value of dogged determination and basic crafting know-how.

THE STITCHES OF
CREATIVE EMBROIDERY
Jacqueline Enthoven / Reinhold

When I was eight, I decided to make a doll, but I didn't really know how to sew. For the head, I cut two fabric circles, did a running stitch around them, and started stuffing it with Kleenex. I thought my mom was going to be mad that I was wasting tissues, but instead she drew a figure on newspaper and had me cut it out of fabric. Then she made me sew it the *right* way, so I had to learn a backstitch. She even taught me how to do the hair, which was really cool. Then I started sewing all these *Anne of Green Gables* clothes for the doll, and that was superfun.

Before I made the *Sessile Handbag,* I first tried knitting a capelet that lights up, as I wanted to make something that was small enough to be intricate without needing a ton of power. I was really attached to using a coin-cell battery, as I didn't want a bunch of hardware sticking out, so I could light only two LEDs at once. At first I tried putting LEDs in floral embroidery patterns, but it seemed cheesy—I wanted the LEDs to look natural and subtle, like a bead catching the light. Then I found a pattern in a Scandinavian book, *The Stitches of Creative Embroidery,* and it reminded me of wood grain. It had these circular elements with two lines passing by them, and I immediately thought of power and ground. So I wondered if it could represent the flow of electricity.

When I started making the bag, I needed something to protect the LEDs. I'd been sewing yo-yo quilts, and I decided to try housing LEDs in the yo-yos and scattering them all over the bag. When I put the LED inside the first one and it started fading, it dawned on me that it looked like a lifeform breathing inside a barnacle. But I liked that, when the bag was turned off, the LEDs were concealed—it made it clean and minimalist.

GRACE'S GO-TO TOOLS: MAUCH CHUNKY YARN, KNITTING NEEDLES, AND LOTS OF CONDUCTIVE THREAD TO MAKE THE MAGIC HAPPEN.

TINKERER DETAILS

First tinkering moment I wanted to sew a tote bag when I was a kid, and my mom grabbed a paper bag, turned it inside out, and said, "See where the glue lines are?" She taught me to figure it out myself, rather than buying a pattern.

"Real" job Interaction designer. I make wireframes and system diagrams.

Getting unstuck Honestly, I freak out a little! But I've done this enough that I recognize the stages, so I can realize that I'm just at a certain point and it may suck for a while. And when you solve it, you feel really happy—it's empowering.

The bag looks neat now, but making it was chaos—fabric was all over the floor, I was covered in pieces of thread, and I kept stepping on needles. And the bag looked completely insane. I had alligator clips attached to each LED and I was trying to hook them all up to a LilyPad in the center, then flipping it over to see if it worked. Some of the conductive threads had to cross each other on their way to the LilyPad, so I put a few on one layer of felt and some on the layer underneath so they wouldn't touch and short out. For the fade, I assigned each of the LilyPad's digital pins a light level using the values of a sine wave from the Arduino community. The order in which the LEDs fade in and out is determined by the Fibonacci sequence, giving it a natural look.

HOW YOU CAN TINKER
Fashion Soft Circuits

Grace's soft circuits are beautiful and inspiring, and we like how she combines old, tried-and-true crafting skills with new technologies. You can tinker with these techniques to create items that you would want to wear out and about— and these simple light-up pieces are a good place to start!

FIRST THINGS FIRST To make the crafts you see here, you'll need to source conductive thread and conductive fabric (the kind used here is called zelt), both of which are available online. (It's pricey, but if you buy both copper and silver fabric, it'll be easy to keep track of what's power and ground.) Other electronics to scope out include LEDs, coin-cell batteries, and battery holders. You'll also need felt (cut into pieces large enough to fit around your wrist with a little overlap, and extra for decoration), needles, pliers, and magnetic snap closures.

A BEGINNER'S BRACELET Cut two narrow strips of conductive fabric that, when put end to end, will run the length of your felt, with an LED-size gap between them. Sew the pieces to the felt with conductive thread. Use pliers to twist the legs of an LED into little eyehooks, and place it between the conductive-fabric strips. To stitch the light to the conductive fabric, repeatedly pull the conductive thread through the LED's eyehooks, down through the silver fabric, and then up again until it's secure. Sew the battery holder to the conductive fabric with its positive end oriented toward the LED's positive leg, and attach snap closures to both ends of the fabric strip. Now for the fun: What felt scraps can you sew around your LED to make it special? To light it up, slide a battery into the holder and snap it around your wrist.

. . . OR SAMPLE A SAMPLER Another of Grace's crafts is a classic embroidery sampler—only this one lights up! To make your own, sew two strips of conductive fabric down either side of a piece of felt, then use conductive thread to practice your favorite stitches. Leave a place for a battery pack, LEDs, and other components in every row, lining them up so that the positive legs are on one side of the sampler and the negative ones are on its opposite side.

TRY A BRIGHTER BRACELET OPTION What's better than a bracelet with one LED? One with two, obviously! Tinker with your materials to see what designs you can light up, experimenting with more complicated soft circuits that feature different types of conductive fabric (silver for negative, copper for positive); smaller LEDs that draw less current; and multiple layers of felt with the electronics sandwiched between them. Just remember that your LEDs' positive and negative legs must be connected to the positive and negative terminals of your battery pack, respectively. Also, your snap closures must be in contact with the conductive fabric in order to be functioning parts of the circuit and light up when you clip the bracelet on.

HI-TECH STYLE

Technology is all about trends, and it's merging with another realm ruled by fad: fashion. These days, designers and geeks are teaming up to make apparel that's nothing short of wearable wizardry.

HANNAH PERNER-WILSON / TEXTILE SWITCHES
Hannah's sensor switches have ushered in a whole new way to develop electronic textiles. Many wearables artists have used her fabric push buttons, beaded tilt sensors, pompom sensors, and bend sensors as parts of their playfully illuminated, almost sentient clothing.

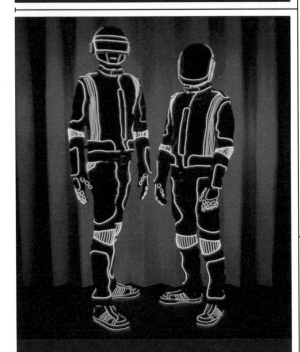

JANET HANSEN / EL-WIRE APPAREL
The unofficial light-up apparel designer to the stars, Janet uses thin strands of battery-powered electroluminescent (EL) wire to outline costumes' seams and construction details with vivid, brightly colored lines of light. The results are show-stopping.

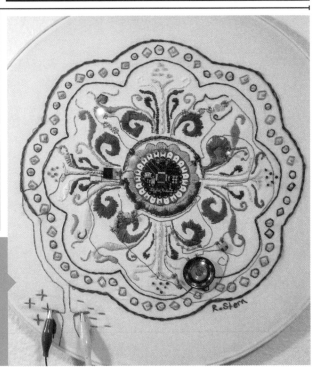

LEAH BUECHLEY / LILYPAD ARDUINO
A former professor at MIT's Media Lab, Leah developed the popular LilyPad Arduino (shown here in embroidery by Becky Stern). A microcontroller mounted to a lightweight, flexible board, the LilyPad can be programmed to control lights, sensors, and other fashion-forward components that users attach with conductive thread.

MARY HUANG / LED DRESS

Designer Mary Huang's jersey and crocheted dress features a dozen battery-powered LEDs that light up the garment's torso. When the dress isn't worn, it can be used as a lamp, expanding its usability and cutting down on its time hanging in a closet. Huang wanted to make a piece that was truly day-to-night: In sunny hours, the LEDs are hidden from sight. But when it's dark, the garment transforms into an ethereal, spectral light show for the body.

NAIM JOSEFI & SOUZAN YOUSSOUF / MELONIA SHOE

If 3-D printing is the future, what better vehicle to transport you there than these 3-D-printed shoes? Sketched by designer Naim Josefi and then modeled in Rhino software by Souzan Youssouf, the footwear introduces a brand-new production process to apparel manufacturing.

HUSSEIN CHALAYAN / TRANSFORMER DRESS

Turkish designer Hussein Chalayan works at the intersection of high fashion and technology, incorporating muscle wire (an alloy that morphs when heated and returns to its original shape once cool) to create shapeshifting garments that magically drape, fold, and pop up all on their own.

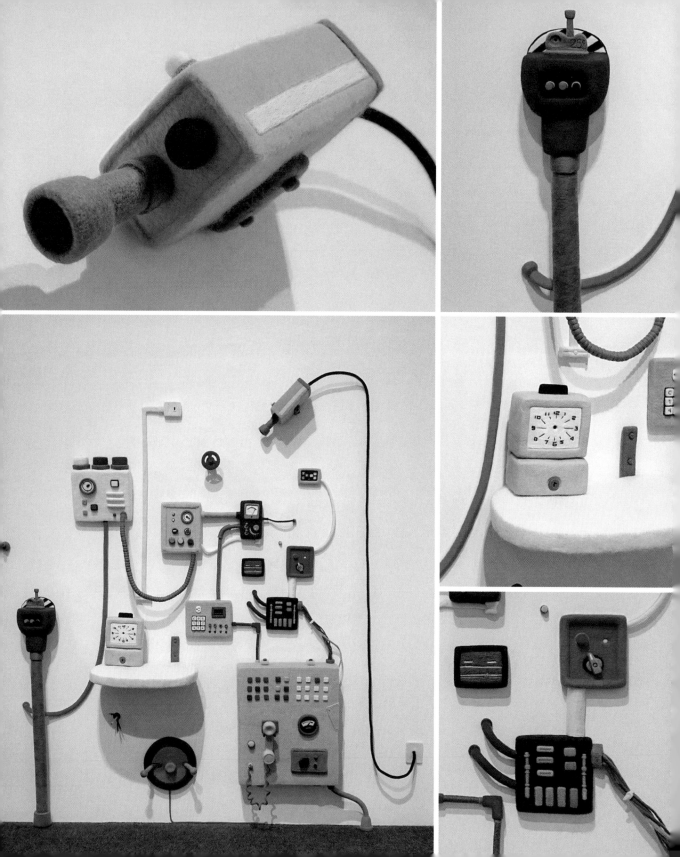

FELTED TECH

LOOK CLOSELY AT THE GIZMOS HERE—YOU WON'T SEE THE USUAL FLASH OF CHROME OR BLINK OF LIGHTS. THAT'S BECAUSE THEY'RE ALL FELT.

Every day, most of us walk by thousands of mechanical and electronic gadgets—some hidden behind walls or under your feet, and some stationed right in the open. Rarely are these pipes, valves, switches, keypads, and indicator lights considered the stuff of art—much less art of the amusing, soft-to-the-touch, and cuddly variety. But under the playfully stabby felting needle of Moxie Lieberman, anything is possible.

In fact, that's a bit of a mantra for the wildly popular fiber artist: "I love to make wool do impossible things," Moxie says. To date, that includes adorable felted monsters caught chowing down on doll parts, and supersize replicas of childhood memorabilia (you remember cassette tapes, right?). And now there's *Control,* a wool piece felted right into a gallery wall that mimics the gadgets quietly, somewhat insidiously ruling over our modern lives. *Control* asks viewers to consider the way our world works—or doesn't.

"I think that the cross between hopeful, whimsical cuteness and the idea that we're all doomed is probably what my heart is made of," she says. "There's no solving it, so you might as well express it in as many ways as you can." To that end, felting seems like a perfect medium for Moxie: She uses supersharp needles to make "bajillions" of tiny pokes, transforming brightly colored wool into smooth 3-D objects that look lighthearted and totally comical—a process that she likens to extreme acupuncture.

But like all makers, Moxie had to find her own way. "Tinkering is really important, especially when you don't know where you're going but you just have to play a bit," she says. Because when Moxie first picked up a felting needle, the world of fiber arts was more or less flat. But through a mischievous yet painstaking process, Moxie took the 2-D medium and used it to bring the world around her to furiously funny life.

Sculpting with Wool

Moxie got into felting when she hired a fiber artist to teach at a summer camp. She started out with flat stuff but grew bored. "This was before it was second nature to Google everything, so I didn't think to look up 3-D techniques," she says. "One day I just grabbed a needle and made a ball. And then I pretty much stopped doing anything else." From that moment, everything became fair game for feltification—and the results are pretty much the embodiment of what we call snarkasm: witty without meanness, lightheartedness with an appreciation for the dark.

66 The first time I figured out how to make wool do what I wanted was when I made this replica of a Fisher-Price toy dog, Bo, from back in the day. Only I made him 2 feet [60 cm] tall and 3 pounds [1.4 kg]. It was the turning point, the point I call leveling up—when you figure something out about life or communication or process, and you build on it. After that I did a full-size pickax. And a whole set of billiard balls. I was off and running.

MOXIE'S TECHNIQUE FOR MAKING A SMOOTH FINISH? A STRATEGY SHE CALLS "TINY POKES FOR THE WIN."

66 The tool that I use to make flat fabric has, like, 25 needles in it, and it's really heavy metal. Gravity does part of the work with that thing. The tool I use for detail work is my beloved single felting needle—it's covered with notches, and the needle opens and shuts the wool's scales so they lock like Velcro. And wool . . . I need *all* of the wool. My favorite is Corriedale, because it's soft enough that it's pleasant to touch and coarse enough that it layers and bulks into 3-D really nicely. I have to hold on to it and look at it for so long—it may as well be enjoyable!

> When it came to installing *Control*, I wanted to felt it to the gallery wall. So I made the main components first, then I arranged photos of them in a computer program called OmniGraffle, printed them out, and went about felting all the connector pieces. Still, the negative space in my sketches didn't look the same as the negative space on the wall. It took four days to install—nailing pieces and felting over them so you couldn't see where they were connected, and gluing metal pieces to the back of the wall so the pieces could hang. Those are the tiny details that make it awesome.

> I'm a big believer in looking at pictures of what you're trying to make—you assume you know the shape, and you just don't. For *Control*, I looked at photos of Russian submarines, boiler rooms, and workers' desks. (In the finished piece, check out the surveillance camera trained on the desk, and the time clock—it's got no hands. For a reason.) Some objects are replicas of stuff from films—one keypad is Darth Vader's chest plate, and there's another one based on a handheld Coleco game from the '70s. And then there are buttons from my total love, *Mystery Science Theater 3000*.

TINKERER DETAILS

Where tinkering happens I'm working in a basement with lots of old pipes. When my upstairs neighbors flush their toilet, you hear it through the pipe above my desk. I call this my "water feature."

Next big thing I have some plans, but I want to hold them close for a while. I will say that I'm never done with replicas; I'm never done with the big stuff. Whenever I see some piece of equipment that I don't know what it does, I'm like, "I could totally felt that."

Getting unstuck If I need to cleanse my palate creatively or if I get stuck or just bored, I make a new finger puppet. Because you always need a new friend.

93

Felt Your Own Fabrics

Before you join in all the fiber fun, recognize that felting takes time, it's most enjoyable when you surrender to its Zenlike flow, and it requires serious attention to your tools—because they are *sharp*. After you've made flat felt and a few basic shapes, who knows what tactile creations you'll dream up?

GATHER THE GOODS Before you get fuzzy with it, head to the craft store. You'll need a 38-gauge multineedle felting tool and a few 38-gauge single felting needles, too. Fall in love with a wool's color and texture, and find a piece of simple foam to use as a mat. Warning: Do not forgo the foam. It protects your surfaces from all that viciously fun poking action.

TEASE APART SOME TUFTS Start by pulling the wool apart into pieces measuring 2½ by 2½ inches (6.5 by 6.5 cm). Spread these tufts so that they're thin and even, then lay them in rows across your foam with all the fibers pointed in the same direction. Lay out another tier of pulled fiber atop the first, but this time orient the sections perpendicular to the fibers in the first layer. Keep layering, alternating the fibers' direction, until you have about four layers.

FELTERS, START YOUR POKING Grab your multineedle felting tool and poke your fiber layers with firm but shallow punches, holding the tool at a 90-degree angle to the foam. When your wool starts to adhere into a single layer, flip it over and poke more, continuing to flip and poke until your wool looks like fabric. To incorporate the thin, fuzzy edges, fold them over and poke them down. Hold your fabric up to the light and fix any thin spots by adding criss-crossing wisps.

SHAPING A SPHERE Pull off a tuft of wool fiber about 3 inches (7.5 cm) long. Pinch and pull the fibers apart to loosen them, then roll it into a ball. Lay it on your foam and poke it gently from all sides with your single felting needle, rotating it often. Add more tufts—thick or thin, depending on how big you want your sphere to be—and keep on poking! Finish up with more of those tiny, shallow pokes to smooth the surface. Now that you've done a few shapes, try your hand at felting around objects by covering, say, a toy part with felt that you've already pulled and stretched, then building up around it by—you guessed it—poking and adding more tufts.

FELTING A LOG You can use this basic and versatile shape in tons of felt sculptures. To get started, grab 2 inches (5 cm) of fiber, pinching and pulling to loosen it. Fold the tuft into a puffy log-esque shape, place it on your foam, and start poking it with your single felting needle, frequently flipping it. Roll it around, too, to help shape uniform sides, adding more tuft layers for the strength and thickness you want. When you've poked and rolled your way to a dense, shapely log, use tiny, shallow pokes to smooth out its surface.

TINKERING WITH TEXTILES

The way Moxie tells it, felting is weirdly, wonderfully addicting. Here are some additional artists who've caught the fiber-pushing bug, plus a few who make similarly intriguing pieces out of yarn and other cozy materials.

CAROL HUMMEL / LICHEN IT!
In *Lichen It!* at the Morton Arboretum in Chicago, yarnbomber Carol Hummel used macramé to re-create the symbiotic relationship between trees and fungus.

EMILY STONEKING / AKNITOMY
Vermont-based crafter Emily Stoneking knits adorable animals—except they're all split open as if under a surgeon's scalpel and pinned to an aluminum-tray frame, like an anatomy lesson.

LAURA SPLAN / DOILIES
Each of the doilies here is actually a representation of a virus—the flu, hepatitis, and herpes, from left to right. Laura starts with an image of a virus's molecular structure and then outputs her design through a computerized sewing machine.

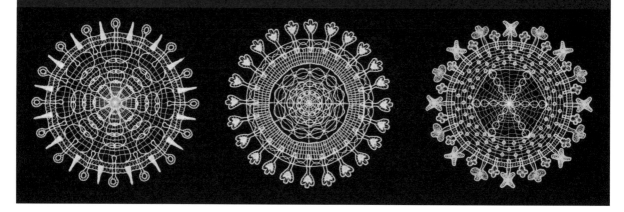

NATHAN VINCENT / LOCKER ROOM

Juxtaposing cliché masculine idioms with crafting techniques traditionally associated with women, Nathan Vincent surprises viewers with a collection of life-size urinals, showers, lockers, and benches made out of yarn. The details are amazing—the benches, for instance, are covered with hand-stitched "wood grain."

TOSHIKO HORIUCHI MACADAM / RAINBOW NEST

This colorful net playground at the Takino Suzuran Hillside National Park is a kid's dream. To make it, Toshiko first built a model of the space and crocheted between its architectural details, then scaled it up to fit the room's actual dimensions.

SIREN ELISE WILHELMSEN / 365 KNITTING CLOCK

With each stitch in time, the knitting clock built by this Norwegian artist makes a stitch of yarn. After a year, a 6-foot- (2-m)- long scarf finally completes itself.

FIVE
WORDS
OR LESS

"THINK OF A SCENARIO, SAY IT IN FIVE WORDS OR LESS, AND I WILL SEW IT FOR YOU."

That's the promise you'll get from Paul Nosa when you someday find yourself standing in front of his sewing machine, surveying a portfolio of patches stitched with clever drawings. In response, you'll likely think up a pun, or recall a meaningful story from a long time ago, and Paul will sew his visual interpretation of it onto a patch just for you.

You'll definitely feel special, but Paul does this for everyone, sewing patches at music festivals, museums, and DIY gatherings around the United States. And for a man who spends so much time on the road, portability is crucial. That's why Paul teamed up with metalworker Ben Olmstead to custom-build his own sewing-machine rover. His machine and supplies pack neatly inside it, along with a suitcase that displays his art, and Paul hooks it up to a bicycle, so he can ride to events without shouldering his heavy gear. Once there, his bicycle-powered generator and a solar panel keep his sewing machine running for hours.

Despite all its mechanical ingenuity, Paul's *Five Words or Less* project is really about his love of sketching. Because when he makes a patch for you, Paul's actually drawing with his sewing machine, guiding the fabric under the needle to create a tiny story using just a few lines of thread. It's a souvenir you can wear right on your sleeve.

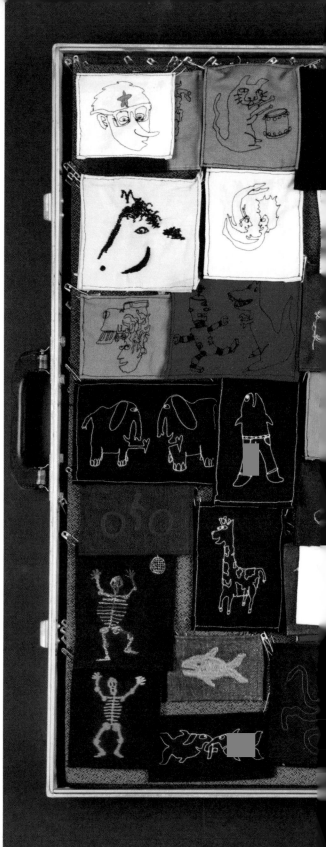

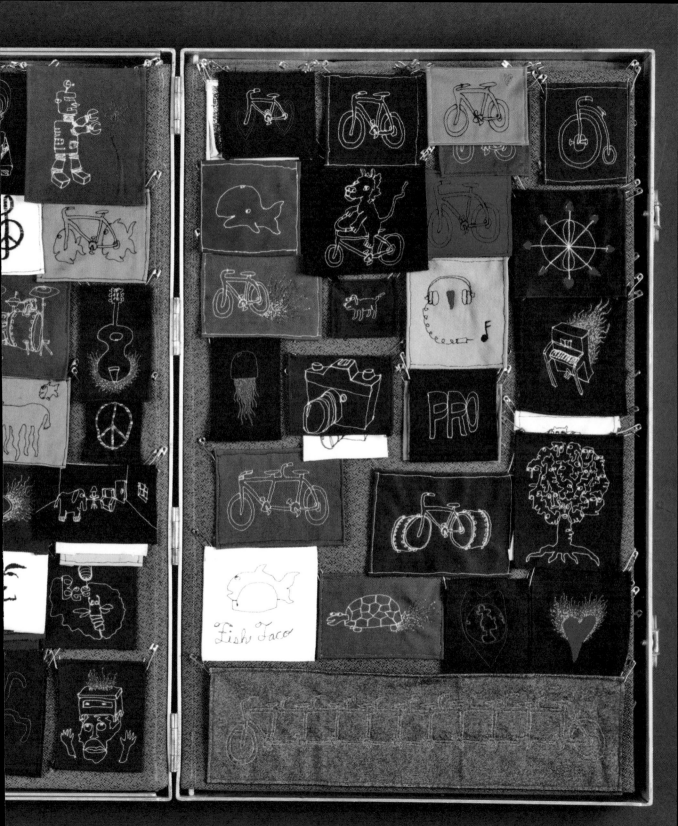

Fish Taco

HOW PAUL TINKERS
Stitching a Story

When you ask Paul how long it takes to make a patch, he'll tell you 40 years—which is, comically, his age. But it's not that each patch takes a lifetime to produce. He means that they're all the result of a lifetime of tinkering.

EARLY TINKERING: PAINTING BY SMEARING FLOWER PETALS INTO PAPER TO PERMANENTLY EMBED THE COLOR

〝 I started making drawings, and people said they liked my work, but no one ever bought it. So I started making art that people could really use, like candles with drawing designs on them and shirts, ties, hats, pillows, and dresses with sewn-on drawings. It felt very real to embroider the design into the fabric itself. Then someone suggested I should try patches, and the ideas exploded. Unlike sewing on shirts, there's no pressure to make a design on a small patch of fabric. The first one I made was a fish.

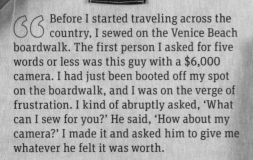

〝 Before I started traveling across the country, I sewed on the Venice Beach boardwalk. The first person I asked for five words or less was this guy with a $6,000 camera. I had just been booted off my spot on the boardwalk, and I was on the verge of frustration. I kind of abruptly asked, 'What can I sew for you?' He said, 'How about my camera?' I made it and asked him to give me whatever he felt it was worth.

PAUL ALSO WROTE A KIDS' BOOK CALLED *FISHTOWN*. ITS HERO IS MR. TROUTPANTS, WHO YOU SEE HERE AS A STUFFED TOY.

〝 I still make patches for the masses— bicycle-themed pieces are the most requested ones. But these days, I've gone back to doing more abstract art, like my earlier drawings, but larger and made with the sewing machine. For me, it's about the details. It's kind of like meditation.

> My first attempt at portable sewing was the Solar Sew'er, which I built on a Radio Flyer wagon. It was pretty primitive. The new rover is a much better tool for making art. It's made entirely of aluminum and has drawers for thread and fabric, and the deep-cycle battery is near the ground to distribute the weight. Since it's a bike cart, I can ride into an event and have my table, machine, power source, and sewing supplies all in one setup. Everyone assumes I use a computer to control the sewing machine, but it's all done by moving the fabric by hand.

TINKERER DETAILS

Favorite material Denim. It's a durable fabric that doesn't stretch, but it's relatively porous, so it's easier to embroider onto.

Tinkering strength I draw, play music (drums, guitar, and vocals), and make movies; each endeavor influences the others. Drumming has helped me keep the right timing with my sewing, and sewing taught me new patterns for playing drums.

Getting unstuck You've got to get the idea out of your head without judgment and begin physically working with it.

Advice to new tinkerers Produce, but balance productivity with just being. Both are essential.

Where tinkering happens Everything packs up into the sewing-machine rover—tinkering can happen anywhere.

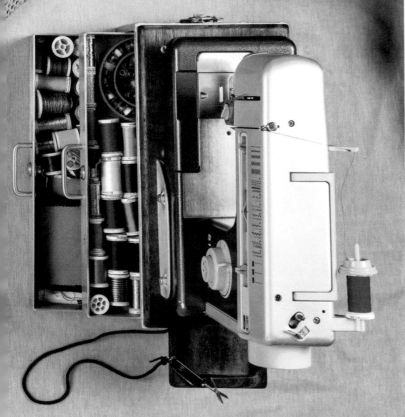

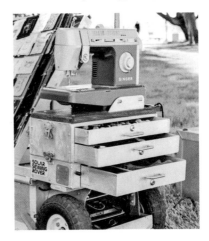

MARK-MAKING MACHINES

Paul's sewing-cum-drawing machine is just one of many types of automated artistry—from replicable digital designs to random, once-in-a-lifetime drips and doodles.

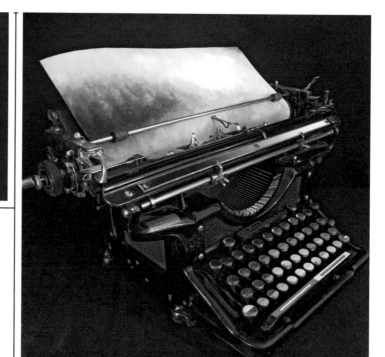

TYREE CALLAHAN / CHROMATIC TYPEWRITER
The hand behind this colorful painting isn't wielding a brush—it's tapping on a vintage typewriter that presses paint onto the page. To create this unexpected art-making device, Tyree Callahan modified the keys of a 1930s-era typewriter and loaded up the typebars with paint blocks. To change out the hues or re-up the pigment, he manually adjusts the bars one by one.

BRUCE SHAPIRO / EGGBOT
A fascination with stepped motors paved the way for Bruce's Eggbot, a machine that rotates a vice-clamped egg while doodling a computer-programmed design onto it. After his first prototype, Bruce teamed up with Evil Mad Scientist Laboratories to make it into a kit.

DOUGLAS REPETTO / GIANT PAINTING MACHINE
In Douglas's art machine, switches and a DC motor controller team up to move a paintbrush across a sheet of Mylar, creating continuous looping brushstrokes. The machine is largely constructed of found materials, and he's made many versions, which run for different amounts of time and create varying densities of paint.

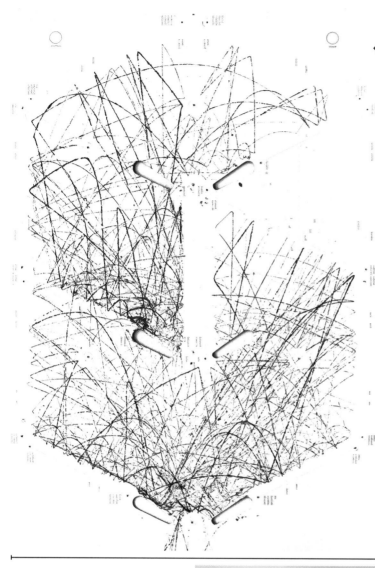

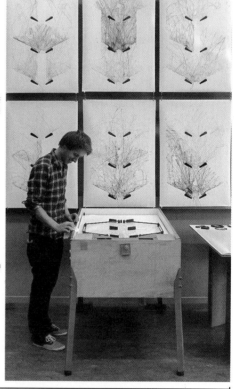

SAM VAN DOORN / STYN
Pinball has always been a blast, but this Dutch artist has hacked an old pinball machine to propel an ink-covered marble over posterboard, creating art as you ping around the interface. The better you play, the more intricate and interesting your designs turn out to be.

ROBERT HOWSARE /
DRAWING APPARATUS
Two turntables get hooked up to a pen, and when the songs are over, you've got a DJ performance documented with a spirogram-esque drawing. The print can be replicated using the same vinyl and rate of rotation, so it's a departure from some mark-making machines' inherent randomness.

HOW YOU CAN TINKER
Build a Scribbling Machine

Paul uses his sewing machine to draw, but you can create
lots of DIY contraptions to make art, like this scribbling
robot. It may just be markers attached to a motorized base,
but the squiggly lines it draws as it moves are wild, and
you can tweak its configuration and balance for surprising
and experimental patterns.

START BY GATHERING STUFF Scrounge around for a base for
your scribbling machine and some art supplies—we often use
punnets (a.k.a. strawberry baskets) and markers. Play with
other drawing tools, too, like crayons or chalk. We fastened
our art supplies to the base with pipe cleaners in a balanced
setup, but making off-kilter or otherwise unexpected machines
is wholeheartedly encouraged! You'll also need a DC motor, a
AA battery, tape, wire cutters, and a rubber band.

GIVING IT JUICE Taping the simple DC motor to the
base is what gives your robot its get-up-and-draw.
But because the motor is secured in place, it can't
shake your scribbling machine into action. So to
offset your motor—i.e., attach something to it that
will hang off the edge of the punnet and do all the
necessary spinning and wiggling—we stuck part of
a glue stick onto the motor's spindle, but a pencil
nub could also work. Try a bunch of stuff!

INTRODUCE NEW COMPONENTS You can add a variety of electronics to your scribbler by wiring them between the battery and motor. Try out an on/off switch, which lets you decide when it's time to scribble (and when it's time for the machine to be shut down to preserve its battery). You can also experiment by attaching a light-sensitive cell, which will make your scribbler spring into action when a light shines on it, or adding a sound sensor so you can trigger your scribbling machine by clapping or shouting.

MAKE IT GO! Use wire cutters to strip the ends of your motor's wires, exposing ¼ inch (6.35 mm) of bare wire. Wrap a rubber band around the battery, then tape it and the motor to your scribbling machine and place your 'bot on a big expanse of white paper. Finally, insert the motor's wires between the battery and the rubber band, making sure the negative and positive leads touch the negative and positive contacts on the battery, respectively. It will immediately start moving, leaving a trail of ink! Watch its pattern, and think about adjusting your components to create different designs.

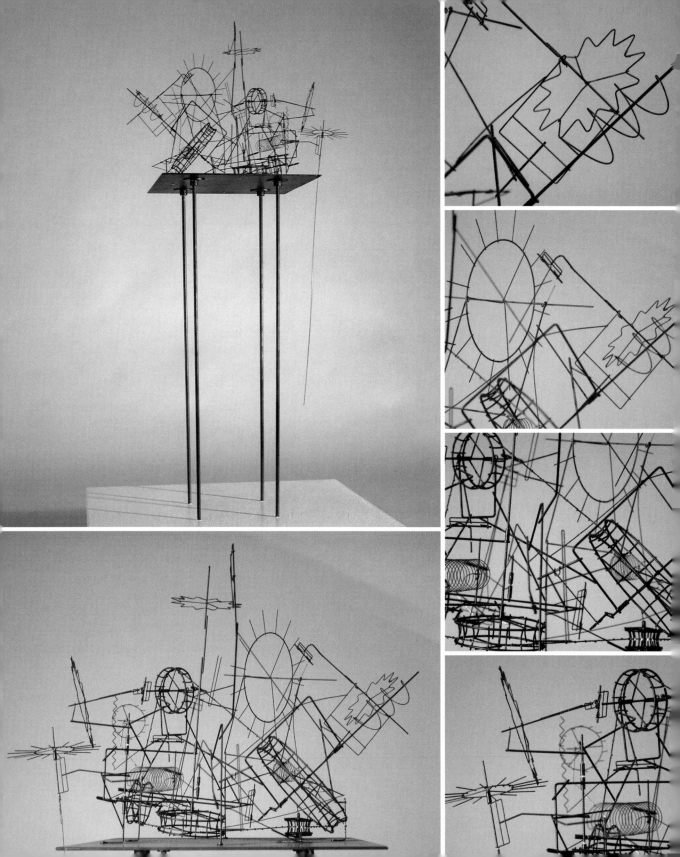

WIRE WORKS

SPIRALING SPROCKETS, SLOWPOKE GEARS, AND TINY RHYTHMIC RODS ALL PERFORM IN ARTHUR GANSON'S DELICATE DANCE OF WIRE.

When you encounter *Untitled Fragile Machine,* you might not know where to look first: Its elaborate, interconnected gears and wheels all whirl about in a beautiful, quiet frenzy. But then you'll start peering closely at its detailed mechanisms—maybe you'll notice a thin finger of wire methodically ticking through the spokes of a wheel. Or perhaps you'll spot a small wire foot dragging in a circle, or a very long tendril reaching down to brush against the statue's leg. Suddenly, *Untitled Fragile Machine* will seem alive with choreographed, near-human gestures, all improbably expressed through the medium of wire.

But human bodies are what its creator, Arthur Ganson, first studied: He dreamed of being a surgeon before he considered being an artist, and he credits that first aspiration for his art's subtle corporeality. When he discovered wire in college, he was surprised to find that it spoke to three of his most important impulses. "There was the part of me that wanted to work with my hands as a surgeon—to test the limits of my manual dexterity," Arthur says. "And there was the part of me that loved computer programming in high school, and that wanted to come up with logical systems in three dimensions. And then I wanted to express feelings in an object—to make machines that are a reflection of my own fragile humanity."

Clearly, Arthur does a whole lot of tinkering. He constructs his own wire gears, sprockets, wheels, and connector pieces with handmade jigs, resulting in unique, slightly inconsistent ratios that he likes for their organic quality. And in general, he embraces the unknown: "For *Untitled Fragile Machine,* I started with a blank canvas: the platform and the first sprocket," Arthur says. "Then I made a bunch of pieces and began composing them in space. Imagine a machine growing like a plant—that's how it happened."

HOW ARTHUR TINKERS
Gesturing with Wire

For all their mechanics, Arthur's wire machines are ultimately exercises in sketching: "This way of working is as close to oil painting or free drawing as I can get," he says. To mold such a hardcore engineering material into the articulated, graceful pieces for which he's known, Arthur created his own toolkit and work flow. But each project introduces something new to the mix. "There are always known processes," he says. "But I also always want to explore something new."

SOME OF ARTHUR'S WHEELS WERE INSPIRED BY DIAL INDICATORS, WHICH HE SPENT A SUMMER FIXING IN HIGH SCHOOL.

66 I really love working with soft, black annealed wire. It spot-welds okay, it silver-solders fine, and I coat it with blackening agent to make it look really nice. I made a tool to standardize the gear-bending process—a plate with holes in the center and 180 holes around its perimeter, and a hand tool with a pin on the end. I put the hand tool's pin in one of the center holes and pins in two of the holes on the outer ring, and bend wire around the central pin until it hits one of the outer ones, which acts as a stop. Then I reorient it and bend the other way until it hits the other stop. It's been helpful to track the gear specifications in a notebook.

66 Every sculpture starts with a feeling, and there's an infinite number of ways that it can be expressed physically—sometimes it's just wire in space, like *Untitled Fragile Machine*, in which all it really has to do is move. But sometimes I find an object and it triggers an idea. In *Child Watching Ball*, you turn a crank to make a doll's head follow the motion of a small blue ball. It took more analysis and invention, because I'm using the found part as a sort of puppet to make the wire's gestures more expressive.

Initially, it's like I'm the puppeteer, the doll head is my puppet, and I supplant myself with the machine.

SOME OF ARTHUR'S YOUNGEST TINKERING EXPERIENCES WERE WITH CLASSIC TINKER TOYS.

" My life completely changed when I came across a spot welder, a tool with copper pincers that lets you focus welding current onto a small space. I have a large, bench-mounted one, but a friend found one that was small enough to hold in your hand and use like tweezers, allowing you access in all planes. I was so entranced that I made my own version of it by hand. The spot-welder itself is so old that it has vacuum tubes inside, but it works like a charm.

TINKERER DETAILS

First tinkering moment The first complicated thing I built was a mechanical wine stopper. It had two figurines on top—a boy and a girl—and when you pressed a lever, they would turn and kiss each other.

Next big thing There's a part of me that's really in love with the idea of learning to program for the iPhone.

Getting unstuck I sometimes go through a slow, torturous process of narrowing down an infinite number of possibilities to one physical manifestation. You just have to stick with it.

Tinkering tale My first machines aren't working anymore because I made them with tin-lead solder, which over time will break. With *Untitled Fragile Machine*, I learned that silver solder lasts. These days, I often sketch them out before building them—below is the sketch for *Machine with Cat Whiskers*.

HOW YOU CAN TINKER
Go Wild with Wire

Arthur shapes wire into surprisingly expressive kinetic
sculptures, and most of them are powered by small motors.
Start your own experiments with wire by building a homopolar
motor—the simplest type of electric motor there is—and turning
it into a spinning figure with just a few materials.

FIND YOUR COMPONENTS For this
tinkering experience, you'll need some
copper wire, pliers, several AA batteries,
neodymium magnets (also called rare
earth magnets), and cup washers that
will fit the end of your battery. (We built
wooden battery stands with screws in
their centers for this activity, but you can
tape the battery to a table for stability.)

BEND SOME WIRE Before adding whirling,
gestural shapes to your motor, practice bending
wire first. If you want straight, angular bends,
grab a pair of needlenose pliers and insert a
piece of wire into their jaws, positioning them
where you want the first bend. Then use your
hand to push the wire, bending it over the edge
of the pliers, until you like the look of its angle.
For softer curves, pick up roundnose pliers and
insert a length of wire into their jaws, holding
the wire's end in your hand. This time, roll your
wrist away from the pliers, wrapping the wire
into a round shape. You can also coil wire around
your battery to make a neat spiral.

TRY DIFFERENT CONFIGURATIONS
Now that you've played around with a simple spinning motor, think about ways you can trick it out. Make asymmetrical wire shapes and then use counterweights to balance them on the battery contacts—cork, washers, and modeling clay can work as weights. To give your homopolar motor a distinct personality, try adding pom-poms, feathers, craft foam, or Styrofoam bits. Note that your battery, magnet, and wire will get hot, so as soon as you sense a little warmth, separate them and swap in a new battery.

MAKING THE MOTOR Stick a magnet to the battery's flat negative end, then stand it upright with the magnet on its bottom. Now that you've got the hang of bending wire, twist some into any shape you want to see spin. The crucial bit? Your wire piece needs a point that rests on top of the battery's positive end. (It helps to cover the battery's positive end with a washer to keep the wire rotating in place.) You also need a point, curve, or length of wire that makes contact with the magnet under the battery. Rectangular forms and spirals are great places to start, but tinker with your shapes and contact points to get it balanced and rotating smoothly.

WIRE-WARPING WHIMSY

You've seen wire in all sorts of mechanics and everyday objects, but how often do you see it sculpted, woven, worn, or used to tell a story? The wire-workers here bend it to their will, and all as a means of artistic expression.

ALEXANDER CALDER / CIRQUE CALDER
Step right up! Playful and insouciant, the lion tamers, big-ring leaders, strongmen, and acrobats of Calder's circus are shaped out of wire and puppeted around charming, diminutive sets, showcasing the expressive possibilities of wire as a medium.

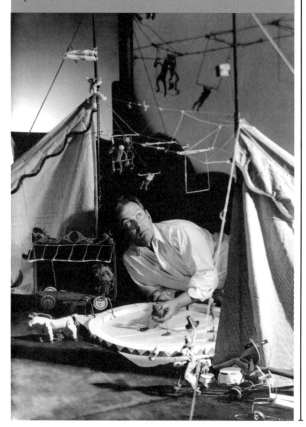

TEN THOUSAND VILLAGES / GALIMOTOS
Found throughout Africa, *galimotos* are small, handcrafted figurines, usually riding bicycles or driving cars. These charming push toys are made by children, who bend found wire pieces into human and transportation forms, then wrap them with fabric, cornstalks, and other accessible, decorative materials.

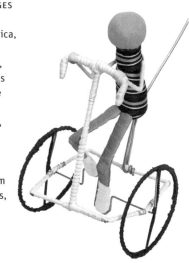

DUKNO YOON / WINGS
Slide this elegant, winged ring onto your finger, and control its flapping feathers with each bend of your knuckle. Its Korean creator, Dukno Yoon, uses wire to craft kinetic jewelry and masks that explore mechanisms as wearable art.

BARBARA LICHA / IN RUNNING
Sydney-based Polish sculptor and painter Barbara Licha makes immense cubes of tangled wire, embedding running, climbing, and falling human figures inside that she crafts of tighter wire coils. Barbara installs these pieces both in museums and outdoor spaces, exploring the physical and emotional relationships between humans and their environments.

KAREN SEARLE / HOW MY MOTHER DRESSED ME
In the works of Minnesota artist Karen Searle, fiber and wire techniques merge to explore feminine idioms, with an emphasis on the female body and the garments that have traditionally covered it. For Karen, the act of crocheting wire is meditative, and the results are unexpected, reverential plays on folk-art practices, like these 7-inch- (18-cm-) long dresses.

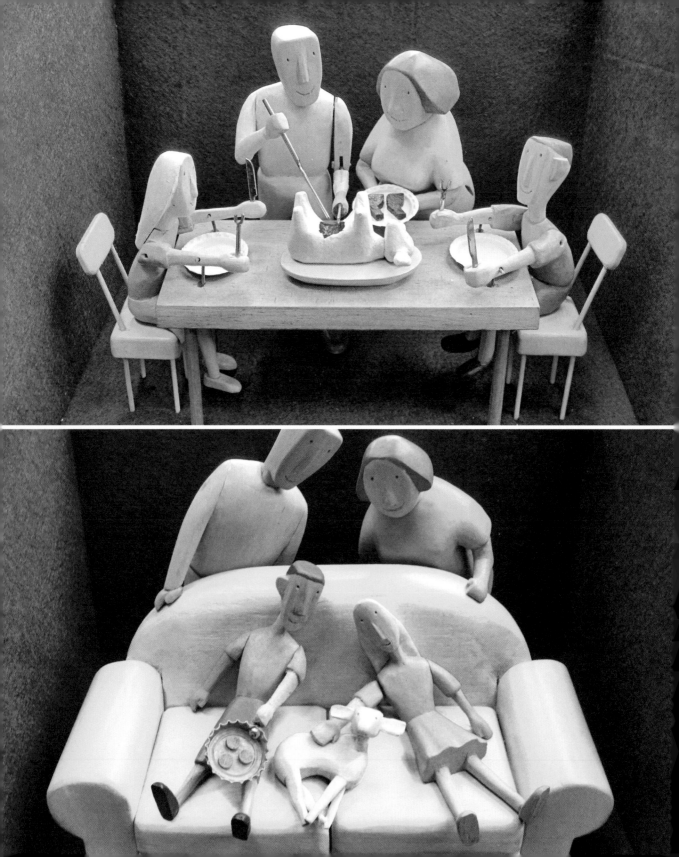

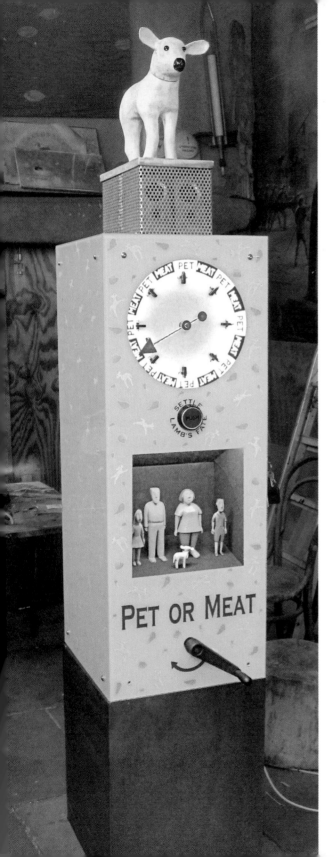

PET OR MEAT

FORGET LAUNDRY—SAVE YOUR SPARE COINS FOR TIM HUNKIN'S HILARIOUS ARCADE INSTEAD.

If you ever find yourself in Suffolk, England, there is only one thing you really must do: Make a beeline to the Southwold Pier, the site of Tim Hunkin's zany, maddeningly gleeful arcade. There you'll encounter *Pet or Meat,* a sly social commentary that lets you push a button to learn whether an adorable lamb will be welcomed into the family— or welcomed as a dish at the family's dinner table. Or pay a visit to *The Chiropodist,* a life-size, papier-mâché Nurse Ratched type who tickles your toes, should you be brave enough to offer her your bare foot. And visitors after a little R&R will enjoy *Microbreak,* a vacation-simulation ride that culminates in a heat lamp blasting in your face while you gaze at a photo of a dull beach.

While Tim's games are wildly silly, he's one of the most serious tinkerers around. An expert engineer, beloved cartoonist, and host of the '90s show *The Secret Life of Machines,* Tim has spent his life building devices that defy usefulness, and in the process he's wielded every tool in the toolshed, messed with mechanics galore, and experimented with different electronics and multimedia displays. Of his work, Tim says: "Our lives are pretty comfortable now—do we need any more gadgets? Making things that make people laugh seems a much more sensible proposition."

HOW TIM TINKERS
Making Laugh Machines

As funny as it is, *Pet or Meat* is the result of tragedy—multiple tragedies, in fact, all inflicted by Tim's cat on the innocent critters roaming the backyard. It got Tim thinking critically about food: "The idea for *Pet or Meat*," he says, "came from being baffled at how much I equally love watching lambs frolic about in a field and eating them as lamb chops." The result makes for a witty addition to Tim's Southwold Pier arcade, the site of more than 20 lighthearted, handcrafted machines that he has tinkered together during the past 15 years.

66 When I was seven, I took the motor out of a toy submarine and put it in a shoe box with a hole in the front. I put bits of rubber on the motor's spinning spindle, and then got people to put their bare feet inside, where they got a good tickle. I did it for the reaction, and I've never looked back.

66 My first coin-operated game that enjoyed any real success was called *The Birth of Venus*. You'd put in two pence, and water would pump into a bucket on top of the machine until it tipped and poured into a colander. The colander was hooked to a pulley, and the extra weight inside it would pull a poster of Raquel Welch out of a bathtub. I placed her outside an art gallery at Camden Lock in London, and a week later I returned to find the coin box overflowing.

TIM'S ALSO A MASTER CLOCK BUILDER—IN FACT, HE BUILT THE ONE ON DISPLAY NEAR THE TINKERING STUDIO.

66 The interesting thing about making these machines is their beginnings, when I don't quite know where I'm going. For *Pet or Meat*, the very first thing I made was the theater, the little set in which the modern family appears. Next I had to work out how high up the theater needed to be so that adults and little children alike could see inside. I made a drawing of the machine with a man sketched to scale so I could get an idea of how big the case needed to be. I also used CAD software to work out the case design, but the sketching is the much more fun part.

" When you put your money in *Pet or Meat*, an electric clutch is energized, and you turn a crank to make a pulley and a flywheel revolve, spinning the arrow quite fast. When you press the stop button, the clutch is released and the flywheel slows down, making the arrow stop on the word *pet* or *meat* and causing the drum to rotate, showing the lamb's fate. I did three versions of this prototype—replacing the rubber belt with a chain so it wouldn't wear down, and swapping out a nylon strip that makes the machine's creepy shrieking noise with a more reliable gear sensor. I plugged that into computer speakers, and they play the noise to match the result.

THE LAMB ON TOP CAME FROM A HUGE LUMP OF POLYURETHANE THAT TIM WHITTLED DOWN WITH A BANDSAW.

" I design by making things at least as much as I do by drawing, so after I got a good sketch and made a test theater, I built a full-scale prototype using my trusty rail saw. I first wanted a lamb on top that would drop down when you saw the results, but when making the prototype I found that it would have crowded the coin mechanism. I tried raising the prototype to make it fit, but then the lamb would have been too high for the users to see its fate. So I added a lamb in with the family in the theater. It's the fate of *that* lamb that you're watching.

TINKERER DETAILS

Favorite tool I like my TIG welder. It's a beautifully made, very precise German tool. You can do tiny things with it. But that's at the posh end. On the not-so-posh end, I like my French mole grips.

Where tinkering happens I've been in the same workshop for a long time, and fine-tuned it to how I like it. For a work surface, I put new chipboard down for each project, because then you can draw on it and use it to lay things out.

Next big thing My next arcade game is called *Alien Probe*. You use the controls to poke at a little alien, but then it turns out it's actually probing you. This big tentacle of LEDs will swim up from the game's base and stick you in the rear!

Inspiration I admire political cartoonists, particularly the eighteenth century's Rowlandson, Gilroy, and Hogarth, who were mercilessly rude about the king. They make me proud to be English.

HOW YOU CAN TINKER
Build a Coin-Operated Machine

You've probably played a few coin-operated games in your time, but have you ever considered what magic transpires after you drop in your money? The secret is that the coin makes momentary electrical contact as it rolls down the slope on the other side of the slot, which switches on a circuit and . . . well, after you've made this simple cardboard mechanism, what the circuit does is up to you!

TEMPLATE TIME You'll need to obtain a low-torque microswitch (available online and at hobbyists' shops), some thin cardboard, and a hot-glue gun. In addition, grab a pair of pliers and the timers, buzzers, lights, and whatnot that you plan to coin-power once you've built your mechanism. To make it, go to tinkering.exploratorium.edu/coin-operated-machine.pdf, download the template, and trace it onto cardstock. Then cut it out with a craft knife and crease it along the fold lines.

BUILD THE MECHANISM The pieces you see here are the slotted faceplate into which you insert money (you may need to fiddle with the slit size, depending on your coin); a track for the coin to travel down; and a mount for the track and the microswitch. To assemble the pieces, hot-glue the track to the back of the faceplate so that it's in line with the slit, then hot-glue the mount to both the faceplate's back and the track's side, as you see here. The microswitch is the hero—when a coin slides down the track and hits its sensitive wire, it triggers your circuit. Bend the wire into an L shape and secure it to the mount, then use a craft knife to cut a slit in the mount under the track's end.

- Remove shoe
- insert foot
- insert coin

25¢

LEVELING UP Tim Hunkin's coin-operated machines are hilariously sophisticated, and (once you've played with a few basic components) we encourage you to incorporate more advanced electronics and explore more coin-operated possibilities. Here we re-created Tim's coin-operated foot-tickling machine with an Arduino (a microprocessor available online and at hobbyists' shops that allows you to control components with simple code), a motor, some wire, and a breadboard. When players insert a coin, the code causes a rod inside the box to spin, tickling the player's toes with rubber tubing. What can you tinker up with a little programming power?

ADD COMPONENTS Now attach your microswitch to whichever electronic components you like! Think up a delightful surprise that's worth a quarter or a nickel, and pick a component that will help you achieve it—like the motor, speaker, or LED you see here. To hook it up, wire the microswitch to your chosen component and enough batteries to power it. Then start dreaming up an interface and housing for your game—maybe it's a cardboard box, like the one you see here—and a container positioned under the track to collect your winnings. Then hot-glue the coin-operated mechanism to its front.

JOHANNES VOGL / UNTITLED (MACHINE TO PRODUCE JAM BREADS)

German artist Johannes Vogl rigged a conveyor belt that ushers bread slices under an enormous jam squirter, then under several knives that spread the good stuff out. The slices then travel up the belt and are dropped into an appetizing heap.

COMEDIC CONTRAPTIONS

Everyone can appreciate a good joke—especially when it's an elaborate feat of tongue-in-cheek tinkering. Here are some machines that are less about fabricating products than they are about manufacturing glee.

BRETT COULTHARD / THE ULTIMATE MOST USELESS MACHINE

Push the "on" button on this sleek, handsome device developed by Canadian maker Brett Coulthard, and a finger will emerge to hit the button and turn the machine right back off.

RONNIE YARISAL & KATJA KUBLITZ / ANGER RELEASE MACHINE

We all need to break something every now and again, and this vending machine by Swiss and Danish artists Ronnie and Katja allows you to do just that. Put in a coin, select a plate, and watch it smash to the machine's floor.

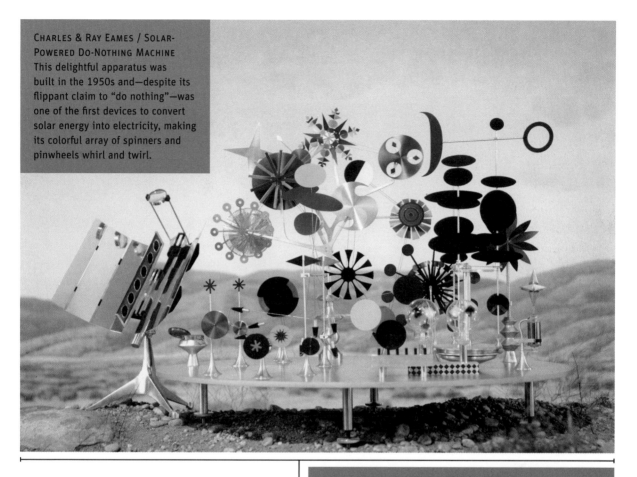

CHARLES & RAY EAMES / SOLAR-POWERED DO-NOTHING MACHINE
This delightful apparatus was built in the 1950s and—despite its flippant claim to "do nothing"—was one of the first devices to convert solar energy into electricity, making its colorful array of spinners and pinwheels whirl and twirl.

ADRIANA SALAZAR / MACHINE THAT TRIES TO TIE TWO SHOELACES TOGETHER
Try is the operative word in the title of this quirky, humorous project by Colombian kinetic sculptor Adriana Salazar. Shoelaces are threaded through the endpoints of two motorized silver brackets, which then slowly, slowly rotate in an ill-fated effort to twist the laces into a proper knot.

BENJAMIN COWDEN / EATING MY CAKE AND HAVING IT TOO
Turn the handle of Oakland-based Benjamin Cowden's pretty piece of steel machinery and get treated to a perverse little delight: A prosthetic silicone tongue mounted to a mechanized arm extends out to lick a lollipop, darting back for another lick with each spin of the handle.

ANIMATRONIC CREATURES

GIVE ONE OF THESE PECULIAR PLUSH CREATURES A POKE OR A PUSH, AND IT'LL DO A SURPRISING, CURIOUS SONG AND DANCE FOR YOU.

There are a million stories lurking in every bin of discarded stuffed animals, and Asia Ward should know: She's rifled through tons of them at flea markets, secondhand shops, and discount depots.

But Asia's not just a collector of toys that have seen better days. Once she's fished out a good candidate— one selected for its intriguing hand feel or color, or for the electronic components stashed inside—she takes it to pieces. Then she combines its parts with ones salvaged from other once-loved toys and a few found curios (like bits of coral and even teeth). The results are humorous, a little unsettling, and incredibly endearing: Her animatronic critters scoot around, make strange and vaguely animalistic noises, and test out their new limbs with funny, quizzical gestures. Asia also gives each creature a unique character, complete with a name—like *Knob, Lamb, Quid, Mouseteeth,* and *Bambi,* which you see at right.

Her first instinct, however, wasn't to invent a whole new species. As a student of sculpture, she started out looking for interesting fur and premade plastic parts like claws and beaks that might look cool when cast in bronze using the lost-wax method. "I dipped them all in wax, and I thought they would turn out amazing," she says of her initial efforts. "But when I broke open the castings and saw the results, I thought they were the ugliest things I'd ever seen."

Every tinkerer runs into this sort of frustration— when things don't work the way you expect, and you have to regroup and find your way to a solution. It was no different for Asia: "I realized that what I really wanted to do was make entirely new creatures using stuffed animal parts in an unusual way, like attaching an arm to a head. And since I was already taking them apart, I figured, 'Why not hack around with the electronics, too?'"

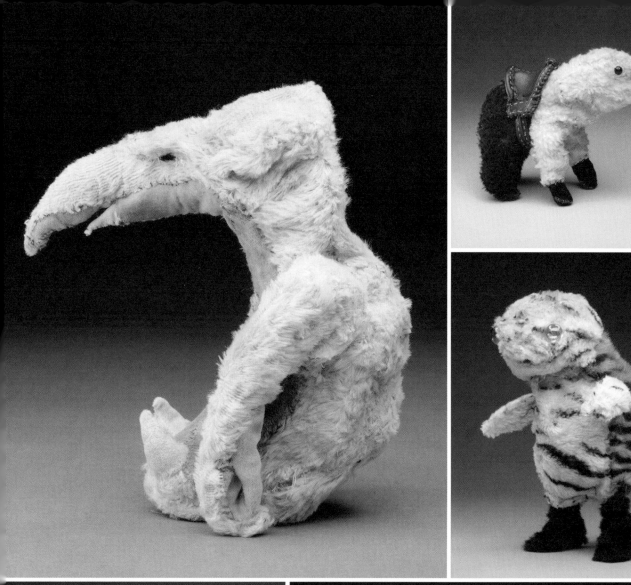
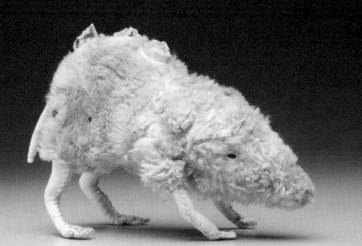
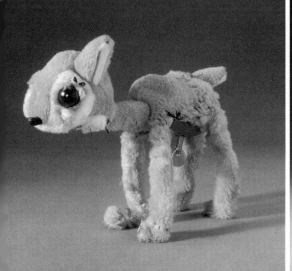

Inventing New Animals

The first time Asia performed a stuffed-animal operation, she got her mind blown. "All of these mechanics that I thought were supercomplicated and magical turned out to be really simple and easy," she says. From there, she started hacking and rigging various electronics together to endow her creatures with haphazard, fanciful animatronics.

66 I get my toys from thrift stores, where people have pretty much abandoned them. My favorites are the FurReal Friends—they've got really great, sensitive sensors. I'm always on the hunt for nice textures that have a worn-out look or unusual quality, and sometimes I dye the fabric to give them spots or stains. The slightly ratty-looking material that *Knob* is made of came from a flea market in Connecticut. A guy had been traveling around the country with this weird stuffed animal—like some sort of good-luck charm. He called him his best friend. When I told him what I was doing, he gave him to me.

ASIA'S FIRST FORAY INTO SONIC SCULPTURES: GRINDING DOWN THE PEGS ON MUSIC BOX MILLS AND TWISTING OFF THEIR WIND-UP KEYS.

> I'm fascinated by the idea of devolving animals, like I'm making a real animal that's had to survive in an alternate universe. They usually start with a sketch. Since I was a kid, I've always drawn my pets (I had a rat, frog, and turtle). My family lived in the country, so we would capture caterpillars and other weird insects and study them. Even back then, when I was drawing, I was trying to figure out what new, crazy animal I could make.

WHAT ARE ASIA'S SCULPTURES MADE OF, EXACTLY? MOLDABLE PLASTIC FOR STRONG APPENDAGES.

> *Knob* is this weird, pterodactyl-looking thing. I really wanted him to have a long beak nose, but it made him topple, so I gave him two arm things for balance. He uses them to scoot around on his bottom—which is actually a plastic jaw from a toy lion. I thought it was important to make the interaction special for each creature, so to turn *Knob* on, you have to poke him in the eye, where the sensors are. Then two motors inside him start up this strange series of motions. He never does the same thing twice.

> I like all my pieces to feel random and unique, and toys from the store only do one thing over and over. So I often include a circuit from another toy, wiring them in series or parallel, which messes up the circuits' timing and lets me run more than one motor or add a sensor. I've tried using Arduinos and kits, but there was no real surprise to the characters.

TINKERER DETAILS

"Real" job I work for the KidWind Project, training educators about renewable energy—specifically wind power—and providing activities and resources for the classroom.

First tinkering moment I was really into My Little Ponies, and I had this bookshelf in my bedroom that I turned into a building for them—each shelf was a new land or room. There was an aquarium room, an exercise room, a beach room. . . . I realized I needed an elevator, so I made myself my first pulley with a steel spring.

Favorite tool I really like hedge clippers. They have a weird, curvy edge that can cut through superheavy plastic.

Advice to new tinkerers Get interested in your medium. You don't have to know its history or all that other crap; just really feel out what the medium can do.

Take Apart Your Toys

Ever wonder what's trapped inside your favorite playthings, and what makes them do whatever they do that's so special? Put on some safety goggles and dissect your old stuffed animal, remote-controlled car, or singing Santa. You'll make some surprising discoveries, and you can remix your toy when you're done.

SOURCING SOME TOOLS Collect a few toys you want to investigate and a variety of tools for your toy autopsy. A screwdriver, a seam ripper, a pair of strong scissors, and a small saw will all be useful. When it's time to put parts back together, you'll want superglue (or hot glue and a hot-glue gun), a needle and thread, and possibly a soldering kit. If you want to take your experiment a step further and try circuit-bending (manipulating your toy's circuitry to make different noises), you'll need alligator clips and wire, too.

NOW FOR THE TEARDOWN Dive in with the appropriate tools: If you're opening up a plush toy, start with a seam ripper and scissors. If your toy is soft plastic, you'll likely need scissors or a saw, but start by looking for screws that you can simply undo to remove the casing. Now poke around and check out the mechanisms, circuit boards, computer chips, lights, and wires you find inside. If your toy has a special function (like sound triggered by squeezing a paw), activate it while you're watching the toy's insides to see how the internal parts work together.

FINALLY, REUSE AND REMIX We like this activity because it encourages you to create, rather than consume. So don't scrap those synthetic pelts, plastic bits, and electronics—you can use the toy's parts, your tools, and your imagination to create a new and original plaything. To cause some mechanical mischief, strip wires and solder them to new places to see what happens. Or design a unique stuffed animal by sewing a teddy bear back together inside out, or combining parts of different toys or stuffed animals.

INTRO TO CIRCUIT-BENDING If the toy you're working with makes sound, you can mess with its circuit for completely bizarre, bewildering experimentations in noisemaking. (For safety's sake, only bend toys with batteries that are 9 volts or lower.) Explore the inside of your toy until you find its circuit board, and identify the side with tiny lines, called traces, that run between the silver solder. While triggering the toy to play a demo tune, moo, or whatever it does, run alligator clips across the circuit board's bumps. Sooner or later, you'll make a connection that alters the sound. Use wire and your soldering tools to lock this connection down if you want to add it to your toy's repertoire.

FREYA JOBBINS / MEDUSA
Australian-by-way-of-South-Africa artist Freya Jobbins expresses humor with her elaborate, slightly disturbing heads made of meticulously placed doll parts. The details boggle the mind: For instance, this sculpture's mouth is composed of tiny, pursed doll lips; its necks is tons of hands; and its chin is a doll's bottom.

BERNARD PRAS / BLANCHE NEIGE French artist Bernard Pras built this anamorphic, Disney-themed assemblage out of plastic toys. Look at it from just the right angle, and its chaotic array of doll parts, figurines, and plastic trinkets cohere into a statue of Snow White.

KASEO / PIKAREMIN
This Japan-based master circuit-bender takes electronic toys and warps their soundmakers to create strange, ear-startling noises. His favorite plaything? Pikachus, which he modifies into theremins and plays in a choir.

ATELIER VOLVOX / OUTSIDERS
Zurich-based design collective Atelier Volvox disassembles secondhand stuffed animals, turns them inside-out, and stitches them back together. Even their eyes are inside-out!

JASON FREENY / ANATOMICAL LEGO MEN
What lies under Mr. LEGO's plastic outer shell? Alas, hardly the cool innards that you see here. To create it, Jason Freeny carved away the exterior plastic of an 18-inch (46-cm) novelty LEGO figurine, then sculpted organs and bones out of foam and installed them inside.

WENDY TSAO / CHILD'S OWN STUDIO
Who wouldn't want to doodle a little creature and then be able to treasure it as a touchable, three-dimensional object? Wendy Tsao's Child's Own Studio does just that: Upload a child's drawing, and receive a plush toy to match, lovingly handcrafted by Wendy herself. Her first "softie" was based on her own son's self-portrait. His excitement inspired her to offer her skill to the masses.

131

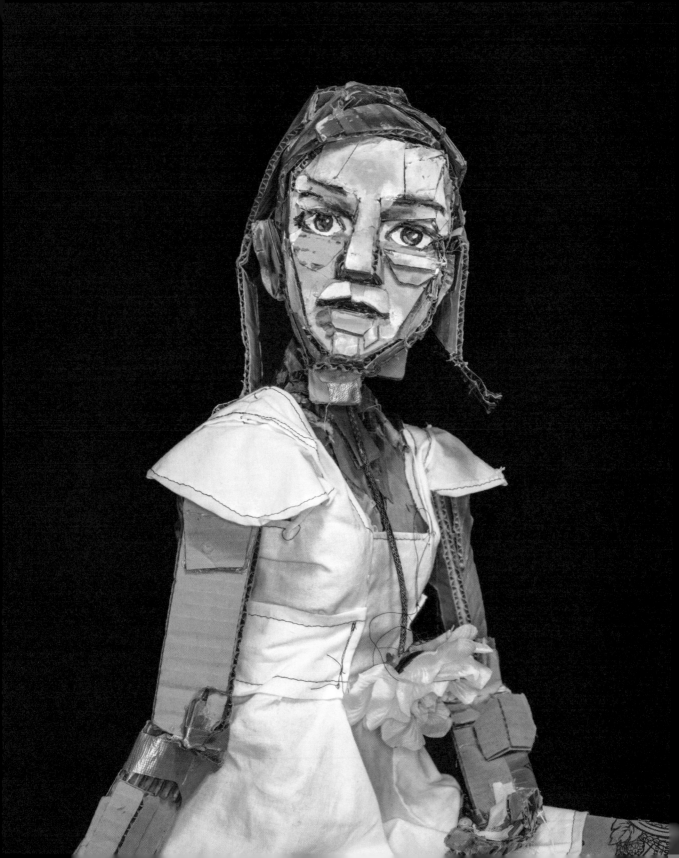

CARDBOARD GIRL

BUSTED-UP BOXES, DUCT TAPE, AND HOT GLUE WERE ALL DAX TRAN-CAFFEE NEEDED TO CRAFT THIS EXPRESSIVE, THEATRICAL PUPPET.

With her gangly, logo-emblazoned limbs, delicate yet odd grace, and fierce but soulful gaze that follows you around the room, *Cardboard Girl* is a far cry from the host of Ernies, Oscars, and Kermits that many folks associate with puppets. "Puppets start out creepy and then you have to work to make them personable," says her creator, Dax Tran-Caffee, an interdisciplinary artist who tinkers with theater, music, animation, and, of course, puppetry. "With puppets, you're up against the uncanny valley effect—people get freaked by objects that look almost human. So it's important to learn how to move with puppets—to let them breathe instead of imposing your breath on them."

Dax learned how to both make and perform with puppets during an apprenticeship with Chicago's Blair Thomas & Co. Theater. He went on to build all sorts of performative pieces: a huge set of wings that he wears while on stilts, a goose that lays eggs as it waddles, and an immense, Jabberwocky-esque creature that requires three puppeteers to maneuver, to name just a few. But as diverse as his creations may be, they all make use of really basic materials—such as cardboard, duct tape, and papier-mâché—and scavenged items, like crutches and bicycle cables.

Cardboard Girl is no exception. Her body is made of broken-down boxes, except for the folds of duct tape that make up her joints and the dress that Dax hand-stitched just for her. Despite all the details, this puppet was never meant for the stage—or at least not for long: "She's a prototype for a piece called *The Ballad of Barbara Allen*," Dax says. "I made her thinking I would tear her apart and build her again from scratch once I knew how she would break, but instead I've ended up repairing her over the years. That's the thing with puppets—you're never done making one as long as you're performing with it."

HOW DAX TINKERS
Bringing Puppets to Life

Cardboard Girl was inspired by the work of puppeteer Bruce Schwartz, and Dax crafted her for one dance. "The idea was that I would puppeteer her across a stage while singing this old-timey ballad," he says. "Then I would lay her down in a suitcase and close the lid." The role may have been small, but the lessons Dax learned while assembling her were big—from tinkering her together to tinkering with her onstage.

DAX SHAPES FACES BY LAYERING CARDBOARD SCRAPS, MUCH LIKE HE DID WITH CLAY IN HIS SCULPTING DAYS.

"Cardboard is my favorite material. You can get good-quality stuff for free, and it's really light and strong. Also, corrugation is genius. It's great for sculpting—if I score, bend, and push it around, it makes this really beautiful, dynamic form. I also use a lot of hot glue, which my mentor didn't like, but I've proved him wrong! Hot glue is stronger than the glue that holds the cardboard together, so the cardboard will fail before the glue does. When I'm making a puppet, I'll put hot glue and wood glue in the same joints. The hot stuff bonds it immediately, and then the wood glue holds it together in sun or under stage lights.

DAX'S TOOLS OF CHOICE: A BOX CUTTER, VARIOUS RAZORS, AND A COLLECTION OF NICE WOODEN GOUGES

"There isn't much of a puppetry tradition in the United States, so to learn how to perform with puppets, I watched other people screw up and thought, 'Oh, that's what you *don't* do.' I also talked with clowns and mimes about how to present your body. It's all about pushing your attention into the puppets, so the puppet appears to have more life than you do. You try to play down your rapport with the audience as a human body, and play up the puppet's rapport with the audience. I also learned a lot about the way to move with puppets through animation and modern dance.

THE SECRET BEHIND THE INTENSE STARE? HER EYES ARE CONCAVE, NOT CONVEX—A TECHNIQUE DAX CALLS "THE OLDEST TRICK IN THE BOOK."

TINKERER DETAILS

Getting unstuck When you mess around with these handmade machines, you realize it's not like they're built at IKEA and then supposed to just fit together. Every time you assemble a lever or another mechanical part, you sort of expect it to fail, and you know that there's going to be a reinvention of it.

Advice to new tinkerers The best advice I ever received was from another musician who also made visual art. He said to me, "Don't ever stop making. It doesn't matter if it's not working. Don't stop." And I would tell that to anybody.

Next big thing I want to train a bunch of puppeteers with cardboard birds, and then let them loose in the city with some simple rules so there's sort of an open, game-based choreography. People in the streets would follow them around and try to figure out what it was all about.

" *Cardboard Girl* has a lot of the classic puppet hinges. Most of her joints are made of duct tape folded in half, so the joints only swing in one dimension. She also has a tiny bit of string attaching the control rods to the palms of her hands—twist the control rod and it makes her hands flip in a lifelike gesture. She doesn't have a captive ball joint, though, which is my favorite joint. Her head-to-shoulder connection is nonexistent—I'm just holding her head above the shoulders since she has no neck. This is fairly common in modern puppetry, just holding objects close to each other and pretending that they're connected. With my other puppets, I've used bike brakes and crutches—anything I can find in a thrift store and use as a mechanism. A lot of them I make out of aluminum or wood.

Make a Cardboard Mask

Dax's cardboard puppets take a little mastery, but you can try your hand at making a basic—though no less fantastical—mask. All you need is cardboard (of course!) and a hot-glue gun, plus whatever fixings you like.

MAKE YOUR HEADBAND Start by cutting a strip of cardboard 1 inch (2.5 cm) in width into a piece that's long enough to wrap securely around your head, with a bit of overlap to spare. Bend it to mold it to your head's contours and test it out to be sure it fits, then connect the cardboard ends with hot glue and wait for it to dry. (Watch out for burns, but if you do get hot glue on you, follow Dax's advice: Douse it with cold water before the glue burns you.) You don't want the crucial headband to slide loose, so Dax taught us to attach a half-loop of cardboard underneath the main headband. This should fit around the base of your skull, and will help balance out any heavy builds on the front of the mask.

SCAFFOLD STRATEGICALLY Think about what you want your mask to look like—what it should represent and how much space you want it to take up. For a lifelike effect, you'll need a 1-inch (2.5-cm) gap between the mask and your forehead. To create this gap, hot-glue a few strips so they extend forward on the mask's sides, making a visor shape that angles the mask slightly upward. To keep your mask from wobbling, add supports to balance out its weight. Try a few things to get it just right! (If the mask starts to rub against your head in an uncomfortable way, hot-glue foam to the headband's inside.)

GO TO TOWN Tinker up a face that pleases you. You can try bending and folding cardboard into 3-D forms, or sticking triangular scraps of cardboard onto the mask like clay, creating dimension and personality. Consider using paint or markers to emphasize your mask's features, and cut depressions into the cardboard to make eye holes, nostrils, and more. When you slip your mask onto your head, remember to move in an exaggerated new way to make the mask come alive. Stand in front of a mirror and tinker with your posture and gestures to make them believable.

TINKERING BEFORE A LIVE AUDIENCE

For Dax, tinkering is half in the making of the puppet, and half in performing with his resulting creation. Here are other artists who build extensions of their bodies and then use them to tell a story.

REDMOON / THE ELEPHANT & THE WHALE
Chicago-based spectacle troupe Redmoon has been staging surprising, disruptive phenomena in social spaces for more than 20 years, including the recent *The Elephant and the Whale*, which features live song, shadow play, and panorama-painting machines.

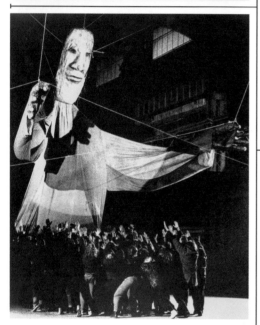

BREAD & PUPPET THEATER / UPRISING OF THE BEAST
Founded in 1963 by Peter Schumann, this troupe delights attendees with its large-scale puppets, outlandish pageants, and politically radical spectacles—and with the bread slices given out at each show to demonstrate the necessity of theater.

BERTJAN POT / ROPE MASKS
This Dutch artist fashioned his first rope mask by mistake while trying to loop rope on a flat surface. The rope insisted on curving, and the idea for these bewildering, colorful masks was born.

ROYAL DE LUXE /
THE SULTAN'S
ELEPHANT
This French street-theater group causes quite a stir with its immense, crowd-pleasing processions, which have featured a 36-foot- (11-m-) tall elephant and a giant marionette of a young girl. The elephant was made of wood and powered by hydraulics and motors, with several puppeteers piloting it around European cities.

HANDSPRING PUPPET COMPANY / WAR HORSE
For the play *War Horse,* this celebrated group of South African puppeteers built full-scale mechanical horses capable of galloping around onstage, carrying human riders, and twitching their ears to show expression.

ABSURDIST AUTOMATA

WITH A SIMPLE TURN OF THE CRANK, THIS FELLOW EATS HIS FILL OF SPAGHETTI—AND GIVES YOU A TASTE OF MECHANICAL COMEDY, TOO.

Somewhere in the village of Stithians, Cornwall, holed up in a rustic, ivy-covered cowshed in his backyard, Paul Spooner is likely to be hard at work. He might be cutting boards with an antique sewing machine that he modified into a saw, or drawing new designs in one of his many sketchbooks. Or maybe he's wielding an old surgical scalpel, whittling tiny and charming figurines from salvaged wood. Only one thing is sure: When Paul works, it looks a lot like play.

And that playfulness certainly makes it into his finished pieces. Called automata, these small, toy-like machines ask viewers to rotate a hand crank, then watch as this gesture is translated by a series of levers, cams, and gears into a tongue-in-cheek joke about *la condition humaine*. In *How to Live #17,* Paul's initial premise was that we all must learn life's lessons—even the most rudimentary, like how to eat spaghetti, a notoriously messy noodle best consumed

in proximity to soap and water. It's an apt choice in setting for such a lesson, but it's also a riot. "Once I made a list of things that were funny," Paul recounts. "And bathtubs came up quite frequently, as did corkscrews and Welsh lessons." As for the spaghetti, there was a practical concern behind making it the machine's main course, as the springy noodles cleverly conceal the mechanics that lift the man's hand to his mouth. "Often what appears to be humorous actually has a good deal of logic behind it," he says.

We love Paul's work because he takes it seriously without taking himself seriously, and because once he's sketched an idea, he plays with the problem to make it function, and leaves the machine's nuts and bolts exposed in the base. "What's the point of doing the work if you don't show it to people?" he kids. But look closely, and you'll get a glimpse of mechanical decisions that, despite their humor, are no joke.

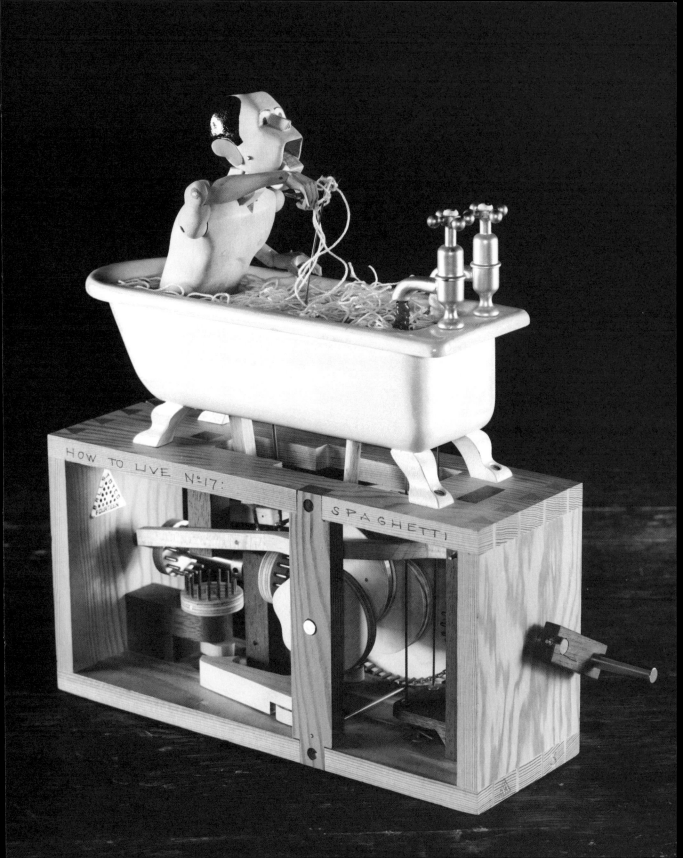

HOW PAUL TINKERS
Carving Cartoons

Paul's automata start as drawings, then he animates them into three-dimensional cartoons-in-a-box, carving characters and making them move with mechanics. To spread the good humor, Paul formed the 14 Balls Toy Company with fellow artist Matt Smith, who makes editions of designs—such as *How to Live #17*—that others can buy for their personal amusement. "The only function of my machines is to make people laugh," he says. "So at least I can tell if they've worked."

66 The project started when a television program approached me to build a machine on camera, and I had the idea to make a man eating spaghetti. If you don't look too closely, it seems that the hand is lifting the spaghetti, but it's actually the other way around. The soft and floppy skein of the pasta—which is silk embroidery thread—keeps you from noticing the rigid post pushing the hand up to the mouth. There's a reverse engineering to it. Then I thought that it would be convenient to have the usual accompaniments of Parmesan cheese and tomato sauce coming out of the tap.

THINGS THAT INSPIRE PAUL: *THE SIMPSONS*, *THE BEANO* (A CLASSIC BRITISH COMIC), AND THE MICKEY MOUSE MUG HE GOT AT DISNEYWORLD WITH TIM HUNKIN

66 I'm a bit of a toolaholic. I bought myself a little Lie-Nielson block plane for Christmas a few years ago, and I'm still slightly in love with it. It's a very strongly constructed, rigid little tool. But I abuse tools as well—I fall out of love with them, and then they suffer. I often use ones that belonged to my grandfather and dad, as I like the feel of my hand fitting where somebody else had theirs ages ago. Corny, but true. To do most of the detail work in my figures, I use an old scalpel. It's very precise and allows me to slowly creep up on a look I like. I also appreciate that whittling for 30 minutes helps me delay making the next evil decision—it lets me clear my head before tackling a looming problem.

> To transform the hand crank's rotary motion into the up-and-down and forward-and-back movements of the spaghetti eater, I hooked a reduction gear to the handle, and it drives several cams. One cam is followed by a roller on a lever with a wire on the end to carry spaghetti to the mouth. Another cam moves the man forward with each bite—connected to a linkage that opens his mouth—and one more cam makes him chew as he moves back. Then came a familiar problem in the automata business: The first mechanism took all the space, leaving no room to make the taps spill sauce and Parmesan. I ended up arranging gears and a drive shaft at the box's other end, and making an elaborate crank to connect them all the way to the tub's taps.

ONE OF PAUL'S FIRST PIECES: A STEEL KINETIC CLOCK SCULPTURE HE MADE FOR HIS DAD IN COLLEGE.

TINKERER DETAILS

First tinkering moment There wasn't a time when I wasn't interested in machinery. I was probably intrigued by the wheels on my pram! I also used to help my grandfather—he was one of those awful workmen who would use a hammer to put in a screw.

Favorite material I'm a big fan of wood, but I hate going and buying it. So I've been very lucky that people just give me wood—old tables and chests of drawers that they couldn't sell at auction.

Getting unstuck I like having lots of projects going at once so I can move from one to the next when I'm stuck.

Advice to new tinkerers Test out your ideas using easy-to-work-with stuff like cardboard and sticks before you try them with a more difficult material.

> I've got a very large batch of drawing books, and I have one open all the time. And if I'm making something, I'll do drawings of how I think it ought to go. And while I'm doing that, I might do a drawing of some new thing. So if you look through these books, they seem rather a jumble. But then you see the germs of ideas, and things that got somewhere and things that didn't. Of course, one of the important things about drawing is that it saves you from wasting materials. You can do a dry run with a drawing and decide whether it's a practical project or not.

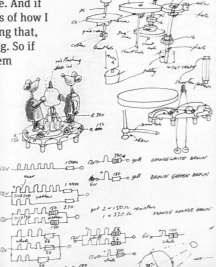

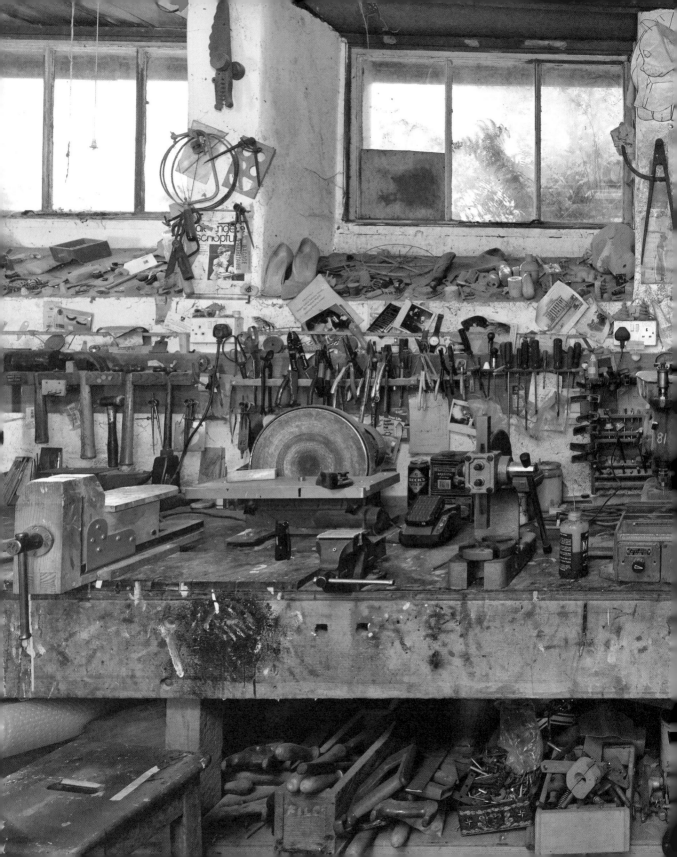

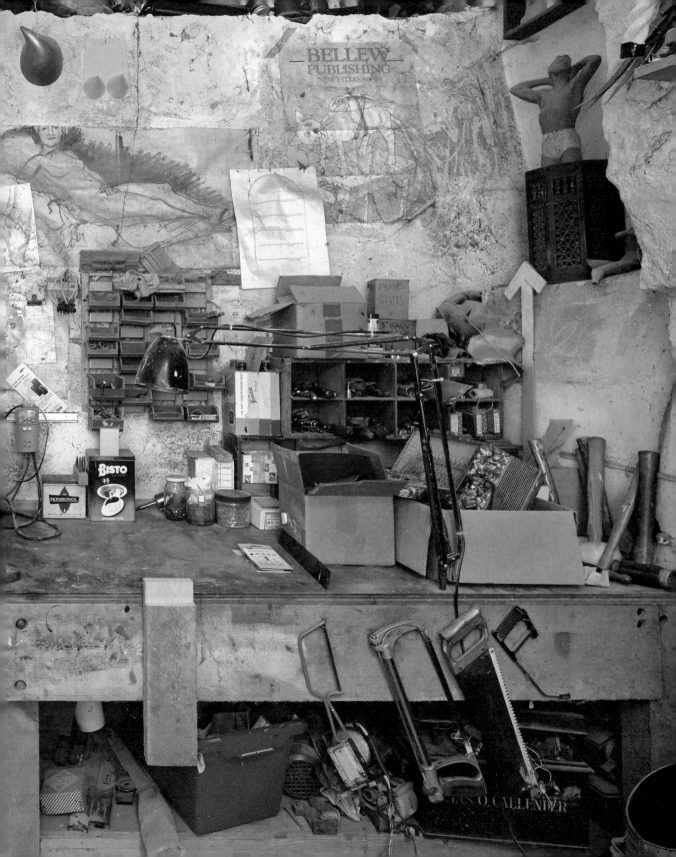

Put Together an Automaton

We like automata because they're made up of simple
machines, but they can be used to tell complex stories.
Configure the cams, levers, and linkages you see here so
that their mechanics make a meaningful motion.

COLLECT YOUR MATERIALS First, source a small cardboard box
and cut off its top and bottom flaps to make an open square.
(You can also cut a cardboard strip and hot-glue it into a similar
shape.) To stabilize your box, cut two triangles of cardboard
and tape them to two opposite corners of the box. Then gather
up scissors, a screw, drinking straws, a hot-glue gun, wooden
skewers, sheets of ¼-inch- (6-mm-) thick craft foam, and anything
you want to use in decorating your sculpture. Markers, colorful
paper, feathers, and the like are a solid starting place.

NOW FOR THE CAMS Cut two circular foam pieces: one about
2½ inches (6.35 cm) in diameter, and another slightly smaller
than the first. These discs are your cam follower and cam,
respectively—the pieces that rotate against each other when you
turn the automata's handle, creating motion in your sculpture.
The type of motion depends on how many foam pieces you use,
where you position them on the skewer linkages, and how you
configure them in relationship to each other, but we'll start here
with two. It's also a good idea to cut a small square of foam that
you'll use as a bushing to keep the handle rotating freely.

INSTALLING THE CAM FOLLOWER Hot-glue the cam follower (the larger circular shape) to the end of a new skewer. Grab a drinking straw and cut it in half. Use the screw to poke a hole in the top of your sculpture and insert the piece of straw, then stick the cam follower's skewer through the straw to keep it vertical. Adjust your cam and cam follower, turning the handle, until you like how they move together. Then glue the cam into place on its skewer so it won't slide. Now decorate your sculpture in a way that makes good use of its round-and-round motion, and turn the handle to watch your cardboard machine in action. Once you've got the hang of it, try several setups to see what motions you can make happen, using different numbers of cams and poking the skewers through the cams so that they're slightly off center.

INSTALLING THE CAM Use your screw to poke two holes in either side of your box, immediately across from each other. Then stick a skewer into one side of the box, and thread the smaller cam onto it, puncturing the foam disc in its center. Push the skewer through the hole in the other side of the box so that the cam is suspended inside. Give the skewer a turn—if it doesn't spin smoothly, hot-glue your foam bushing to the skewer where it comes in contact with the box's side. To craft a handle, cut a small rectangle out of cardboard and glue one of its short sides to the skewer's end, then cut a short skewer and glue it to the rectangle's other side.

AUTOMATED MARVELS

The tradition of automata goes back to ancient Greece, but the novelty of these charming, self-operating machines (and their endless narrative possibilities) never wears off.

PETER MARKEY / BIG WAVE MACHINE
Created for the Cabaret Mechanical Theatre in 1984, Peter Markey's colorful homage to the sea shows three men rowing in a boat with charming biplanes flying overhead.

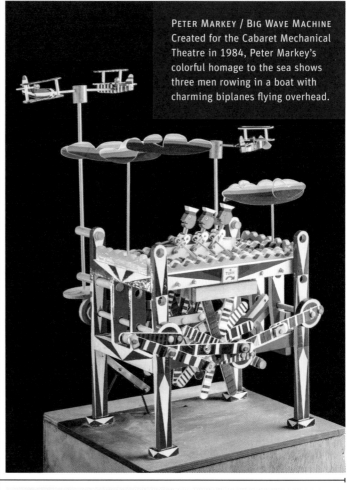

CARLOS ZAPATA / THE AUTOMATA REPAIRMAN
Got an automaton on the fritz? No worries—Carlos Zapata's delightful repairman is on his way. Colombia-born Carlos also added tiny figures (like a fellow gazing sadly at a broken automaton) in the mechanics underneath.

FI HENSHALL / SECRETARY BIRD
In the work of Fi Henshall, scrap tin, old wood, and various bits from the shed converge into lighthearted, folk-inspired machines that star birds, fish, and near-mythological female characters.

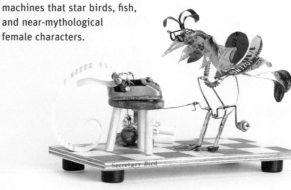

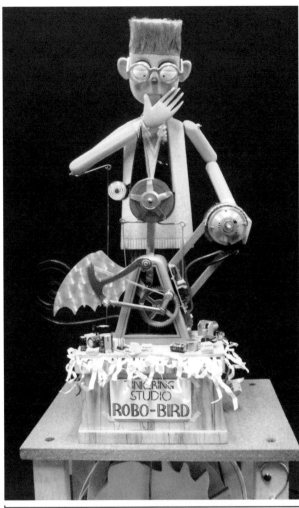

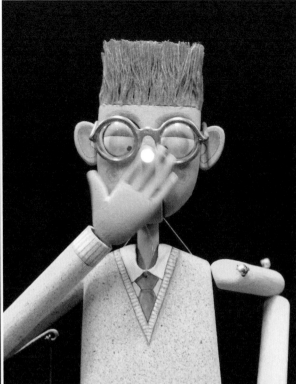

Keith Newstead / Tinkering Studio Robo-Bird
British artist Keith Newstead crafted this automaton specially for the Tinkering Studio. In the piece, a fellow turns a crank to make the beak of a mechanical bird snap open and shut, but it surprises him by biting his nose, making his eyes cross and his nose light up bright red.

Pablo Lavezzari / Barracuda
Turn the crank of Argentine artist Pablo Lavezzari's steampunk-esque automaton and see its sail-like fins and gills flutter, teeth-lined jaws snap, and mechanical innards move in a fearsome yet elegant swimming motion.

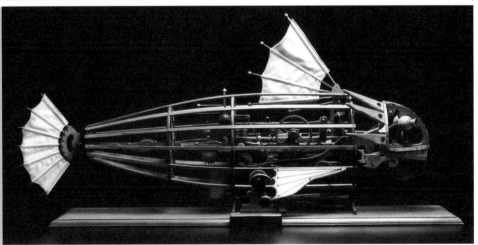

CONSERVATION OF INTIMACY

COME ON IN AND TAKE A SEAT—BERNIE LUBELL'S HUGE INTERACTIVE INSTALLATION IS ABOUT TO TELL YOU WHAT LOVE'S ALL ABOUT.

To get just what's at play in Bernie Lubell's giant wood machines, you need a quick vocab lesson: *Divagate* is one of his favorite words, and its meaning—to meander toward a goal—sums up his pieces' subtle, circuitous, and mesmerizing mechanisms, as well as the tinkering process by which he makes them. "I like to get my sculptures so they barely work," Bernie says. "People think machines function like ideal clockwork, and they want us to work like that. But in truth we're like real machines: Our bodies break, our ideas aren't quite right, our relationships don't really work. The way machines fail is a metaphor for how we fail, too."

Enter *metaphor,* another key term in the Lubell lexicon. Indeed, Bernie's large-scale apparatuses are vehicles for ideas that are equally immense—they're mechanical expressions of language and psychology, history and biology, love and understanding, life and death. And *Conservation of Intimacy* is no exception:

Visitors are invited to team up on a spring-mounted bench, or go solo on a bicycle. The seated pair interact, sending a telltale ripple of air through an overhead pneumatic system, which in turn drives pens across a roll of paper unspooling down the wall, which itself is propelled by the cyclist. Meanwhile, a monitor displays an array of bouncing balls—also controlled by the movements of the couple, who soon begin to realize that their gestures are being documented as a legible, if somewhat enigmatic, love story.

If Bernie's pieces look antique, it's because he's borrowed construction techniques from medieval times, making gears, tambours, and even his own tools by hand. Complicated, yes, but he likes it that way: "We think of simplicity as being more true, but it's not," he says. "Simplicity pushes reality into a perfect little box. But the intriguing stuff happens outside the box, beyond what we already know."

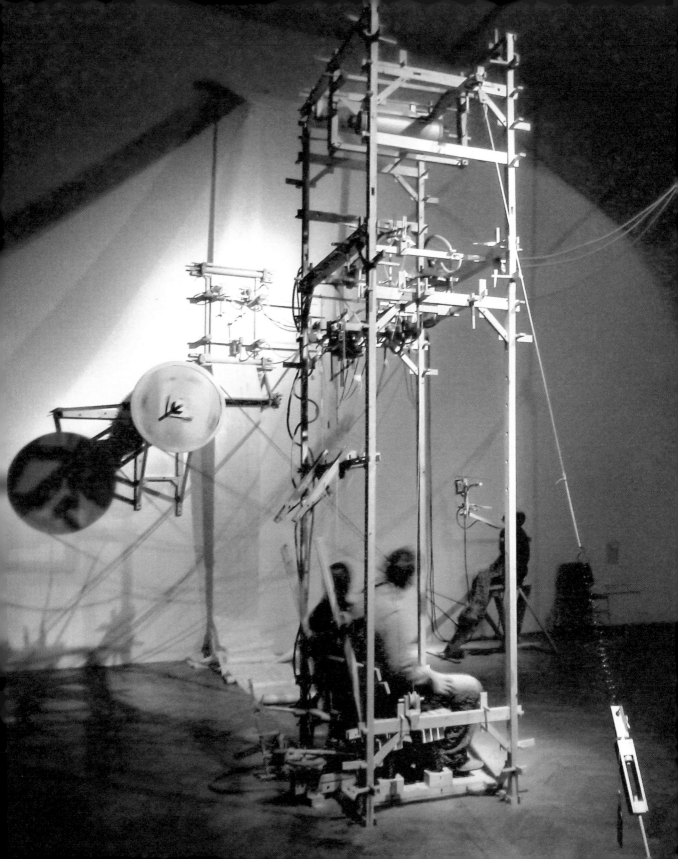

Making Mechanical Metaphors

Conservation of Intimacy's title is a play on the laws that govern our physical world—energy, matter, momentum—and for Bernie, the interplay of these mechanical principles and social dynamics has potential and power. "Even people who don't believe in mechanical metaphors, their hearts go out to the machines because they're just barely making it. They want to help them keep limping forward," he says. Keeping them going is noble enough, but making them go in the first place is nothing short of a tinkering miracle.

" To make my Renaissance-style gears, I use a tool called a divider that looks like a compass but with sharp points for marking wood. First I scratch a radius into a wooden disc, and to mark holes for the gear teeth, I walk the divider along the disc's perimeter and hope to arrive at the exact spot I started. That rarely happens, so I increase the radius slightly or change the space between the divider arms. To trim teeth for the gears, I stick pegs into a piece of wood cut with holes of the same diameter, then saw off the excess. I also created a jig for making the belts that drive the gears. To sew through the belts' thick rubber, I wear a sail-maker's glove that has a thimble at the palm.

BERNIE'S REQUIRED READING: WALLACE STEVENS, *MOBY-DICK*, AND OLD MECHANICAL DIAGRAMS

" In *Conservation of Intimacy,* I needed to control the rate of the paper sliding down the wall. A worm gear hooked up to the bicycle did the trick. It's a toothed wheel driven by a screw, and it was the most compact way to get a large change in speed. For every 10 revolutions of the bike wheel, ½ inch [1.25 cm] of paper flows down the wall.

> To fully appreciate the piece, you need to get physically involved—to participate rather than witness, by either riding the bike or sitting on the spring-loaded bench. In a way, I'm making a setting in which you become actors and create a theater of your own imaginings. I initially added the paper and pens as a joke about how we analyze everything—even intimacy—but I was surprised to discover that the paper markings and balls' motions really showed how participants interacted.

BERNIE PACKS HIS PIECES IN CRATES TO SEND THEM TO MUSEUMS AND INCLUDES AN "OUT OF ORDER" SIGN—JUST IN CASE!

> My work is deeply influenced by Étienne-Jules Marey, a scientist in the 1800s who believed life processes could be understood mechanically. He developed a pneumatic technology to explore human and animal physiology using a system of tambours—little drums—and rubber tubing to register movement, and my pieces incorporate similar elements. To make tambours, I glue a wooden circular disc to a ring of wood, then stretch a latex sheet across the open top like a drumhead. Tubing goes in a hole in the bottom with a linkage that connects to the latex, forming a pump. In *Conservation of Intimacy,* the tambours near the bench send air pulses to smaller tambours via latex tubes, and they make balls move on a tray and pens write on the unspooling paper.

TINKERER DETAILS

Favorite material I'm not an aficionado of exotic woods. I use mostly pine and other inexpensive softwoods that are a poor choice for machinery. There are frequent repairs, so the pieces carry the scars of their evolution for all to see.

First tinkering moment I've got a piece of Ivory soap that I carved into d'Artagnan when I was a kid. (I was enamored of *The Three Musketeers.*)

Tinkering tale I had tested the bench by myself in the shop, but on a sunny day I set it up outside to have more room. A couple came by and tried it out, but the weight of two people overwhelmed the bench's four springs, making it topple backward. So I added a fifth spring to catch the bench if it falls back.

Set Up a Chain-Reaction Machine

Bernie's machines inspire one of our favorite activities at the Tinkering Studio: setting up a bunch of stuff in elaborate themed chain reactions, like this metaphorical love machine. How does it work? Nudge over a row of dominoes, and the last one completes a circuit, which makes a paper mouth kiss another, knocking over a block and flipping a switch. This makes a dowel rotate slowly, tipping a cup and spilling a metal marble down piano-key stairs and an aluminum foil–wrapped track, which completes another circuit and powers a motor. The motor lifts and spins an apple—love makes you dizzy, see?—and releases a heart-shaped balloon. No two machines are ever alike, but here are some principles that'll help you make your own metaphorical chain reaction.

STARTING OFF This is one tinkering experiment that's best done with buddies, so call them over and set up a few tables in a ring—each friend needs a station to create his or her own section of the chain reaction. (Mark off people's sections with tape.) Then decide on a metaphor—brainstorm a bit to pick out a theme that interests you. Look around for stuff you can use, keeping in mind that you specifically want components that can add height, connect pieces, rotate, tip over, and work as ramps. Everyone should have at least one piece that they feel expresses the metaphor; it will become a central part of their own section of the chain reaction.

UPPING THE ANTE Mechanical chain reactions are great, but electronics make them even better. Aluminum foil is conductive, so you can fashion it into simple switches and attach it to basic components, such as slow-moving toy parts, DC motors, lights, buzzers, and battery packs. To do so, wrap a component piece in foil, and build your reaction so that the foil-wrapped piece simultaneously touches two pieces of foil, each alligator-clipped to the negative and positive terminals of a battery, respectively. Then use more clips to attach the battery pack to the component you want triggered in the reaction. (It helps to mount electronics to blocks—see pages 180–181 for more info.)

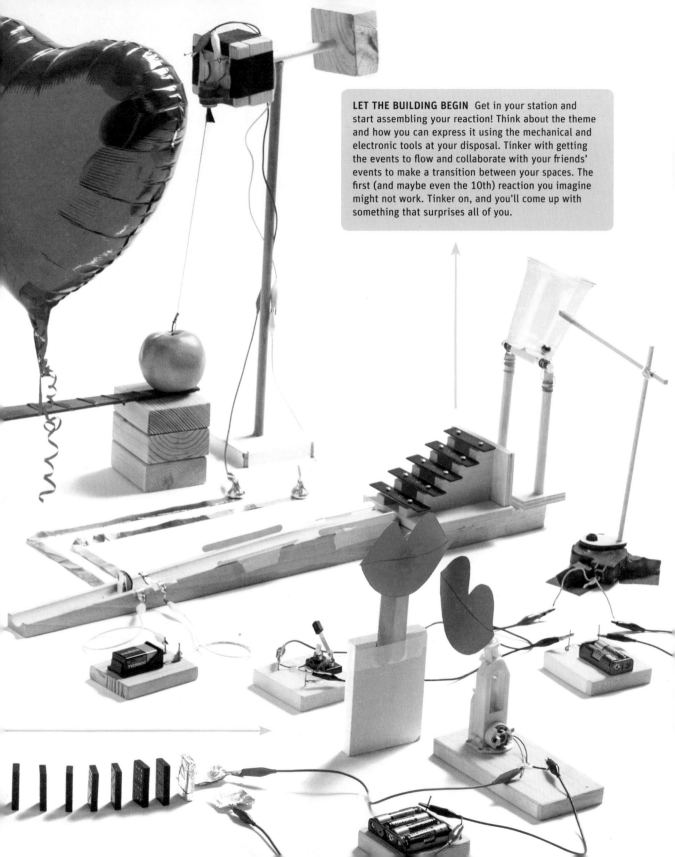

LET THE BUILDING BEGIN Get in your station and start assembling your reaction! Think about the theme and how you can express it using the mechanical and electronic tools at your disposal. Tinker with getting the events to flow and collaborate with your friends' events to make a transition between your spaces. The first (and maybe even the 10th) reaction you imagine might not work. Tinker on, and you'll come up with something that surprises all of you.

ONE THING LEADS TO ANOTHER

Rube Goldberg machines do a lot to achieve a little—unless you count laughter and amazement as achievements, which we do. Bernie's metaphorical machines are poetic renditions of the chain-reaction theme—here are others who build domino effects with hilarious, inventive, and wow-inducing results.

BRUNO MUNARI / MUNARI'S MACHINES
Deemed "the new Leonardo" by Picasso, Italian designer and illustrator Bruno Munari issued a hand-drawn guide to building the most fantastical contraptions—like the egg-boiling Rube Goldberg machine here.

JOSEPH HERSCHER / THE PAGE TURNER
One sip of coffee sets off this hilarious sequence, highlights of which include a hairdryer blowing on a hamster to make him run down a ramp, boiling liquid that generates enough heat to rotate a fly swatter, and a MacBook crashing to the floor—all just to turn a single page in a newspaper. Reading the morning news has never been so eventful.

SYYN LABS & OK GO / THIS TOO SHALL PASS
Power-pop music group OK Go teamed up with possibly the coolest nerds around, Syyn Labs, to create this Rube Goldberg–inspired video. The band members sing amid dropping pianos, drifting derby cars, whizzing TVs, and general enthusiastic chaos. In the video's finale, they're splattered by paint-ball cannons.

PETER FISCHLI & DAVID WEISS / THE WAY THINGS GO
Twirling trash bags, eye-popping pyrotechnics, and vats of corrosive sludge collide in this 30-minute cause-and-effect opus. Elegant yet industrial, the piece explores both physical and chemical chain reactions.

KEIO UNIVERSITY MASAHIKO SATO LAB.
EUPHRATES & NHK / PYTHAGORA DEVICE
Pythagora Device is a wildly popular segment in the Japanese educational TV program *PythagoraSwitch*. These chain-reaction shorts show basic items rolling, tipping, falling, and propelling each other forward, and each device ends with a rousing chorus of "Pythagora Switch!"

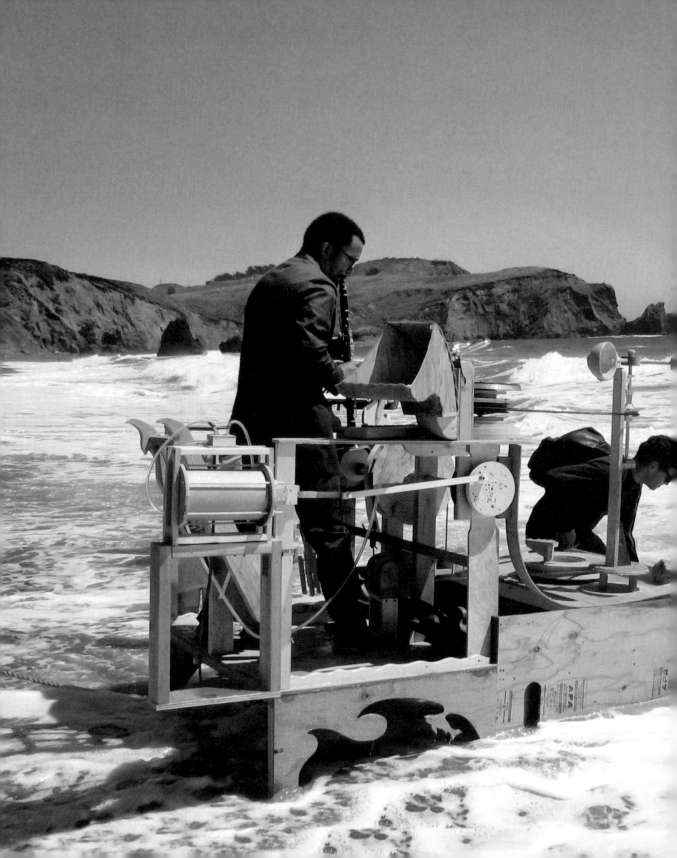

OCEAN EDGE DEVICE

WIND AND WATER POWER UP A DEVICE THAT'S HALF BOAT, HALF MUSICAL INSTRUMENT.

In Marin, California, on a bright, clear day in 2005, a crowd gathered on a beach, abandoning their sandcastles and surfboards and heading toward a beautiful vessel adrift in the surf. Outfitted with wooden mechanics and soundmakers, the apparatus shifted to and fro in the waves, playing a curious music with each upsurge of water and gust of wind.

And just who was at the helm? Walter Kitundu, a designer and artist at the Tinkering Studio and a MacArthur Fellow. Walter invents and builds musical instruments, most of which combine record players with more lo-fi lyrical tools (like guitar strings or *kalimba* tines), and many of which are powered by natural energy sources—wind, water, or fire. *Ocean Edge Device* is his most elaborate instrument to date: Waves flow into its base and spin a wheel, which creates enough energy to compress an accordion and pump air into a melodica. Meanwhile, the wind blows an anemometer made of salad bowls, generating the juice needed to spin a record on a turntable. Not to be left out, Walter stands on deck and plays a clarinet.

The concert lasted 15 minutes before a wave busted the crucial wheel, but Walter didn't mind. "I like giving up control so that the result isn't up to me," he says. "Like the record—it didn't need to spin at 33 RPMs. I wanted it to play however fast the wind was blowing, to reinterpret the music in a surprising way."

HOW WALTER TINKERS
Making the Sea Sing

Long before Walter waded out with his huge, ocean-powered music machine, he discovered one of his great loves: turntables. "Every night, I'd go to a local gas station and get a rose for my girlfriend," he says. "The gas station attendant was a DJ named Itchy Fingers Al, and he showed me the ropes." Later, this love of analog music devices merged with an appreciation for the world at work, and Walter built many variations on the record-player theme, including phonoharps, elemental turntables, and *Ocean Edge Device* itself.

WALTER'S FIRST TURNTABLE EXPLORATIONS: HITTING THEM WITH CHOPSTICKS AND TIN CANS

66 I was playing the turntable in a live band, and I got envious of other musicians' ability to make whatever sounds they wanted. I decided to transform an old flea-market record player by building a structure around it and adding strings, and that became my first phonoharp. It's kind of cobbled together. The switch is an old light switch, nothing is sanded, and the cuts are raw. But it is about bringing the idea into the world in a form that works. I've learned that if you make something beautiful, it tends to work beautifully, too. If you labor over details, that sense of craft works its way into the object and helps it function.

WALTER ALSO LOVES WATCHING BIRDS— ESPECIALLY HAWKS, OWLS, AND EAGLES.

66 The turntable became my lens to the world—I'd even look at car wheels and think about putting records on them. So I started making turntables powered by wind, water, or fire. The one at right is my fire one—it's expensive to play because all the candles melt in five minutes, but the heat they generate spins the blades, which makes the record play the entire time.

> "There's little left of *Ocean Edge Device*— I took it apart the day after the performance, and all that remains is the bell that amplified the turntable and the accordion. When you think about ocean waves and the way beaches are constantly reshaped, it makes sense not to hang on to things too much.

> "The first thing I built for *Ocean Edge Device* was a water wheel, which I then mounted on a lazy Susan inside a housing. Then I rigged a pulley system to get power off the main wheel and redirect it to an offset cam that would work the accordion and pump air into a melodica. I made the anemometer out of wooden salad bowls—one of my friends still makes fun of me for not taking the price tags off. The wind would spin it and power a gramophone, slowly playing a record of old spirituals.

TINKERER DETAILS

First tinkering moment Growing up in East Africa, we had to go out into the world and engage—exploring coves on the Indian Ocean or making toys and slingshots. Those were formative years that really stuck with me.

Favorite tool For a while I joked about getting a jigsaw tattooed on my arm, just because I use one so much.

Next big thing I'd like to press huge records and install the negative molds in Iceland's lava fields. When a volcano erupts, the lava would cast itself into the record's shape. After it cooled, you could excavate these boulders and play the sound information in them.

Tinkering tale I should have followed my initial sketch for *Ocean Edge Device*. Instead I positioned the wheel horizontally and didn't secure it all the way through both sides of the axle. I thought it was the strongest part, but it lost out to the waves.

NATURAL INPUTS

Wind, water, and fire—all these elemental forces can be harnessed as tools of expression, as in these stunning collaborations with nature.

TIM PRENTICE / LEXAN CURTAIN
In this kinetic work by sculptor Tim Prentice, an aluminum and steel framework anchors hundreds of white plastic flags, which put on their own show in the wind.

CAI GUO-QIANG / EXPLODING HOUSE
Fire is the element of choice for Chinese multimedia artist Cai Guo-Qiang. Here, he's sprinkled various colors and textures of gunpowder onto paper, covered and then anchored the arrangement with rocks, and lit the gunpowder on fire. The blast creates beautiful, violent patterns on the paper.

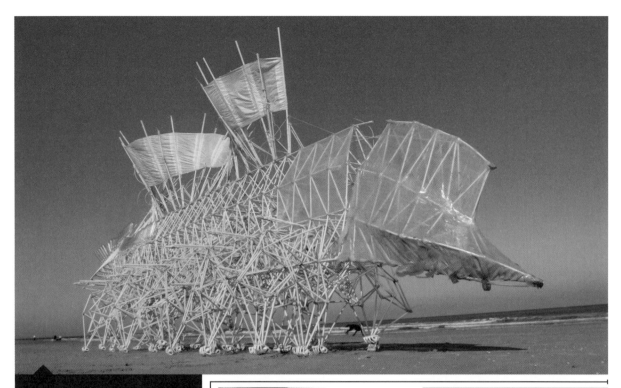

THEO JANSEN / STRANDBEESTS
These lumbering sculptures by Dutchman Theo Jansen are propelled across the land by wind. They're largely composed of plastic tubing and bottles—which act as lungs—and paper fins, all of which catch the breeze. Theo hopes that herds of them will someday roam beaches all on their own.

BARTHOLOMÄUS TRAUBECK / YEARS
If you stare at the rings in a slice of tree long enough, you might notice how similar they are to the grooves in a vinyl record. German artist Bartholomäus Traubeck did, and modified a record player to translate trees' secret sound patterns into haunting piano music.

MARKUS KAYSER / SUN CUTTER
This lo-fi, solar-powered lasercutter focuses pure sunlight with a ball lens, slicing preprogrammed shapes into plywood and paper. Thus far, Markus has used this technology mainly to lasercut sunglasses—an apt use for a solar-powered machine.

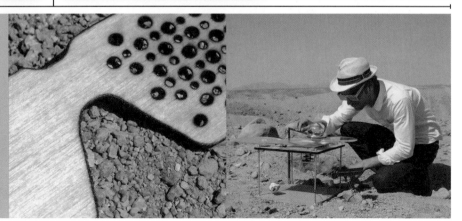

Play with a Wind Tube

We like Walter's musical instruments because they harness the natural elements in a brand-new way. You can get to know one of these elements with this wind tube, one of our most beloved things to play with in the Tinkering Studio. It's a breezy build that will let you create things and send them aloft.

GET YOUR GEAR Shop for a thin, lightweight acetate sheet that's 4 by 4 feet (1.2 by 1.2 m) in size. You'll also need four wooden embroidery hoops that measure 14 inches (36 cm) in diameter, three wooden spacers that measure 2 by 2 by 6 inches (5 by 5 by 15 cm), and a 14-inch (36-cm) fan with three speeds and an adjustable tilting head. Other must-have tools include wood glue, transparent tape, scissors, a hand drill, a saw, and zip ties.

PIECE TOGETHER YOUR BASE With the fan facing straight up, place the spacers around the fan's perimeter and balance one embroidery hoop on top. Trace a line on the spacers where the hoop sits, then use your saw to cut a notch that's deep enough that the hoop can rest securely inside. Then use wood glue to attach the spacers' bottoms to another hoop, which will sit directly on top of the fan. Drill three sets of hole pairs in this loop and attach it loosely to the fan with zip ties.

NOW WHAT CAN YOU FLOAT?
Once you've constructed your wind tube, it's time to experiment by letting a variety of objects surf the air. Turn on the fan and place an item between the fan and the tube—it will float or fly out if it's light enough. Test pieces of thin foam, strawberry baskets, feathers, wooden skewers, and lightweight plastic balls. We also like to take derders (toilet-paper tubes) and paper cups and cut them into pinwheel shapes that ride the wind. Tinker with what you'd like to see take to the sky, experimenting with making objects soar or hover for long periods of time.

CRAFTING THE TUBE Roll the acetate into a tube shape and slide it into one of the hoops. Push it down to the tube's end and tighten it there. Repeat with the two other hoops, placing one in the center and one at the far end. Then tape down the edges of the acetate to seal the tube against leaks. Slide the lower hoop into the notches of your spacers.

AN INSTRUMENT
A DAY

TAKE A GOOD LOOK AROUND:
PRETTY MUCH ANYTHING YOU
SEE CAN MAKE A JOYFUL NOISE.

Every February, Brooklyn-based artist Ranjit Bhatnagar does something a little special: He makes a musical instrument. But not just one, mind you. He makes one *every day of the month,* using common stuff from his kitchen junk drawer and scraps he finds in the natural world. To date, he's made a thimble xylophone that you play with a nail, a piano with Jell-O keys, gongs fashioned of old clock parts, a Coke-can whistle, amplified Christmas lights that make a chiming sound when they blink on and off, a matchbox synthesizer, a hand-cranked Möbius musical device, and rattles out of paulownia pods. The list really does go on and on, because Ranjit's been doing this since 2008, resulting in a grand total of 170 amazing musical instruments and counting. Get excited, Philharmonic—you're about to learn a whole new repertoire.

So does Ranjit plan his daily dabbling in instrument-building? Not so much. "I made it a ground rule that I wouldn't plan in advance," he says. "I didn't want any project to take more than a day, so I didn't want to cheat by thinking ahead." There were some exceptions, especially as Ranjit expanded his own repertoire by picking up 3-D printing and lasercutting skills. "I joined a hackerspace in Brooklyn called NYC Resistor, and using the lasercutter and 3-D printer there means that I plan more, but it's worth it."

HOW RANJIT TINKERS
Messing Around with Sound

Ranjit's annual 28-day tinkering marathon always kicks off with a whistle—which is the first instrument he made, as you'll see. As for his own musical chops, they don't go much beyond playing chopsticks. But through building instruments, Ranjit's gotten in touch with playing, too, rehearsing on them with friends and staging performances.

" It all started when a couple of students from NYU came up with the Thing-a-Day concept, which encouraged people to do one creative thing every day in February. I decided I would go for it, and on the last day of January, I took a workshop with Michelle Rosenberg, who was teaching how to make whistles out of sticks. I thought, 'Why don't I just make a new musical instrument every single day?'

WHERE RANJIT LEARNED THE BASICS: CHECKING OUT OTHER CULTURES' INSTRUMENTS AND READING UP ON EXPERIMENTAL MUSICAL DEVICES

February

EXPERIMENTAL MUSICAL INSTRUMENTS

HANDMADE ELECTRONIC MUSIC
THE ART OF HARDWARE HACKING

Nicolas Collins

" I remember my earliest awareness of sound: As a kid, I would lie on the floor and strum on a spring doorstop. It would make a "dubbullullullull" sound. Also, when I was four or five, I found a ball of string and wrapped it around every object in my bedroom. My parents came in to find a spiderweb going around all the knobs on the dresser, the doorknob, everything. I plucked the strings to make simple tunes.

RANJIT'S FAVORITE LOW-TECH TOOL: A JAPANESE HAND SAW

When I start to make an instrument, I dig through my junk drawer and see what components I have, like magnetic pick-up mics, contact mics, and cheap guitar strings. For the matchbox synth, I had this cute little speaker and some switches, and I thought, 'I could make a tiny, tiny synth with this.' Sometimes I just assemble really basic junk into instruments—like a bottle-cap rattle, or the time I froze all the contents of my junk drawer and recorded the sound of it melting. I also go on walks and pick up wood or nuts that would make cool instruments.

Sometimes I revisit an old idea with a new skill, as in my pine-box violin. It barely worked, and for years I wanted to make a more serious one. I used Google to find violin diagrams and imported them into Adobe Illustrator. Then I traced the outlines of a real violin and redrew them in 8-bit style. When it was done, I uploaded the files to Thingiverse, and other people have downloaded my plans, changed and improved them, and made their own 8-bit violins. It's been inspiring to see their variations.

TINKERER DETAILS

Tinkering tale Some of the projects don't last longer than the day they're made—they fall apart, or I use the stuff for something else. But that's part of why I tinker like this—I'm not making something for the ages. I'm making it to feed myself for the day.

Inspiration Duchamp and John Cage, of course. I wanted to work with the idea of improvisation and extend it beyond musical performance to the creation of the instrument itself.

Where tinkering happens For a few years, I worked in my apartment. If a project was too big to fit on my desk, I'd literally be working in bed.

Fiddle with Contact Mics

Aspiring sound artists, start here: Using a tiny contact microphone, you can amplify and investigate the secret noises in the familiar objects all around you. Tune in to the otherworldly music that's invisible to your naked ears.

GET THE GEEKY STUFF This incredibly fun project requires two must-have cheap electronics: a small battery-powered amplifier and a tiny contact microphone, both of which you can find online or at hobbyists' shops. To hook up the contact mic to the amplifier, first strip the end of the amp's microphone input with wire strippers, revealing its positive and negative wires. Then tape the wires down to the contact mic. If you want to experiment with your contact mic regularly, use a soldering iron to permanently attach the wires to the mic.

DISCOVER HIDDEN SOUNDS Use your amp and contact mic to investigate the intriguing noises lurking inside everyday stuff. How does a cactus sound when you tape the contact mic to it and strum on its pricklies? And what about drinking out of a bottle of water—does amplifying its familiar *glug-glug* change its sound? Take your amp and contact mic on a stroll, and you'll find all sorts of new favorite songs.

SCAVENGE UP SOUNDMAKERS Look around—what objects do you have on hand that you're curious about playing and listening to? You can piece together traditional-style percussive and stringed instruments, such as the cardboard drum and rubber-band harp you see here, or invent your own instruments out of the nearest mint tin and marble. Whatever your musical tastes, tape your contact mic to the object, start playing, and explore the range and rhythms of your amplified creation.

IMPROVISED INSTRUMENTS

If Ranjit were the only artist to tinker up musical instruments, what a quiet world it would be. Here are some other playful noisemaking contraptions.

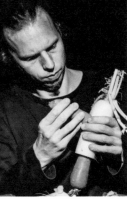

NICK CAVE / SOUNDSUITS
When decked out properly, the human body can be the most rocking instrument of all. The performance artist Nick Cave fashioned these head-to-toe soundmaking suits out of sequins, twigs, dyed hair, vintage noisemakers, plastic buttons, feathers, and loads of other loud, colorful materials.

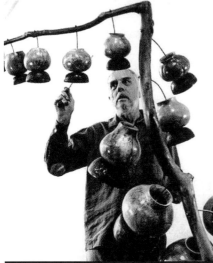

HARRY PARTCH / GOURD TREE
Visionary composer and music theorist Harry Partch rigged Japanese temple bells to gourds, then attached the gourds to a branch of a eucalyptus tree.

THE VEGETABLE ORCHESTRA
This Austrian supergroup doesn't just eat their vegetables—they play them too, crafting everyday carrots, potatoes, pumpkins, peppers, and a variety of leafy greens into hilarious flutes, horns, drums, and stringed instruments. They also incorporate turntables and power tools to give their tunes a little electronic kick.

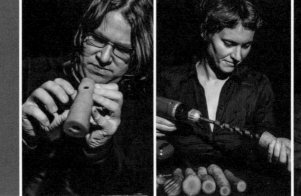

LANDFILL HARMONIC / RECYCLED ORCHESTRA

This heartwarming tinkering tale begins in the Paraguayan village of Cateura, which is built atop a landfill that daily receives 1,500 tons of waste. One day, citizens started turning garbage into instruments, such as the violins and banjo you see here. Now, kids from the community receive musical training and tour the globe.

TIM HAWKINSON / ÜBERORGAN

Step into this installation by Tim Hawkinson, and it's like you're suddenly inside an enormous bagpipe. A dozen huge plastic bags inflate and deflate based on photocells, which scan a Mylar roll of black dashes representing the musical notes of hymns and pop songs.

DIEGO STOCCO / ARCOPHONICO

In his Custom Built Orchestra, Italian sound designer Diego Stocco makes great-sounding music from all sorts of ordinary objects—bansai bushes, fruit trees, you name it. He outfits thimbles, bowheads, and stethoscopes with special microphones, then shakes branches, taps orange slices, and bows boughs for wild-sounding songs.

TECHNOLOGICAL LIFEFORMS

WELCOME TO THE TWILIGHT ZONE—A REALM OF SWELLING, SENTIENT-SEEMING MACHINES.

Walk into an installation by Taiwan-born artist Shih Chieh Huang and you may suddenly feel as if you've voyaged deep into outer space—only, upon closer inspection, that outer space might also be underwater. Vaguely aquatic beasts drift through the dark room, and their colored, illuminated limbs inflate and deflate in a bewilderingly beautiful dance. Some creatures have old-school monitors for faces, and strange footage of eyeballs flickers across their screens. But as alien as Shih Chieh's creations may seem, they aren't from a galaxy far, far away. Instead, he hacks sensors from nightlights and puts them on the screens, where they read the eyeballs' dark and white areas as night and day, switching computer fans and lights on and off and making the plastic lifeforms breathe and shift in hue.

And where did the idea for these pieces come from? "I studied deep-sea bioluminescent organisms—how they move and behave—at the Smithsonian," Shih Chieh says. But before his studies, he stashed fans and LEDs in a plastic bag to see if they could convey life. "It was a little glowing, breathing egg thing," he says. "I wanted to know what it would be like when it grew up." The results are pulsing, pleasing multicellular machines from a place that doesn't exist . . . yet.

HOW SHIH CHIEH TINKERS
Growing Geeky Creatures

Shih Chieh's crucial *aha* moment came late one night when he really started paying attention to the automated nightlight in his hallway. "When I turned the bathroom light on, it turned the nightlight off, so I tried using my body's shadow to control it, too," he says. "From that realization, I started videotaping my eyes and displaying the footage on a monitor in front of the nightlight's sensors." The result? The sensor thought the black of his iris was night and turned the light on, but it clicked back off when the monitor displayed the white of his eye. Mix that uncommon knowledge with an interest in plastic inflatables and off-the-cuff coding chops, and you've got one eye-opening installation.

My first inflatable was made around 2006. I was walking in the park on a jogging trail, and suddenly I saw some garbage bags. I thought, 'What if one of the bags started breathing?' So I installed two cooling fans, a red LED, and a blue LED in a bag so that when it was inhaling it was red and when it was deflating it was blue. I put the whole thing on a timer so that in the morning and at sunset the bag would come 'alive,' startling people passing by. I wanted to make bigger ones that were all grown up, that had divided into more complex organisms.

THE UNREAL COLOR COMES FROM "HIGHLIGHTER JUICE": BROKEN PENS SOAKED IN WATER, THEN POURED INTO PLASTIC BOTTLES USED TO BALANCE THE SCULPTURES.

The tentacles in my pieces are made from huge rolls of painters' plastic. I fold and fuse them into the shapes I want with this weird tool that's supposed to be for sealing potato-chip bags. In each of the cone-shaped bags, there are computer-cooling fans that inflate and deflate the bags. I have to throw in a computer chip to tell the light that the fan is on, and from there it keeps growing organically—that's how I build them. There are motion sensors that detect when you come into the room, and they trigger the fans on one side of the machine to turn on and inflate just those tentacles, which makes the machine move in one direction. I use a relay and a microprocessor to keep all the sensors, lights, and fans in sync.

I modified a bicycle helmet with a video camera so that other people could have their eye activity captured and transported to different creatures, too. It has a pulley system with water bottles that act as ballasts if the helmet is too heavy and isn't positioned correctly on the user's head. There are two photos for users to focus on to control the sensor: one of a kitten in a funny dress that makes their eyes move to activate the sensor, and another of a random family that makes their eyes move to deactivate it.

66 I was looking at creatures that live where the sun stops penetrating the ocean—like the anglerfish, which has this light organ that helps it lure small prey. But it didn't evolve it all on its own: It got some bioluminescent bacteria stuck to its dorsal fin, and the relationship was symbiotic, so the two creatures merged. What I do is similar—I'm not building something completely new, but I'm taking something that already exists and modifying it, changing it, to make something else.

TINKERER DETAILS

First tinkering moment I remember taking apart my brother's BB gun and trying to put it back together before he got home. Of course, there was a missing screw and it didn't work.

Inspiration I like seeing how things function. I have friends who live under a bar, and all the tanks and tubes are downstairs, so you see all the liquid shooting up to the taps. People upstairs drinking beer don't know about the system below supplying their drinks.

Getting unstuck I work on several projects at a time, so when I'm stuck I work on something else. But in the back of my head, I'm still thinking about it.

Next big thing I've started working with a glassmaker in Murano, Italy, redesigning 15th-century Renaissance chandeliers to integrate contemporary materials such as LEDs, computer chips, cooling fans, and plastic.

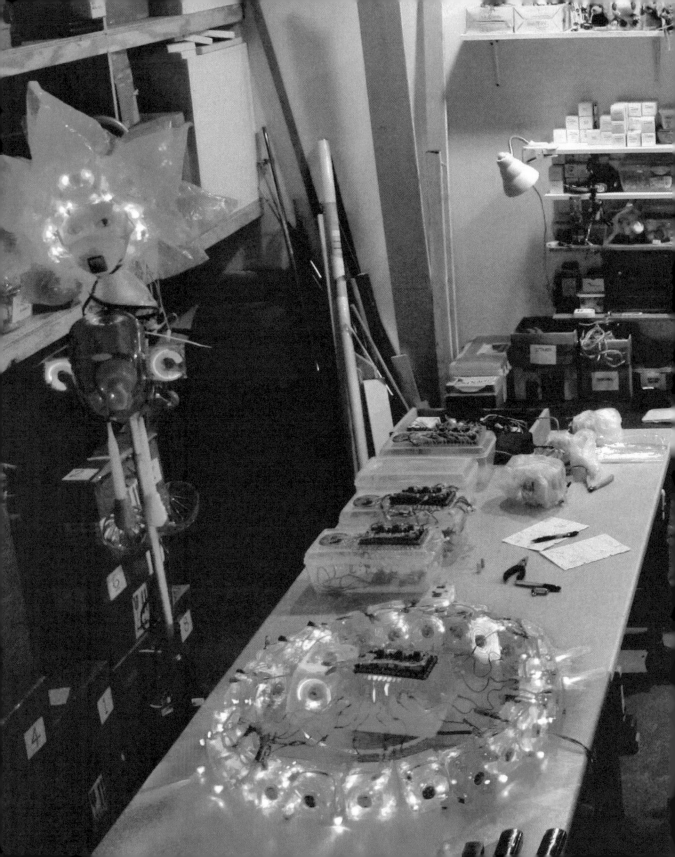

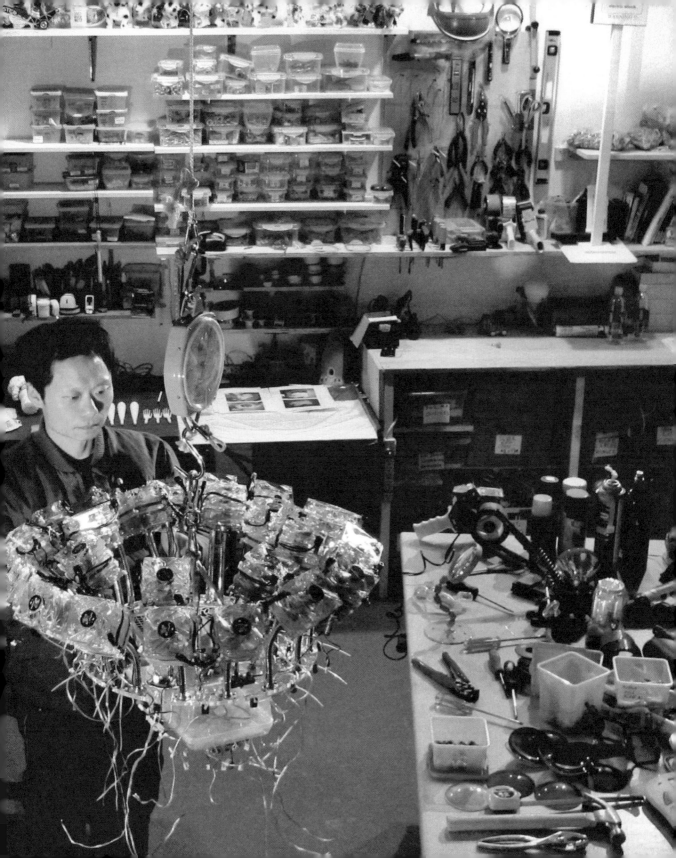

Play with Circuits & Sensors

We like Shih Chieh's installations because he uses familiar materials in a totally unfamiliar way, activating his elaborate, self-inflating plastic sculptures with dead-simple sensors and circuitry. Dabble with these technologies, and you'll soon be triggering your own interactive art pieces.

GATHER COMPONENTS When playing with electronics, the more the merrier. Start off your investigations by visiting a hobbyist shop and picking up motors, on/off switches, speakers, lights, computer-cooling fans, light-sensitive photocells, sound sensors, and batteries. To make circuit building blocks that you can use again and again in different configurations, buy pieces of wood cut in various sizes.

GET BUILDING To make a component modular, hot-glue it to an appropriately sized wooden block. Then create contact points by hammering nails into the block, one near each component's positive or negative lead. Use solder to attach each lead's wires to the nail, making it a conduit for electricity. To hook up, say, a light and a battery pack, attach alligator leads between their positive and negative nails.

WHAT CAN YOU TRIGGER? Now that you have a mini-arsenal of circuit building blocks, think about what you can do with them. We were inspired by Shih Chieh to set a light inside a plastic bag and rig that light to a battery pack and a photo-sensitive cell. When you hit the photocell with a flashlight, you illuminate the other light inside the bag. Spread out your components and look around your home for objects to illuminate, inflate, or make spin— what geeky goodness can you make happen?

TRIGGER MANY COMPONENTS
It's neat that you can make a light flick on, or make a computer-cooling fan spin into action. But to trigger multiple electronic parts at once, try a relay—an electromagnetic switch that allows you to control several circuits with one low-voltage signal. To use it, take two components—for instance, a light and a fan— along with a battery pack, and hook them all to the relay so that their positive leads connect to the relay's positive contacts, and their negative leads attach to its negative contacts.

DATA IN, MAGIC OUT

Shih Chieh's magical sculptures are all cued by stimuli, moving and changing color in response to light. Here are other reactive innovations and installations that feed off real-time activity or data to do their thing—whether it's in the name of engineering, humor, activism, fine art, or play.

JESSICA MATTHEWS & JULIA SILVERMAN / SOCCKET
These aren't decorative soccer-ball lamps: They're real soccer balls that real kids can play with, and they provide light in locales where electricity is scarce. With each roll of a ball, a fist-size gyroscope inside charges a battery. Play for 30 minutes, get three hours of light.

ROBERT WOOD, RADHIKA NAGPAL & GU-YEON WEI / ROBOBEES
The world's tiniest robot has taken flight. Developed at Harvard, each beebot is outfitted with tiny sensors that behave like eyes and ears. The hope is that swarms of them will soon communicate and work together like a real hive.

DOMINIC WILCOX / FINGER-NOSE STYLUS
This comic creation of London product designer Dominic Wilcox allows you to peck away at touch-sensitive screens while your hands are wet. The device is a regular stylus stashed inside a plaster nose.

PHILIP BEESLEY /
SAINT-EXUPÉRY FIELD
Part of Canadian
experimental
architect's Hylozoic
Series, *Saint-
Exupéry Field* is a
sprawling array of
feathered meshwork
meant to mimic
living systems. It's
embedded with
reflexive sensors,
photocells, and
microprocessors that
make the sculpture
twitch in response to
viewers' movements.

JAY SILVER & ERIC ROSENBAUM / MAKEY MAKEY
This crazy-cool product allows you to turn anything into a button. Hook up a MaKey MaKey
board to a computer, then string alligator clips between the device's ports and bananas,
playdough, or graphite drawings to turn them into instruments or video-game controls.

FUSED FASHIONS

THERE'S TURNING LEMONS INTO LEMONADE, AND THEN THERE'S TRANSFORMING EVERYDAY TRASH INTO STUNNING APPAREL.

At this moment in history, the plastic bag enjoys a long life—but it hardly has a respectable biography. Each bag can take up to 1,000 years to decompose, littering streets, inundating landfills, threatening wildlife, and clogging waters. But if all that plastic is here to stay, then someone should put it to good use. Tinkering Studio codirector Karen Wilkinson has done just that, collecting hundreds of bags and plastic scraps and "fusing" them into fabric that she sews into clothing. "I was in Africa," Karen says, "and there were all these plastic bags caught in a fence—someone made the sad joke that they were the national flower. Back home, I had so many bags that I couldn't throw out, and fusing them into fabric seemed a good way to learn to sew and to create rather than consume."

Though fusing may sound like the stuff of nuclear physicists, it's actually a crafting technique in which you iron over plastic sandwiched between parchment paper. The resulting fabric is sturdy and water-resistant, and it glows with a futuristic, industrial sheen. Karen also loves that plastic presents endless chances for personalization: It comes in a rainbow of colors and tons of textures, and retail giants have emblazoned it with graphics and slogans galore.

For Karen, the impetus to make clothing out of trash came from a love of wearable art forms and a desire to learn to sew without buying expensive fabrics. Her work is whimsical yet functional, delicate yet fortified, and her sense of humor shines in her selection of brand names and found objects. Note, for example, the wry yet beautiful irony of a plastic jacket decked out with Naturally and Organic logos, as in *070085* at left, aptly named after the San Francisco city ordinance that banned plastic bags.

And does Karen go around in her pieces? "No, I don't wear them out all the time," she laughs. "It was mainly an exercise in learning to sew. Plus, you kind of feel like you're putting on a shower curtain."

HOW KAREN TINKERS
Prototyping Textiles

Believe it or not, *070085* was Karen's first-ever fabric-fusing project: "I had the attitude of, 'I'm going to try this and see what happens,'" she says. Since then, Karen's crafted tons of clothes and housewares out of stuff that's often discounted as trash. While she certainly uses this all-too-familiar material in a fresh way, Karen began working with it as a starter fabric that would help her master a tool. "That was how we learned a process in art school. We'd do sand casting with aluminum, then work with real bronze. So I started with plastic and moved on to fabric."

EVEN KAREN'S SEWING PATTERNS ARE DIY. TO MAKE THEM, SHE DISASSEMBLES GARMENTS AND TRACES THEIR PARTS.

" My great-grandmother supported our family during the Depression by being a tailor, so sewing was a part of my family history that I wanted to know more about. When my mom gave me her old Elna—a really great sewing machine that a lot of people love—I decided to learn how to sew on it. But all the fabrics that I was looking at were too expensive; I couldn't justify the expense when I was just a beginner. Then, on a visit to the Etsy space in New York, I saw fused plastic for the first time. I realized it looked similar to the nicer fabrics that I'd been drooling over and decided to make my own fabric to learn on.

" I hate plastic bags, but I constantly bring them home—just for a different reason than most people do! I sort bags by color, so white, clearish with a color, clear, and then all the good stuff—colorful placemats and tablecloths, which just kill me to throw away. Some plastic is better for some things than others. Garbage bags have a shiny surface and lay down nicely, bags from The Home Depot have a neat matte feel, and the circles on bubble wrap show through and make for a cool texture. I got really into experimenting with making the plastic delicate in some areas and thick in others that needed support. There are probably six layers in the stiff sections of *70085,* while the back is thinner because it needed darts for flexibility.

TIME IT TAKES TO
FUSE A PLASTIC
TABLECLOTH: 10 MINUTES

TINKERER DETAILS

First tinkering moment My grandfather was a large-animal veterinarian, and one of my first memories is helping him build a table that would lift cows onto their sides so he could trim their hooves. Crazy, but true.

Tinkering strengths Stubbornness and always getting interested in new things.

Inspiration Everything I make at home stems from my work at the Tinkering Studio—from interacting with makers.

Next big thing I'd love to use conductive thread on a full-scale loom.

Tinkering tale For the *Skin Jacket*, I first tried embedding glittery red plastic strands—the idea was it would look like veins. But one day I tried drawing on a clear, shiny dry-cleaner bag and then layering it between opaque bags. That's how the tattoo idea was hatched.

66 I was inspired by Hussein Chalayan, a designer who was using muscle wire to make these architectural dresses that moved and changed shape on their own. I played with this idea by making my bags so that they're totally flat when unzipped, but when you zip them up, they're 3-D shapes.

66 I figured out how to layer plastic for different effects and to make images peek through, like the hand-drawn tattoos on the *Skin Jacket* here. I also like to give the fabric dimension by sandwiching objects between the plastic—little toys, ticket stubs, ribbon—and I have fun making tags, like this Home Depot one. Sometimes I use an LED closure or a glass-bead button from my glassblowing days, like in *070085*.

Fuse Your Own Fabrics

Turns out that all you've needed to craft your own textiles is lurking in your recycling bin: plastic, and lots of it. Once you've got the basics of plastic-fusing down, you can stitch the resulting fabrics into whatever creations you want. Here we show you how to fuse, plus some ideas for a neat tool pouch and lamp.

RAID YOUR PLASTIC RESERVES Look around for good plastic bags and scraps with various palettes, textures, and graphics. Flatten these bags and cut off any seams or handles, then unfold them. It helps to have several layers of bags, as thin stacks can tear a bit under the iron. Layer these plastic pieces so that the elements you want to be most visible are on the outside, and play with creating patterns out of different plastics—this is a great chance to design your own motifs. Sandwich any textures or details that you want to peek through the plastic between the exterior pieces. If your chosen scraps have printed graphics, turn them upside down before ironing them so the ink won't run. Once you've got your stack arranged, add a sheet of parchment paper on the top and bottom.

FIRE UP THE OLD IRON Experiment a bit with your iron settings to see what works for you (we like the rayon setting, but that's just us!). Let the iron heat up, then move it constantly back and forth over the plastic scraps. Flip the stack over and do the other side, too. Test it out: Peel back some of the parchment paper and gingerly touch your fused plastic to make sure it feels smooth and papery thin. (Be careful: It's likely to be pretty hot.) If it's good to go, remove the parchment paper, let it cool, and then get crafting. If not, give it a few more runs with an iron.

LET THERE BE LIGHT For another fun fused-fabric project, create a lampshade. Start by sewing the plastic into a rectangle or square that's large enough to cover your light. (We mounted a bulb to a wooden block, but any lamp base will do—just make sure you use an LED light so it won't overheat and burn your plastic.) Next, cut wooden skewers to the length of the box's short sides. To make the fabric rigid enough to stand upright, put the skewers along the box's top edges, then fold the plastic over the skewers and sew it down to create a hem. Place it over the lamp, hit the on switch, and see the world get a little brighter and a little closer to trash-free.

MAKE SOMETHING! Now that you've got your fused plastic, it's time to make a ton of stuff with it. You can start with a simple tool bag or cutlery carrier: Fold a rectangle of plastic in half and use a sewing machine to create compartments and a hem. (Don't have a sewing machine? Fused plastic is tough to sew by hand, so punch holes in the sides of your pouch or bag and thread yarn through them to make a hem, then tie off the ends.) You can also add buttons, snap closures, or other fasteners that you have handy.

JEREMY MAYER / BUST V (GRANDFATHER)
Oakland-based tinkerer Jeremy Mayer disassembles typewriters and pieces their parts into full-scale, anatomically correct human figures. Miraculously, he doesn't use anything in his assemblages that didn't come from the typewriters themselves.

TRASH ART
One big-time tenet of tinkering is to use materials that are easy to find, and trash is about as available as it gets. Karen's low-brow-yet-deluxe plastic garments are just one of many garbage art possibilities—there's no way you'll want to throw these fanciful end products away.

AL WADZINSKI / FISH
A toaster head, coffee-creamer-bottle eyes, and a mini-globe body—these are just some of the found objects Al Wadzinski uses to make his clever menagerie. Here a fishing reel comically makes up the body of a trout.

JOSHUA ALLEN HARRIS / AIR BEAR
These inflatable bears are made of plastic bags and tethered to subway gratings in New York City. When air from a vent rushes into them, they come to life, making passersby stop in their tracks.

JEAN-LUC CORNEC / TELEPHONE SHEEP
Swiss artist Jean-Luc Cornec has lovingly wired hundreds of discarded rotary phones into a flock of amicable sheep, complete with quizzical headset faces and wool made of twisted phone cords.

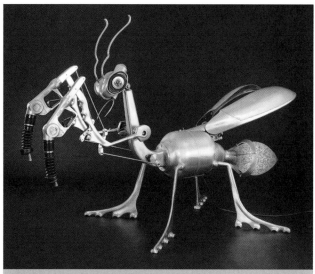

NEMO GOULD / PRAYING MANTIS
Inspired by his residency at the San Francisco dump's Recology Program, Nemo welded together this praying mantis from salvaged scrap metal. When turned on, its wings spread, its forelimbs paw the air, and its hind section glows.

VIK MUNIZ / MARAT (SEBASTIÃO) FROM PICTURES OF GARBAGE
Brazil-based photographer Vik Muniz arranges garbage from São Paulo's notorious dump into recognizable compositions, like this homage to Jacques-Louis David's 1793 painting, *The Death of Murat*. Watch the documentary *Wasteland* to get a glimpse of his process.

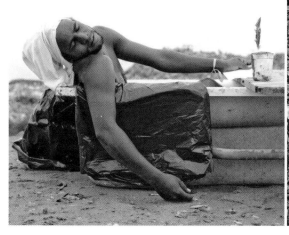

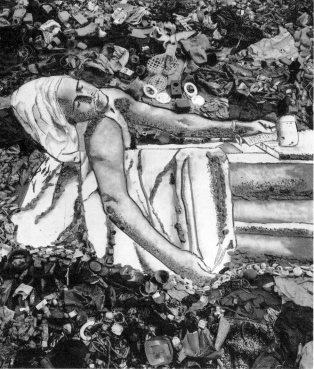

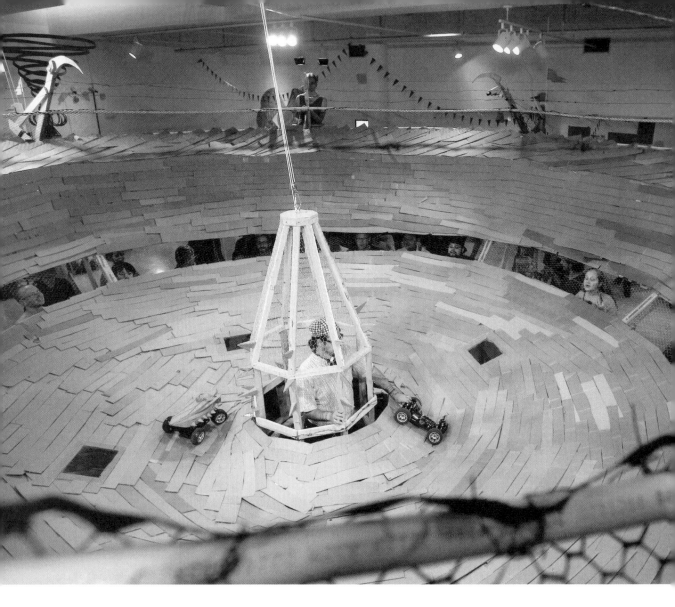

CARDBOARD SUPERTRACK

RACECAR FANS, START YOUR ENGINES: THE CARDBOARD INSTITUTE OF TECHNOLOGY WANTS YOU TO JOIN IN AT THEIR DEMOLITION DERBY.

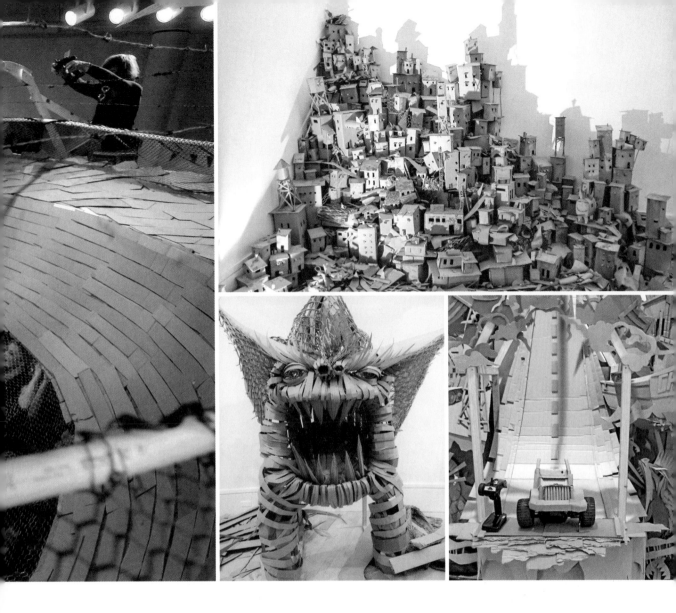

After weeks of late-night sculpting and panic-inducing hot-glue shortages, things were about to get underway at the Bedford Gallery in Northern California. Four souped-up, cardboard-bedecked remote-control cars were rip-roaring and ready to go, positioned on a huge racetrack made of cardboard—complete with a pit stop, a betting booth, an announcer's stand, and individualized parking spots for each car. A crowd had formed, and as Cardboard Institute of Technology member Joel Stockdill began to sing a special cardboard-themed national anthem, you could tell that something rad was about to take place.

And that's true of all CIT's immersive, interactive cardboard environments. An apocalyse-embracing, power-to-the-people artists' collective, CIT builds vital, imaginative worlds out of scavenged stuff, then asks visitors to "activate" their exhibits with no-holds-barred participation. "There's a punk-rock side to this," says Joshua Short, one of CIT's founders. "You have to show up, or you miss the experience."

Constructing Disposable Multiverses

When you look at CIT's *Supertrack,* you're seeing about 600 pounds (272 kg) of cardboard and 30 pounds (13.5 kg) of hot glue, plus the blood, sweat, and tears of its makers: Joshua Short, Scott Falkowski, Michael Murnane, Robin Frohardt, Caryl Kientz, Jesse Wilson, and Joel Stockdill. You're also taking in a tinkering process that's equally collaborative and autonomous, and a politically fueled, chaotic-by-design experience that—as CIT likes to say—"brings the thunder."

"Cardboard is such an abundant medium—it's on every street corner. And if you work with the corrugation, it can have real structural integrity. These projects also take tons of hot glue—we buy it in bulk in these 20-pound [9-kg] boxes. When we work together to do an environment like the *Supertrack,* we have to plan stuff out to cover the space, so we do sketches. Other times we work in tandem and around each other so we feed off each other's ideas, but we're still in our own bubbles. Since the pieces are all cardboard, it makes a universal color scheme and medium. —Jesse Wilson

SHANTYTOWNS: TINY HOUSES THAT ALWAYS POP UP IN CIT'S WORK

"We all have a love of mystical, mythical storytelling with a punk-rock edge. So for the *Supertrack,* we decided that there would be four cars, and that each person would be in charge of coming up with a mythology for each. We didn't want to use any NASCAR tropes, like sponsorships. We wanted to do something more sublime or metaphysical. I'm interested in nature reclaiming the environment, so I came up with a mythological creature. Jesse's universe was run by insects, so she made a car that was a giant cockroach. Joel was really into ideas about alternative power, so he made a Tesla-themed car. And Joshua built a gas-guzzling big rig to battle big oil. —Michael Murnane

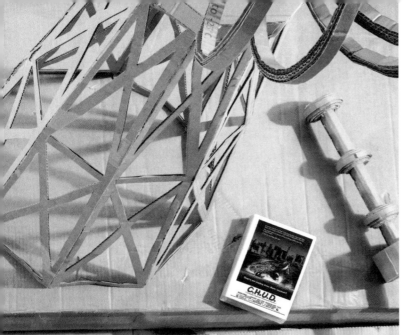

CIT ALSO MADE SYMBOLS OF CONSUMER CULTURE THAT VISITORS WOULD CRASH CARS INTO.

" We made altars for all the cars that functioned as portals for the cars' mythologies and microworlds, like the oil rig here. There was also a pick and pull—a toy-truck junkyard where you could grab parts—and a viewing area with monitors that showed live footage from cameras mounted on the cars. We often reference *C.H.U.D.*, a movie about these monsters that rise out of nuclear waste— it's a terrible movie, but the storytelling is great. Our work's themes and stories similarly rise out of the oil industry's excesses. —Joshua Short

" During the race, we had to referee and repair cars when they broke, so we all wore matching jumpsuits, like mechanics in a NASCAR pit stop. Joshua was the announcer, the Texas oil man. Jesse was a bookie— she was slinging deals and organizing races. Michael was rallying the crowd. I wrote a cardboard-themed version of the national anthem, so I belted it out and kicked off the event. —Joel Stockdill

TINKERER DETAILS

Where tinkering happens In a huge shared warehouse space on Treasure Island in the San Francisco Bay.

Favorite material Cardboard, obviously. It's the most basic thing. Everyone has a relationship to it—everything gets transported in cardboard boxes. You can't live without it. Just like oil.

Inspiration Satire, improv, and sticking it to the man. We also draw on game design to explore our society's gladiator and battle rituals—like the *Supertrack*, which is a death race where players drive cars and bet on them.

Tinkering tale We recycle a lot from earlier installations. Joel had used plywood ribs to make a Viking death ship. We put them in a circle and they made a perfect shape for the velodrome.

HOW YOU CAN TINKER
Install a Cardboard City

CIT sets up large-scale cardboard installations of all kinds—from pirate ships to mythological galaxies—but one element that seems to recur again and again is what they call a shantytown: a cluster of sloppily constructed, endearing cardboard houses that's a respectful nod to the proletariat. It's a perfect way to get started with cardboard construction, and you can scale them up or down and give them whatever details you want.

MAKE A BASIC BOX CIT encourages you not to overthink this: The more slapped together your structure, the more honest and power-to-the-people it will be. Start with a strip of cardboard and score its sides to create a box shape. Before hot-gluing it together, use a box cutter to make holes for windows and doors.

RAISING A ROOF Fire up your hot-glue gun and close up your box, then cut cardboard into a roof shape and glue it to the box's walls at a sloping angle. For a cool corrugated-metal effect, peel back the paper on the roof to reveal the ridged, reinforcing cardboard strips below. You can repurpose the paper topsheet by rolling it into a chimney.

BUILD BIGGER Now try your hand at crafting larger, more immersive environments out of cardboard. Many of the same construction principles apply, but tinker around with scaffolding and supports so that your structure stands tall and lasts—at least until recycling day rolls around.

ADD AN ANNEX (OR TWO) Once you've got a simple one-room shanty, use the same basic technique to add on smaller wings, porches, decks, and the like. Keep on building cardboard houses of various sizes, arranging them in a chockablock configuration for an authentic urban feel. Play with different types of structures, too, like treehouses or outhouses.

CORRUGATED CREATIONS

Resilient, easy to manipulate, and plain inescapable, cardboard gets almost as much play as a craft supply as it does as a shipping material. And the resulting artworks are as diverse as the goods that they once packaged.

CAINE MONROE / CAINE'S ARCADE
This 9-year-old charmed the worldwide web with a fully functioning cardboard arcade built inside his dad's auto-repair shop.

ANN WEBER / STRANGE FRUIT
First trained in ceramics, Ann Weber turned to cardboard to craft large-scale yet lightweight forms. She weaves strips into cylinders, circles, and orbs, and preserves them with shellac or paint.

ANASTASSIA ELIAS / ROULEURS
French artist Anastassia Elias makes miniature dioramas out of the familiar toilet-paper tube, using tweezers to position cut-out figures inside this household staple. To date, she's crafted about 50 dioramas, including wilderness vistas, glimpses of urban life, and famous scenes in cinema.

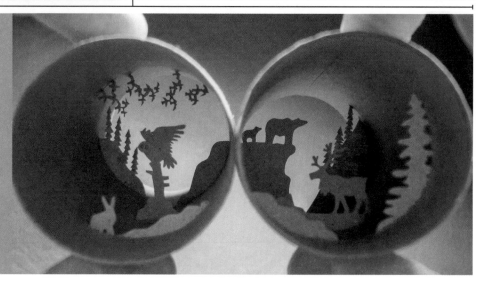

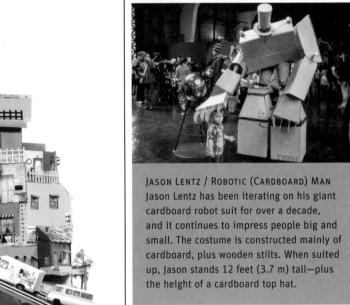

JASON LENTZ / ROBOTIC (CARDBOARD) MAN
Jason Lentz has been iterating on his giant
cardboard robot suit for over a decade,
and it continues to impress people big and
small. The costume is constructed mainly of
cardboard, plus wooden stilts. When suited
up, Jason stands 12 feet (3.7 m) tall—plus
the height of a cardboard top hat.

ANA SERRANO / CARTONLANDIA
LA-based Mexican-American
artist Ana Serrano crafted this
5-foot- (1.5-m-) tall assemblage
of homes using cardboard and
images that she took herself or
found on the web. Look closely
and you may spot a cardboard
resident or two.

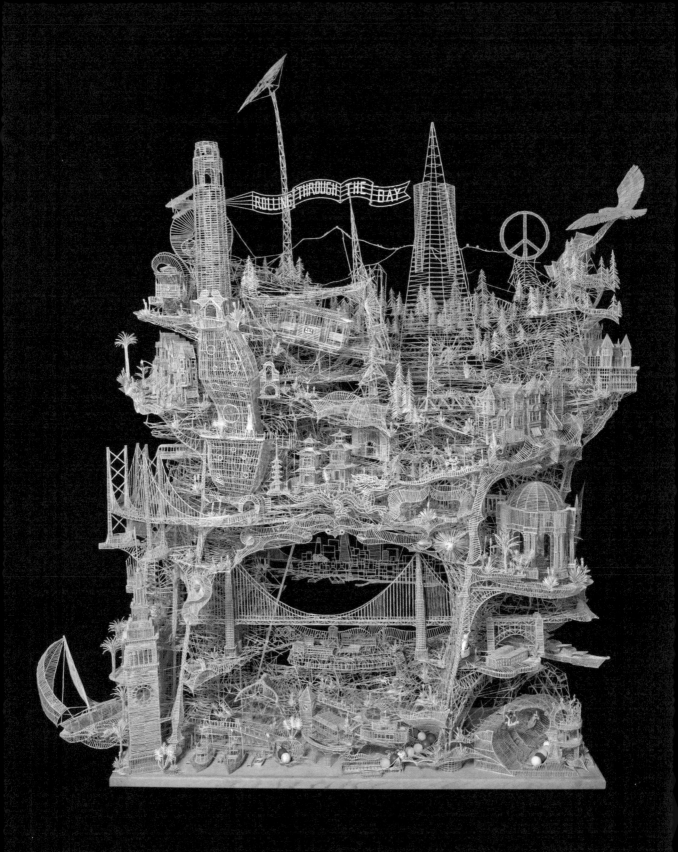

ROLLING THROUGH THE BAY

SCOTT WEAVER'S HUGE TOOTHPICK SCULPTURE OF SAN FRANCISCO MAY BE THE GREATEST VALENTINE TO A CITY EVER MADE.

Scott Weaver is a bit of a marvel. A marathoner, a champion Frisbee player, a swimmer who's paddled all the way back from Alcatraz six times, and a guy who annually rigs up a display of Christmas lights spectacular enough to land him on *Good Morning America* twice, Scott is larger than life—brimming with boundless, almost dizzying energy and a generosity of spirit that's apparent from the moment you meet him.

He's also the premier toothpick artist in the world. His piece *Rolling Through the Bay* is an elaborate ball racetrack made of more than 100,000 toothpicks, all obsessively clipped and glued into an homage to his beloved hometown. There are many paths through Scott's version of the city, all twisting and turning around geographic and personal landmarks. There's a Ferry Building, with three clock faces displaying the times that Scott, his mother, and his wife were born. There's a gymnasium that Scott's grandfather owned

and a toll booth that shows the time his son was born. There's also the TransAmerica building—with a profile of Scott's face gazing up into the sky—and the Giants' World Series Trophy, a surfer at Ocean Beach, the Palace of Fine Arts (with a heart inside as a nod to Tony Bennett's "I Left My Heart in San Francisco"), the gates of Chinatown, Lombard Street, Coit Tower, and Mount Tamalpais. In fact, a ball running through this 9-foot- (2.75-m-) tall, 7-foot (2-m-) wide sculpture likely sees more of San Francisco in 30 seconds than most tourists do in a week.

So how long did it take Scott to craft it? A mind-boggling 38 years. "This is the first year that I felt like I finished it," Scott says. "I included all the things from my life that I wanted." Along the way, he developed a fascinating set of tools (toenail clippers have never been put to more inventive use, as you'll see) and a joyful focus that's tinkering in its most blissful form.

HOW SCOTT TINKERS
Building Toothpick Town

Scott created his first toothpick sculpture in elementary school and swiftly began work on the immense ode to San Francisco for which he's now famous. But where'd he find the time, you ask? A knee injury benched him from working for six months, and he camped out in his living room to finish the work of a lifetime. Here's how.

> Toenail clippers are my tool of tools! I most likely started using them for my toothpick art when I was a kid. They were probably the only thing my mom had around! Scissors, wire cutters, pruning shears—they torque or splinter the toothpicks, but the clippers make such a clean snap. I put skateboard tape on them for a better grip.

SCOTT'S FAVORITE TOOTHPICK BRANDS

THESE TOOTHPICKS COME FROM ALL OVER, INCLUDING MOUNT KILIMANJARO, KENYA, AND BALI.

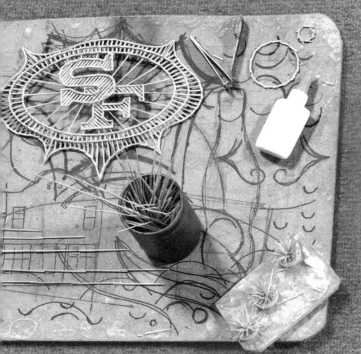

> Basically this is my own way of sketching, but with toothpicks. Anything I can draw I can make out of a toothpick. See the Coke bottle outline on the tray? I used it to create the huge bottle sculpture at the Giants' stadium in *Rolling Through the Bay*. I also fold cardboard and use it as a form for shapes, and I use hairclips to secure stuff while it dries.

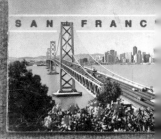

> I'll watch TV— basketball games or whatever— and make what I call 'supplies.' I dip a toothpick in glue and touch it to another one to make a straight pole. I let them dry for an hour and use them in scaffolding. You see the lines on the tray? I'll use them as a guide and just sit there and make a full tray—it's like baking.

SCOTT LOOKED AT PICTURES OF THE CITY TO GET ITS SIGHTS JUST RIGHT.

I made a wearable toothpick sculpture using a bicycle helmet as a mold. The clock on the Ferry Building has 27 pieces of toothpick in it, and each pillar in the Palace of Fine Arts has 50 toothpick pieces in it. I used leftover bits to make little park benches and trashcans.

TINKERER DETAILS

First tinkering moment I had a crush on my fourth-grade teacher, and she had us make hearts out of toothpicks. I wanted to impress her, so I went home and I built an abstract toothpick sculpture with a track for a ball to run through it.

"Real" job I've worked at Lucky Supermarkets for 27 years. It lets me use my free time to make art.

Favorite tool Toenail clippers, hands down. My favorite pair is 30 years old.

Next big thing I'm thinking of using toothpicks to make a life-size self-portrait of myself doing a chest roll with a Frisbee.

Tinkering tale Chloe, my Great Dane, once destroyed the Ghirardelli Square section with her tail. I called the event Dogzilla. That's why the sculpture has a secret stash of emergency Elmer's.

When I'm inserting a new feature, I scaffold it with toothpicks, then I cut them away so people can see into an area. To make the sculpture stronger, I designed these infrastructural supports that I call Weaver Webbing—it's just toothpicks in a lattice or grid, but some of it has lasted 37 years. I ended up putting a few pieces of dowel in the sculpture to prevent sinkage, because if the tracks shift by even one or two degrees, the balls get stuck. It's all trial and error, and that's the fun of it. I can pick and choose where I want the ball to roll—I'm always altering the path in order to incorporate a new piece of the city.

Rig Up a Marble Machine

Get inspired by Scott's immense, sprawling ball run and turn your living room into an analog arcade! It's not just a crazy good time for all involved—making a marble machine lets you use your hands to learn about gravity, momentum, and other wonders of the physical world. It also changes the way you see ordinary wood scraps, pipes, and tubes.

HARNESS YOUR HARDWARE You'll find almost everything you need in a trip to the hardware store. Grab two sheets of Peg-Board with ¼-inch (6-mm) holes, one 1½-inch- (3.8-cm-) thick pine spacer to go between the Peg-Board sheets, and two pine feet—these are specially shaped stands that you'll screw into your Peg-Board to keep it upright, so ask a hardware store to cut some like you see here. You'll also need wood glue, screws and a screwdriver, masking tape, and clothespins. Don't forget the goodies that will become your pegs, tracks, and bumpers: ¼-inch (6-mm) dowels, pine board, and cove molding (decorative trim for windows and ceilings that has a slight arch), all cut into pieces of varying lengths. Oh, and snag some marbles.

SCAVENGING KEY ELEMENTS Rifle through your house—especially the recycle bin—for items like derders (cardboard toilet-paper tubes), pipes, funnels, berry baskets, toy parts, and cooking tools. Anything that can catch, support, or propel a marble is fair game. If you're keen to explore how motorized components can affect your ball run, grab handheld fans or slow-moving toy parts. You can also activate electronics: Position a strip of foil on your track, and use alligator clips to attach a battery pack and an electronic component that will play some role in your ball run. When a metal marble rolls over the foil, it'll trip the switch and make the electronic component do its thing.

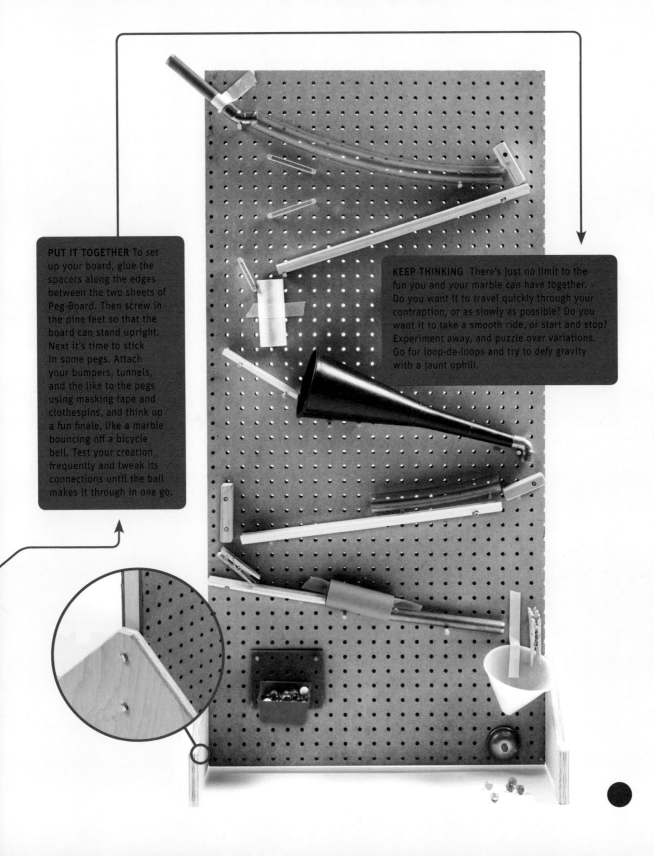

PUT IT TOGETHER To set up your board, glue the spacers along the edges between the two sheets of Peg-Board. Then screw in the pine feet so that the board can stand upright. Next it's time to stick in some pegs. Attach your bumpers, tunnels, and the like to the pegs using masking tape and clothespins, and think up a fun finale, like a marble bouncing off a bicycle bell. Test your creation frequently and tweak its connections until the ball makes it through in one go.

KEEP THINKING There's just no limit to the fun you and your marble can have together. Do you want it to travel quickly through your contraption, or as slowly as possible? Do you want it to take a smooth ride, or start and stop? Experiment away, and puzzle over variations. Go for loop-de-loops and try to defy gravity with a jaunt uphill.

MESMERIZING BALL RUNS

Rolling Through the Bay is totally one of a kind, but Scott's not the only tinkerer who loves a good ball run. Here are some other impressively inventive machines and race-tracks that give balls—or, in one case, toy cars—the ride of their lives.

GEORGE RHOADS / URIDICE

The most celebrated ball-machine builder in the United States, George Rhoads creates machines that dissolve the boundary between work and play, seeking to make machines more friendly and less ominously industrial. His kinetic sculptures often include sound, such as percussion and chimes.

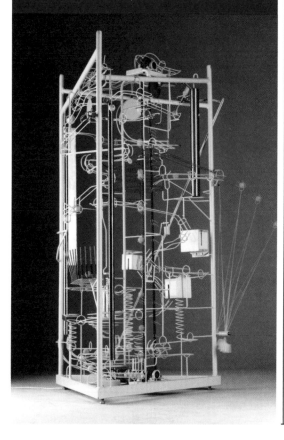

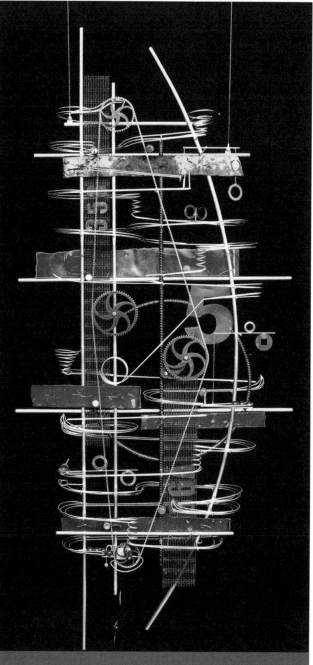

JEFFREY ZACHMANN / KINETIC SCULPTURE #639

A potter by trade, Jeffrey crafts his ball runs by welding, bolting, and screwing stainless-steel rods, found metal, and wire into creations that are as aesthetically pleasing when static as they are in motion.

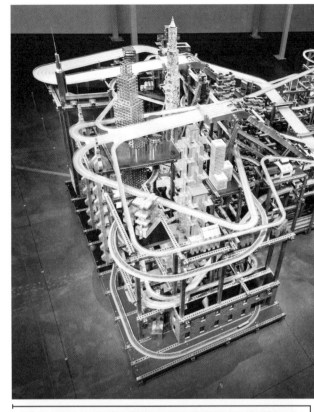

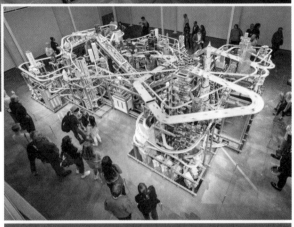

CHRIS BURDEN / METROPOLIS II
This kinetic supersculpture is a playground for 1,100 toy cars, each of which clocks in at 240 scale miles per hour (386 scale km/h). Visitors can walk among its 18 roads to feel immersed in a thrumming and vital yet tiny city.

DRILL INC. / TOUCH WOOD
Interactive-video gurus Drill Inc. built this xylophone-like track through a forest, then videotaped a ball as it ran over the wooden planks, making a delightful *ping!* sound with each key and starting other balls on their own charming, chiming courses. The video was created as an advertisement for NTT DoCoMo, a Japanese cellphone manufacturer.

TAPIGAMI
TAPE MAY BE SIMPLE, BUT WHAT DANNY SCHEIBLE BUILDS WITH IT IS FAR FROM SIMPLISTIC.

The ubiquity of tape can't really be overstated. Painters use it. Plumbers use it. The friendly gift-wrapping people at the mall use it. Annually, millions of tape rolls get consumed in the United States alone. And chances are, Sacramento artist Danny Scheible is buying up a surprising amount of it. His obsession with the sticky stuff began with a desire to work with what he calls "universals": everyday materials that are already in people's homes and that don't require tools to make into art. Cable ties, binder clips, and tape—especially tape—stand out as cheap items that are made inherently to connect, allowing for a process that's additive. Once you've got a few fixed together, there's no limit to what you can do.

Eight years after Danny first experimented with tape, limits are what he's yet to run into: He's crafted a sprawling mini-metropolis out of basic tape tubes, blocks, and cones that he collectively refers to as *Tapigami*. It's definitely a sight to see—there's a downtown of towering skyscrapers, a hill covered with boxy suburban homes, green fields popping with curious flowers, and an ocean of inventive sea life.

But unlike most cities, Danny's tape town is mobile. He packs it up in Tupperware containers and travels around, installing it in museums and galleries. Every time he sets it up, it's different—in fact, he often asks museum visitors to arrange it themselves. "I don't want people to go to the museum to see the art," he says. "I want them to go and *make* the art."

HOW DANNY TINKERS
Sticking a World Together

Danny's work builds on several of our tinkering tenets: He uses a familiar material in an unfamiliar way, and he's constantly iterating on his ideas. Plus, his artistic approach is as communal as the city, his chosen subject matter. "The reason I'm here," he says, "is to share how to do this and to make other people realize that they can take ownership over culture. So it's a collective sculpture, a social sculpture."

❝ My favorite kind of masking tape is very rigid, whereas lots of other tapes are more like cloth—all of my sculptures are made out of tape tubes, and with cloth tape you can roll it for only so long before it droops. Masking tape is so thin, though, that you can just keep rolling it, and it has real structural strength. Sometimes I'll buy from various hardware stores so the whole sculpture isn't uniform, because every tape batch is different. Every once in a while, I'll spend a whole day searching the Internet, just like, 'Where's the new tape?' There's a tape renaissance going on—there are more kinds of it on the market than ever before.

Hobbes

Leviathan

with selected variants from the Latin edition of 1668

Edited, with introduction, by
Edwin Curley

DANNY'S HIGH-BROW
INSPIRATION: HOBBES, WHO
SAID THAT SOCIETIES ARE
LIVING ORGANISMS

❝ When I first started, I sat down to see what I could build out of tape, and after a few days I thought, 'What if I just focus on rolling a tube?' The first real thing I made was a centaur, and then I started making cells because they're the most basic thing that's alive. The city came next because it's the most complicated living thing I could think of making. Since then, I've made a bunch of creatures—like the Tapigami MakerBot, a miniature of a life-size sculpture I made for Maker Faire, and this little creature on wheels who's hooked on car culture. It's part of a series of characters that consume a certain societal norm.

> I store the city in Tupperware boxes. When I open them up, the tape blocks fall out in huge cubes. I have about 50 boxes stored in my basement, all stacked up. Some sections I cover in acrylic so they last longer. I also give pieces that are getting old to artists to mural over with their own art. The idea is, 'Oh, you can paint? Well, paint this, then you become a part of it.' They give me a new perspective, help me get unstuck, and keep me innovating.

> I don't have any hair on my left arm—I shave it because I got sick of it getting pulled out when I wear pieces of the tape city. That's how I learn how to make things—by going out covered in tape and asking people, 'Hey, can I make you something?' It forces me to interact with the material in a whole new way.

DANNY TRASHES EVERY 10TH TUBE HE MAKES JUST TO REMIND HIMSELF OF THE IMPORTANCE OF LETTING THINGS GO.

TINKERER DETAILS

Tinkering strength I'm very rigorous, determined, and disciplined. And rolling tape tubes is pretty much how I meditate—I do this for 10 hours a day. I get to a point when I'm not really thinking, and that's when my mind wanders and runs into new ideas.

Favorite tool I don't use tools—I want to use my hands to make everything.

Where tinkering happens I make tape sculptures everywhere. For some reason, we think that art exists in studios, that it's not an everyday occurrence or part of our daily lives—but it should be!

Next big thing I'm building a huge Garden of Eden. When you're a sculptor, making life-size figures and environments out of your material means you've reached a new level.

Try Some Tapigami

Danny's tape city may be a sprawling metropolitan area, but it's all made up of one basic building block: a simple tube of tape, rolled with its sticky side facing out. After you make that, you can make pretty much anything, such as the towers, cones, boxes, blossoms, and oceanlike texture here.

MAKING A BASIC TUBE For starters, grab a roll of tape and pull the tape out with its sticky side facing away from you. Fix the tape's top corner to one finger, then start rolling the corner toward you and diagonally across the tape, making a long tube. Once it's long enough for whatever you're building, cut it off and wrap the excess tape around the tube.

TWIST UP A TOWER Flatten your tape tube by pressing it between your thumb and index finger, then wrap it so that each coil is level with the one before it. Do this until your tower's top is the circumference that you'd like, then start wrapping the tape so that each coil is a little lower than the one above it.

NOW TRY A CONE Flatten the end of your prerolled tape tube between your fingers. Pinch the end of the tube at an angle to make the tippy top of your cone, then start wrapping the tape around the tip, flattening as you go and creating height by making each wrap lower.

THE BLOSSOM Yep, even this flower is made up of the simple tape tube. Start with a roll of tape and cut it into sections, snipping off one end of each section at an angle to create a petal shape. Roll a tube for a stem, then place your petals sticky side down on the stem in a flower shape.

FOLD A BOX Flatten your tube (Danny taught us to roll over it with a roll of tape), then bend back a section—this will be the first tape "plank" in your box's floor. Keep folding the tape, bending sections of the same length back so that they slightly overlap the ones before, until you have the desired box bottom. Then wrap the rest of the tube around the floor to form the box's sides, making them as high as you like.

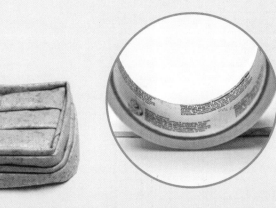

BUILDING A SEA To create an ocean, make tons of tape tubes and stick them together all side by side in a clump. Then take your scissors and cut across the clump, slicing off a layer of tape tubes. Continue slicing off layers until the clump is gone, then arrange the layers side by side in a wide expanse.

TAPE HELPS

. . . is something we say all the time in the Tinkering Studio, and Danny's total-tape artworks certainly demonstrate that it's true. Here are more examples of this medium's marvelous possibilities.

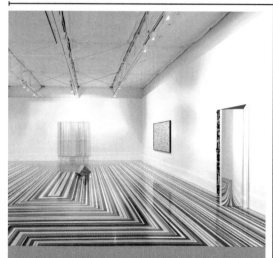

JIM LAMBIE / TOUCH ZOBOP
This Scottish installation artist arranges vinyl tape into pulsing, disorienting patterns that emphasize architectural details and wrap around furniture and sculptures. His pieces last only as long as the exhibit itself, since they're built around a gallery's specific structure.

SCOTCH TAPE & POLARIZING FILTERS
Here's a magic trick for you: Pieces of Scotch packaging tape arranged between two polarizing filters will create a double-sided yet transparent array of geometric colors.

PATRICK NAGATANI / TAPESTRIES
New Mexico–based photographer Patrick Nagatani meticulously layers stripes of variously colored masking tape over found photographs and illustrations, tearing and cutting the tape for a brushstroke effect.

MARK JENKINS & SANDRA FERNANDEZ /
STORKER PROJECT
These artists make human forms out of clear tape and humorously embed them in real urban settings for delightful, made-you-look installations.

WASHI TAPE

Crafters, rejoice: Patterned tape is here, and it's not likely to disappear from the market anytime soon. This strong, functional tape originated in Japan and is made out of natural fibers. Best of all, it comes in pretty much any pattern you can think of.

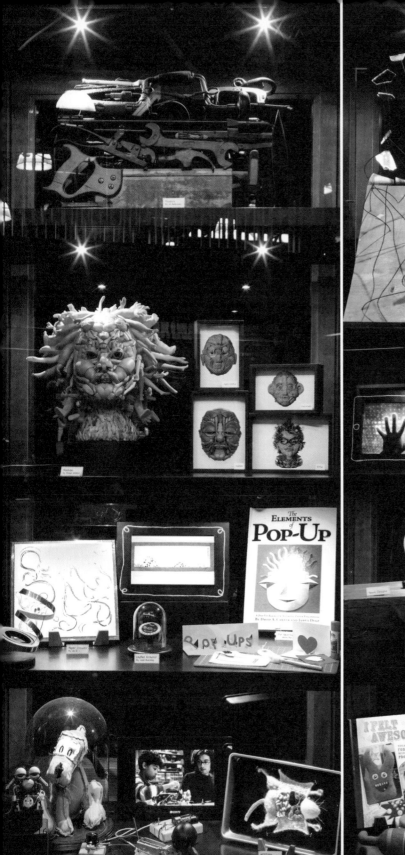
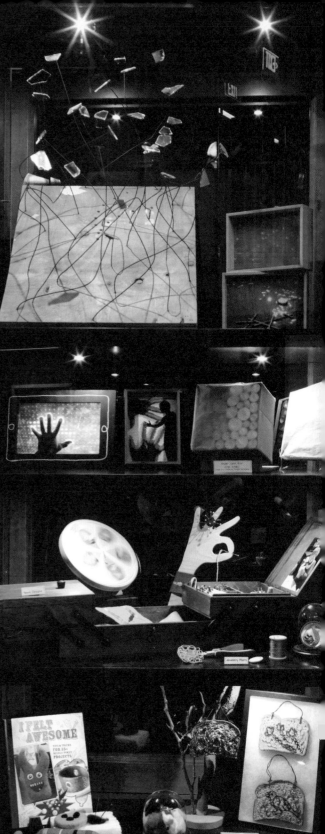

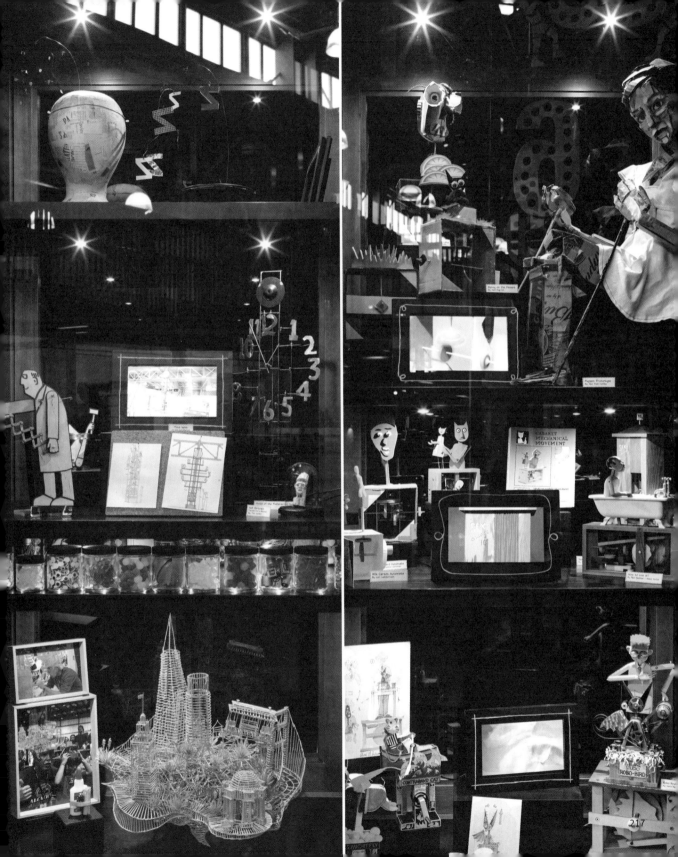

INDEX

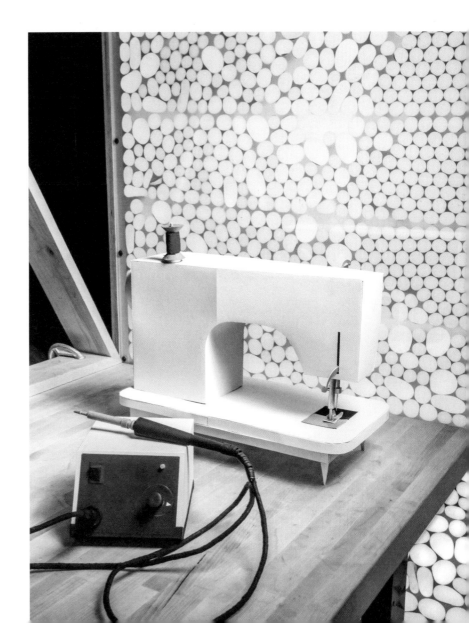

IMAGE CREDITS

All commissioned photography by John Lee/Artmix, except where noted below. All prop styling by Mallory Ullman.

All additional images are courtesy and copyright of the artists, with additional crediting information below:

pp. 14–15: Shutterstock Images pp. 20–21: All images © Exploratorium pp. 26–27, main and lower right: Commissioned photography by Laura Flippen p. 27, upper right: Meredith Scheff-King p. 27 (photograph of Stonehenge): Shutterstock Images p. 28 (photographs of apples): Shutterstock Images p. 31, bottom right: Sarah Phelps p. 35, top right: Danny Wilson p. 38, upper right: Hunter Mann p. 38, bottom right: Chris Gerty p. 39, top right: Qian Qin p. 39, bottom right: Gayle Laird (© Exploratorium) p. 42 (Helix nebula photograph): courtesy of NASA/JPL-Caltech / K. Su (University of Arizona) p. 43, upper right: Christine Chin p. 47, top left: Nancy Rodger (© Exploratorium) pp. 48–49: Luigi Anzivino p. 51, top right: Amy Snyder (© Exploratorium) p. 56, top: Walter Kitundu and Luigi Anzivino p. 56, bottom: Trey Ratcliff for Stuck in Customs p. 57, top left: Amy Snyder (© Exploratorium) p. 57, top middle: Philip Witham p. 61, top right: June Barnard p. 62, top left: Phil Yip for MonkeyLectric p. 62, top right: Ryo Ishihara p. 62, bottom: Ben Davis for The Bay Lights p. 63, top left: Gjon Mili, Time & Life Pictures / Getty Images p. 63, bottom: Tobias Baumgartner, Marcus Brandenburger, Tom Kamphans, Alexander Kroeller, and Christiane Schmidt of the IBR Algorithm Group and Braunschweig University of Technology p. 65 (lightpainting photographs): © Exploratorium p. 69, top right: Gregory Hayes (© Make Magazine) p. 72, top left and bottom: Gigi Giannella p. 73, top right: Matt Johnson p. 73, middle: Oskar Landi for littleBits p. 77, top right: Bénédicte Enou p. 80, top left: Cullen Stephenson p. 80, top right: Peter Engel (Wikicommons) p. 80, bottom: Robert Wilkinson p. 81, top and middle left: Rob McCoy p. 81, top right: John Polak p. 83: Jeannie Choe p. 85, top right: Lisa Wiseman p. 89, top and middle left: firstVIEW p. 89, top middle and right: Michael Sun p. 89, bottom right: Johannes Helje p. 90: Sayaka Ito (featured in Bellevue Arts Museum's BAM Biennial 2012: High Fiber Diet) p. 93, top right: Marlo Miyashiro pp. 94–95: Moxie Lieberman p. 98: Laura Splan, 2004, freestanding computerized machine-embroidered lace p. 99, top: Stephen Miller p. 99, bottom right: Miriam Lehnert p. 99, left: Masaki Koizumi p. 103, top and bottom right: William Mack p. 105, top left and right: Hans Vroege p. 111, top right: Chehalis Hegner p. 114, bottom left: © 2013 Calder Foundation, New York / Artists Rights Society (ARS), New York p. 114, bottom right: Myung Wook Huh p. 114, bottom left: George Hoyningen-Huéna, Condé Nast Archive / Corbis p. 115, bottom: Petronella Ytsma p. 122, top left: Museum Tinguely, Basel, courtesy of Galerie Martin Janda, Vienna p. 123, top: © 2013 Eames Office, LLC p. 123, bottom right: Jaime Pellisier p. 125: Peter Lee p. 131, top left: Franck Stoger p. 131, top right: Samuel Coendet and Lea Gerber

p. 135, upper right: Photobooth at Musée Mécanique p. 138, top left: Anthony D'Urso p. 138, top right: Charles Osgood p. 139, top: Christopher Hunt, Getty Images p. 139, bottom: Brinkhoff/Mögenburg (© the National Theatre) p. 143, top right: Commissioned photography by Alan Williams pp. 144–145: Commissioned photography by Alan Williams p. 148, top right: Heini Schneebeli (© the Cabaret Mechanical Theatre Ltd.) p. 148, bottom right: Paul Carroll p. 156, top left: © Bruno Munari (1942-2004); Maurizio Corraini s.r.l. All rights reserved p. 156, top right: Fletcher Lawrence p. 157, top: © Icarus Films p. 157, middle right: © NHK p. 157, bottom: Kohji Robert Yamamoto pp. 158–159: Laurie Lazer p. 162, bottom: Hiro Ihara, courtesy of Cai Studio p. 163, top: Loek van der Klis p. 163, middle: Martin Bromirski p. 169, top right: Keira Heu-Jwyn Chang p. 172, top left: Wikicommons p. 172, top right: James Prinz, courtesy of Jack Shainman Gallery, New York p. 172, bottom: Zoefotografie p. 173, bottom left: Andrea Nasher, courtesy of Ace Gallery Los Angeles p. 173, bottom right: Gianfilippo de Rossi p. 177 (jellyfish photographs): Shutterstock Images p. 177 (anglerfish photographs): Science PhotoLibrary p. 182, left: Ben Finio and Eliza Grinnell, Harvard p. 182, top right: Emmanuel Nunez p. 183, top: © PBAI p. 183, bottom: Pete Prodoehl p. 184: Amy Snyder (© Exploratorium) p. 187, top right and bottom: Amy Snyder (© Exploratorium) p. 191, top left: © 2013 Artists Rights Society (ARS), New York / VG Bild-Kunst, Bonn p. 191, top right: Sibila Savage p. 191, bottom left: Photo © Vik Muniz / Licensed by VAGA, New York, NY p. 191, bottom right: Art © Vik Muniz / Licensed by VAGA, New York, NY pp. 192–193, main: Jane Tyska / The Oakland Tribune p. 193, top and lower left: Courtesy of the Bedford Gallery p. 193, lower right: Jesse Wilson p. 195, top right: Courtesy of the Bedford Gallery p. 198, top left: Imagination Foundation p. 198, top right: Lee Fatherree p. 199, top: Brian Klutch (© Popular Science) p. 199, middle right: Svetlana Markova p. 199, bottom left: Julie Klima p. 200: Dan Meyers p. 203, upper right: William Mack p. 203, lower right: © Exploratorium p. 207, top and middle right: ©2013 Museum Associates / LACMA pp. 208–209: Commissioned photography by Laura Flippen p. 211, top and bottom right: Commissioned photography by Laura Flippen pp. 212–213: Commissioned photography by Laura Flippen p. 214, top left: Jim Lambie, Zobop, installation view, 2005, Goss Michael Foundation; courtesy of the artist; Anton Kern Gallery, New York; Goss Michael Foundation, Dallas, TX p. 214, bottom left: Educational Innovations p. 215, bottom: cutetape.com p. 219: Commissioned photography by Alan Williams

Additional art and prop credits: pp. 22–23: Tinkering tiles by Nicole Catrett p. 36–37: aerial photography prompt inspired by the Public Laboratory for Open Technology and Science p. 50: light box by Ryoko Matsumoto; based on a kit by Taizo Matsumura p. 55: stroboscope and tutorial by Nicole Catrett p. 66: squishy circuits by Ryoko Matsumoto; tutorial developed by AnnMarie Thomas, Samuel Johnson, and Matthew Schmidtbauer at the University of St. Thomas p. 76: lasercut paper by Jennifer Jacobs pp. 78–79: paper circuits by Ryoko Matsumoto; tutorial developed by Jie Qi pp. 86–87: fabric circuits and tutorial by Grace Kim pp. 96–97: felt pieces and tutorial by Moxie Lieberman p. 121: foot-tickling machine by Nicole Catrett; tutorial developed by Tim Hunkin p. 129: hacked Elmo by Nicole Catrett pp. 136–137: masks and tutorial by Dax Tran-Caffee p. 147: cardboard automata courtesy of the Tinkering Studio p. 189: fused-plastic objects and tutorial by Karen Wilkinson p. 205: marble machine by Meredith Robinson pp. 212–213: tape building blocks and tutorial by Danny Scheible p. 221: paper sewing machine by Nicole Catrett p. 224: cardboard hammer by Dax Tran-Caffee

weldon**owen**

President, CEO Terry Newell
VP, Sales Amy Kaneko
VP, Publisher Roger Shaw
Creative Director Kelly Booth
Senior Editor Lucie Parker
Art Director William Mack
Production Director Chris Hemesath
Production Manager Michelle Duggan

Weldon Owen is a division of **BONNIER**
Copyright © 2013 by the Exploratorium
and Weldon Owen Inc.

**Partial proceeds benefit the Exploratorium
and its programs.**

All rights reserved, including the right
of reproduction in whole or in part in
any form.

Library of Congress Control Number:
2013948536

ISBN 13: 978-1-61628-609-5
ISBN 10: 1-61628-609-1

10 9 8 7 6 5 4 3 2 1
2013 2014 2015 2016 2017

Printed in China by Imago.

Publisher Acknowledgments

Weldon Owen would like to thank Karen Wilkinson and
Mike Petrich for introducing us to the amazing world of
tinkering, and the entire Tinkering Studio team for their
assistance during this book's creation: Luigi Anzivino,
Nicole Catrett, Ryan Jenkins, Lianna Kali, Walter
Kitundu, Sebastian Martin, and Ryoko Matsumoto. We'd
also like to thank Julie Nunn, Silva Raker, and Dana
Goldberg for helping us make it all happen.

We cannot say thank you enough to our featured artists
for sharing their passions and the inspiring details
behind their projects, and for shipping their tools and
artwork from near and far so that we could photograph
them. Thank you for trusting us with your stories.

Gratitude is also owed to Ashley Batz, Tre Borden, Conor
Buckley, Scott Erwert, Gonzalo Ferreyra, Emelie Griffin,
Laura Harger, Andrew Joron, Margaux Keres, Greg Lee
and Mark Lopez at Imago, Tim Lillis, Andrew Lopshire,
Jeremy Maz, Megan Peterson, Meredith Robinson, Katie
Schlossberg, Hilary Seeley, Marisa Solís, Stephanie Tang,
Tigerfish Transcription, Daniel Triassi, and Stephen Yu.

15/17 Pier, San Francisco, CA 94111
www.exploratorium.edu

The Exploratorium—San Francisco's renowned
museum of science, art, and human perception—is
dedicated to changing the way the world learns.
Within the Exploratorium, the Tinkering Studio is a
workshop in which science and technology become
powerful tools for personal expression, and where
visitors gather to participate in hands-on, mind-
expanding activities and demonstrations.

For more information, visit
www.tinkering.exploratorium.edu

Exploratorium® and Tinkering Studio® are registered
trademarks and service marks of the Exploratorium.

Author Acknowledgments

This book would not be possible without the
enormous talents of Kelly Booth, William Mack, and
especially Lucie Parker. The intensity and interest
Lucie brought to this book seemed unmatchable at
times. We marveled at her ability to keep the process
incredibly fun and rewarding despite all of the
looming deadlines that were impossibly timed.

Julie Nunn deserves a debt of gratitude for getting the
ball rolling with such a terrific publisher and keeping
it rolling all these months. The book literally would
not have happened without her. Bronwyn Bevan, Rob
Semper, and Thomas Carlson have been instrumental
in supporting and maintaining Tinkering as a serious
approach to learning at the Exploratorium.

We of course must thank the artists who appear in
this book. Many are dear friends and colleagues,
and all inspire us every day in our work at the
Exploratorium and in our own pursuits. And most
importantly, there would not be a Tinkering Studio
(related programs, artist relationships, and making
activities) without the critical thinking, tireless
work, and creative talents of Luigi Anzivino, Lianna
Kali, Nicole Catrett, Ryan Jenkins, Kate Stirr, Ryoko
Matsumoto, Sebastian Martin, and Walter Kitundu.

Lastly, it feels fortunate that as co-authors and partners
we don't have to thank our spouses for tolerating
the endless hours we spent working on the book, or
for taking it home every night and on vacation. We
always do that—our work is our play and vice versa.
Tinkering as a way of being has been the way we've
operated since the day we met (well, maybe three
months after we met, but that's another story).

About the Authors

As codirectors of the Tinkering Studio, Karen Wilkinson and Mike Petrich see their roles at the Exploratorium as advocates for making as a way of knowing. They believe deeply in studio pedagogy and the ability that we all have to think with our hands, and are curious about how people develop personal and unique understandings of the world for themselves. As undergraduates, both attended the Minneapolis College of Art and Design, where Mike studied fine arts, filmmaking, and photography and Karen focused on environmental design. Through their studies, the two became committed to the idea that constructionism is an incredibly powerful way of learning and that aesthetics matter a great deal—ideas that are often overlooked in more formal education settings outside kindergarten or graduate school.

Before coming to the Exploratorium, where Mike is the director of the Making Collaborative and Karen is the director of the Learning Studio, they pursued graduate studies in education and technology at Harvard and MIT. Today, after more than twenty years working as a team to integrate science, art, and technology into curriculum for both in-school and out-of-school learning environments, they foster and facilitate informal learning spaces for making and tinkering, offering people a chance to connect to their own learning in a deeply personal way. They've worked with audiences as diverse as museum visitors, primary school students, Tibetan monks, prison inmates, and graduate school researchers, and are both happy to call the Tinkering Studio home, where they are able to work with a delightfully quirky group of artists, educators, and innovators.

Cover images: Illustrated pattern based on drawings by Paul Spooner.
Back cover, clockwise from top left: Grace Kim's *Sessile Handbag,*
photographed by Jeanie Cho; Tyree Callahan's *Chromatic Typewriter;* Walter
Kitundu's *Ocean Edge Device,* photographed by Laurie Lazer.

Hacked cover examples: Touch-sensitive light-up book jacket by Nicole
Catrett; pop-up paper workbench by Kate Stirr.

Keep Experimenting!

ONCE YOU'VE PLAYED WITH GETTING BASIC LEDS TO LIGHT UP ON THE COVER, EXPLORE MORE WHIMSICAL POSSIBILITIES AND SOME ADVANCED ELECTRONICS.

Tinkering is all about using technology to tell a story—there's real fun and value in putting hardcore electronics to personally meaningful, creative use. Be inspired by the playful and innovative examples that you see here (as well as the many inspiring projects that you'll encounter inside *The Art of Tinkering)* and consider picking up some of these materials and electronics to use in your tinkering adventures.

Choose crafting materials that speak to you: Colorful tape, everyday plastic bits, touchable felt, discarded wood scraps, and intriguing paper can all play an expressive role in your project, lending personality and narrative to your chosen electronics. Some crafting supplies conduct electricity, too, such as aluminum foil, copper tape (available in home-supply stores), and conductive fabric and thread (which you can find online). There's also Bare Conductive's Electric Paint, which lets you paint your own circuits. All these can be used so that they connect with the conductive ink, running the electrical current from the cover to whatever you like!

Beyond LEDs, there's a wealth of electronics you can incorporate into your projects. Simple DC motors and low-voltage speakers, for example, are available at hobbyists' shops. Playing with these requires the use of a microprocessor or an Arduino, a popular microcontroller that you can program to make your electronic components perform all kinds of functions. You may find it useful to use a multimeter, a tool that will allow you to measure the conductivity of the ink and gauge if it will provide enough current for the project that you have in mind. (Note that we don't recommend soldering directly to the conductive ink, as such high heat can melt it.)